Canon *REBELT2i* EOS 550D

Michael Guncheon

MAGIC LANTERN GUIDES®

Canon EOS REBELT2i EOS 550D

Michael Guncheon

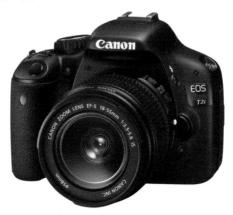

A Division of Sterling Publishing Co., Inc.
New York / London

Book Design: Michael Robertson Cover Design: Thom Gaines, Electron Graphics

Guncheon, Michael A., 1959-

Canon EOS Rebel T2i/EOS 550D / Michael Guncheon. -- 1st ed.

p. cm. -- (Magic lantern guides)

ISBN 978-1-60059-793-0

1. Canon digital cameras--Handbooks, manuals, etc. 2. Single-lens reflex cameras--Handbooks, manuals, etc. 3. Photography--Digital techniques--Handbooks, manuals, etc. 1. Title. TR263.C3C97225 2010

771.3'2--dc22

2010020523

10987654321

First Edition

Published by Lark Books, A Division of Sterling Publishing Co., Inc. 387 Park Avenue South, New York, N.Y. 10016

Text © 2010, Michael Guncheon Photography © 2010, Michael Guncheon unless otherwise specified

Distributed in Canada by Sterling Publishing, c/o Canadian Manda Group, 165 Dufferin Street Toronto, Ontario, Canada M6K 3H6

Distributed in the United Kingdom by GMC Distribution Services, Castle Place, 166 High Street, Lewes, East Sussex, England BN7 1XU

Distributed in Australia by Capricorn Link (Australia) Pty Ltd., P.O. Box 704, Windsor, NSW 2756 Australia

This book is not sponsored by Canon.

The written instructions, photographs, and projects in this volume are intended for the personal use of the reader and may be reproduced for that purpose only. Any other use, especially commercial use, is forbidden under law without written permission of the copyright holder.

Canon, EOS, Rebel, Speedlite, and other Canon product names or terminology are trademarks of Canon Inc. Other trademarks are recognized as belonging to their respective owners.

Every effort has been made to ensure that all the information in this book is accurate. However, due to differing conditions, tools, and individual skills, the publisher cannot be responsible for any injuries, losses, and other damages that may result from the use of the information in this book. Because specifications may be changed by manufacturers without notice, the contents of this book may not necessarily agree with software and equipment changes made after publication.

If you have questions or comments about this book, please contact: Lark Books 67 Broadway Asheville, NC 28801 (828) 253-0467

Manufactured in Canada

All rights reserved

ISBN 13: 978-1-60059-793-0

For information about custom editions, special sales, premium and corporate purchases, please contact Sterling Special Sales Department at 800-805-5489 or specialsales@sterlingpub.com.

For information about desk and examination copies available to college and university professors, requests must be submitted to academic@larkbooks.com. Our complete policy can be found at www.larkbooks.com.

To learn more about digital photography, go to www.pixiq.com.

Contents

Introducing the Canon Rebel T2i 13	
Overview of Features	
Getting Started in Ten Basic Steps	
Conventions Used in this Book	/
Getting Started 19	
Preparing the Camera	
Date/Time	
Auto Power Off	
Batteries	
Memory Cards	
Resetting Controls	
Cleaning the Camera	
Automatic Sensor Cleaning	
Dust Delete Data	
Manual Sensor Cleaning	Э
Camera Controls 31	1
Buttons and Dials Overview	1
Resetting Controls	2
Mode Dial	2
Shutter Button	3
Main Dial	4
ISO Speed Setting	4
Cross Keys	4
Set Button	5
White Balance Selection Button	5
Autofocus Mode Selection	5
Drive Mode Selection	6
Picture Style Selection Button	6
Autofocus Point Selection / Magnify Button 37	

AE Lock / FE Lock / Index / Reduce Button 38
Live View Shooting / Movie Shooting Button 39
Quick Control / Direct Print Button 40
Menu Button
Display Button
Playback Button
Erase Button43
Aperture / Exposure Compensation Button 44
Depth-of-Field Preview Button 45
Power Switch
Flash Button45
The Viewfinder
Viewfinder Adjustment
The LCD Monitor
Quick Control Screen50
Camera Settings Screen51
The Sensor
File Formats and Processing 55
The Power of DIGIC 4 Processing
Picture Styles
Standard
Portrait
Landscape
Neutral
Faithful
Monochrome
Picture Style Processing
Modifying Picture Styles 60
User-Defined Picture Styles 61
Color Space
White Balance
White Balance Presets 65
Using Custom White Balance
White Balance Correction 69
White Balance Autobracketing70
White Balance Autobracketing
White Balance Autobracketing
White Balance Autobracketing

The Menu System and Custom Functions	81
Using the Menus	81
Shooting 1 Menu	82
Shooting 2 Menu	87
Shooting 3 Menu	92
Playback 1 Menu	94
Playback 2 Menu	96
Set-Up 1 Menu	
Set-Up 2 Menu	. 104
Set-Up 3 Menu	
My Menu	. 109
Movie 1 Menu	. 111
Movie 2 Menu	. 115
Custom Functions	. 117
C.FN I Exposure	. 118
C.FN II: Image	. 119
C.FN. III: Autofocus / Drive	. 122
C.FN. IV: Operation / Others	. 124
Jilooting and Dive	129
Shooting Modes	
Basic Zone Shooting Modes	
Creative Zone Shooting Modes	
Drive Modes and the Self-Timer	
Single Shooting	
Continuous Shooting	
Self-Timer/Remote Control	
2-Second Self-Timer	
Continuous Self-Timer	
Mirror Lockup	. 145
Focus and Exposure	147
Autofocus	. 147
AF Modes	. 148
Selecting and AF Point	. 150
Autofocus Limitations	
Exposure	. 152
ISO	
Metering	. 155
AE Lock	
Exposure Compensation	. 160

Autoexposure Bracketing (AEB) 161
Judging Exposure
Live View and Movie Shooting 167
Live View
LCD Monitor
Status Displays168
Quick-Control Screen169
Camera Settings
Focus During Live View Shooting
Quick Mode AF
Live Mode AF
Face Detection AF
Manual Focus175
Focus During Movie Recording
Exposure
ISO in Live View176
ISO in Movie Shooting
Exposure Modes in Live View 177
Exposure Modes in Movie Shooting
Metering in Live View178
Metering in Movie Shooting
Exposure Simulation Indicator 179
Movie Shooting
Movie Recording Quality
Shutter
Audio
Recording Length185
Movie Playback
Movie Trimming187
Still Capture while Recording Movies 187
Flori
Flash 189
The Basics of Flash
The Inverse Square Law
Guide Numbers
Flash Synchronization
Flash Metering and Exposure
Setting Flash Exposure
Flash with Shooting Modes194
Using the Built-In Flash

Advanced Flash Techniques	98
FE (Flash Exposure) Lock	
Flash Exposure Compensation 2	00
Red-Eye Reduction	
High-Speed Sync 2	
First and Second Curtain Sync 2	
Canon Speedlite EX Flash Units	03
Canon Speedlite 580EX II 2	04
Canon Speedlite 430 EX II 2	
Canon Speedlite 270 EX	
Other Speedlites	
Close-Up Flash2	06
Bounce Flash	08
Wireless E-TTL Flash	08
Channels2	09
Groups	
Wireless E-TTL Flash via External Speedlite 2	
Wireless Manual Flash via External Speedlite 2	11
Lenses and Accessories 21	
Lenses for Canon D-SLRs	
Choosing Lenses	
Zoom Vs. Prime Lenses	
EF-Series Lenses	
EF-S Series Lenses	
L-Series Lenses	
DO-Series Lenses2	
Macro Lenses2	
Tilt-Shift Lenses	
Independent Lens Brands 2	
Close-Up Photography2	
Close-Up Lenses and Accessories 2	
Close-Up Sharpness2	
Close-Up Contrast	
Filters	
Polarizing Filters	
Neutral Density (ND) Filters	
Graduated Neutral Density Filters 2	
UV and Skylight Filters2	
Tripods and Camera Support2	
LCD Hoods	29

Output	231
From Camera to Computer	231
The Card Reader	
Eye-Fi	
Archiving	234
Working with Still Images	236
Image Browser Programs	238
Image Processing	240
Printing	244
Digital Print Order Format (DPOF)	247
Working with Movies	248
Viewing Movies	249
Movie Editing	249
Movie Output	251

Introducing the Canon Rebel T2i

Canon created a revolution in digital photography when it introduced the EOS Digital Rebel in 2003. Since then, Canon has continued to introduce new Rebels, each with higher image quality and better features than its predecessor. Now Canon presents the T2i, known as the EOS 550D outside of North America. With its introduction, Canon has continued to set the standard for affordable D-SLRs (digital single-lens-reflex cameras).

The Rebel T2i offers quick start-up, fast memory card writing speeds, and high-definition video recording. The chassis is constructed using stainless steel, which is both lightweight and extremely rigid, allowing the camera to stand up to years of use. The body consists of a specially engineered polycarbonate resin. This again helps create a lightweight, yet strong, unit. The exterior of the camera is ergonomically designed and controls have been redesigned for easy use.

The T2i's body measures only 5.1 x 3.8 x 3.0 inches (129 x 98 x 75 mm), and weighs just 18.7 ounces (530 g) without a lens. Yet, the Rebel T2i offers a newly developed 18-megapixel (MP) image sensor and a high degree of technological

sophistication at an affordable price. In many ways, it sets the bar for all other D-SLRs in this price range.

The new sensor incorporates improved circuitry and new "gapless" microlenses that increase the sensitivity of the image sensor. A key feature of this new CMOS sensor is low power consumption, enabling you to shoot with a live view on the LCD and record HD video. The T2i can record in 1080p with full HD frame rates—the T1i could only record at 20 frames per second.

At the heart of the image processing circuitry is the Digital Image Core 4 (DIGIC 4) processor. This special chip is the latest in a long line of Canon-designed processors. The DIGIC 4 helps make the Rebel T2i's continuous shooting speed 3.7 frames per second with bursts of up to 34 JPEGs or 6 RAW images when used with an appropriate memory card. But the DIGIC 4 processor is not just about shooting speed; it also provides fast image processing, improved light sensitivity, and low image noise.

One of the biggest changes to the T2i compared to other EOS cameras is the new 63-zone dual-layer metering sensor that uses color, luminance, and focus information in order to achieve well-balanced exposures. This system, originally introduced for the Canon EOS 7D, is one of the most advanced metering systems in a digital SLR.

Canon has used its EF-S lens mount for this camera. Introduced with the original Digital Rebel (EOS 300D), this mount accepts all standard Canon EF lenses. In addition, it accepts compact EF-S lenses, built specifically for small-format sensors. EF-S lenses can only be used on cameras designed expressly to accept them.

OVERVIEW OF FEATURES

There are a number of exciting and useful features in the Rebel T2i that will help you have a great photographic experience. Before we get into a detailed look at the functions and operations, let's take a quick look at some of the highlights offered in the T2i:

- O New Canon-designed and built 18MP, APS-C-sized CMOS sensor
- O DIGIC 4 image processor for high-speed, low-noise performance
- O New Clear View LCD monitor—a large, bright, and sharp three-inch (7.7 cm), high-resolution color display with anti-reflective, scratch-resistant coatings, automatic brightness control and an aspect ratio that matches the camera's aspect ratio
- O LCD auto-off sensor to minimize glare when using the viewfinder
- Shoots 3.7 fps and up to 34 frames consecutively at maximum JPEG resolution (6 frames continuously in RAW)
- O Supports SD, SDHC, and SDXC memory cards
- O Includes support for Eye-Fi memory cards for wireless connectivity
- O ISO range of 100 6400, extendable to 100 12800
- O Live view shooting mode with Face Detection AF
- O Integrated sensor-cleaning system and Dust Delete Data system
- O Six preset and three user-defined custom Picture Style settings
- High-speed focal-plane shutter—up to 1/4000 second—with regular flash sync up to 1/200 second
- O 9-point autofocus system
- New multi-layer, 63-zone intelligent Focus Color Luminance (iFCL) metering system that is tightly integrated with the AF system to achieve unprecedented metering accuracy
- O High-definition video recording with full manual exposure control; 1920×1080 resolution at 30, 25, and 24 fps progressive recording; 1280 \times 720 at 60 and 50 fps progressive recording; and standard definition 640×480 at 60 and 50 fps progressive recording, all with audio
- Movie-crop video recording gives 7x magnification
- O External microphone input
- Quick Control screen that provides fast access to camera settings without going into menus
- New Quick Control screen access button
- O User-activated noise subtraction for long exposures
- O High ISO noise reduction
- O Auto Lighting Optimizer for automatic adjustment of scene brightness and contrast
- Lens peripheral-illumination correction for automatic compensation of light fall-off at the corners of the image
- O Exposure compensation system with a range of five stops
- O 12 custom functions

Here are ten steps that will make it easier to record good photos with your T2i. You will probably modify them with experience.

- 1. Set [Auto power off] for a reasonable time: The default duration in the ♥ (Set-up 1) menu is merely 30 seconds. I guarantee this will frustrate you when the camera has turned itself off just as you are ready to shoot. Perhaps it is more realistic to try [4 min.]. (See page 99.)
- 2. Adjust the eyepiece: Use the dioptric adjustment knob to the right of the viewfinder to make the focus through your eyepiece as sharp as possible. You can adjust it with a fingertip. (See pages 46-47.)
- 3. Choose a large file size (RAW or L for JPEG): This determines your image recording quality. Select the a (Shooting 1) menu, then press **SET** and use **◆▶** to select your desired image size (see pages 82-83). You are usually best served to choose one of the high-quality options.
- 4. Set your preferred shooting mode: Use the mode dial on the top right shoulder of the camera to select any of the exposure shooting modes (see pages 134-142) or fully automatic modes (see page 130). If using any of the exposure modes, select a Picture Style (see pages 56-62).
- 5. Choose AF mode: Autofocus (AF) mode is set by pressing the AF button. The LCD monitor then displays several AF mode options. Use the main dial (△) or ◆ to select an AF mode, then press SET. A good place to start is AI Servo AF. The selected mode displays in the camera settings on the LCD. (See page 149.)
- 6. **Select drive mode:** Drive mode is selected by pressing □ ₺ . Select either single shooting □, continuous shooting □, self-timer/remote (10-second self-timer) ₺, 2-second self-timer ₺2, or continuous self-timer &c. (See pages 143-144.) The LCD indicates the mode the camera is in. Depending on the shooting mode, not all drive modes will be available
- 7. Choose metering mode: Metering mode is set via the (Shooting 2) menu. Use AV to highlight [Metering mode] and press SET. Use \P to select the metering mode as displayed on the LCD panel. Choose from four different metering modes: evaluative (a), partial (a), spot (1), or center-weighted average []. Press SET to accept. (2) is a good starting point. (See page 155.)
- 8. Select white balance: Auto white balance AMB is a good place to start because the Rebel T2i is designed to generally do well with it. To set, press the WB button. (See page 64.) The different white balance choices display on the monitor; use ☐ or ◆ to select one, then press SET. After making your choice, the selected white balance appears in the camera settings display on the LCD.

- 9. Pick an ISO setting: Though any setting between 100 and 400 works extremely well, you can generally set higher ISO sensitivity (with less noticeable noise) with the Rebel T2i than with other digital cameras. (See pages 152-154.) Press the ISO button, located immediately behind the main dial (△). The LCD monitor displays a range of ISO speeds to choose from. Use △ or ◆ to select. Use △ to rotate through the ISO choices.
- 10. **Set a reasonable review time:** The default review time on the LCD monitor is only two seconds. That's very little time to analyze your photos, so I recommend the eight-second setting, which you can always escape out of by pressing the shutter button. If you are worried about using too much battery power, just turn off the review function altogether. Review time is set in \square . (See page 85.)

CONVENTIONS USED IN THIS BOOK

When the terms "right" and "left" are used to denote placement of buttons, features, or to describe camera techniques, it is assumed that the camera is being held in the shooting position, unless otherwise specified.

The T2i has a number of buttons that have dual functions and dual labels. For example, with the cross keys, the AF button is used for accessing the AF settings and is also used for scrolling right in menus and other settings. In the interest of clarity, when referring to these dual purpose controls, I will indicate just the label of the function I am talking about.

When describing the functionality of the Rebel T2i, it is assumed that the camera is being used with genuine Canon accessories, such as Speedlites, lenses, and batteries.

Custom functions are indicated by the Canon nomenclature of C.Fn, followed by the custom function number. Canon further divides the functions into groups—indicated by roman numerals—but it is easier to remember them by their number.

We are now ready to explore the features, functions, and attributes of the Canon Rebel T2i in detail. Before we go any further, let me first acknowledge that this book would be impossible to write without the help of many people. Thank you to Rudy Winston, and Chuck Westfall at Canon. I would also like to thank the gang at Lark Books for all of their support, especially Kevin Kopp, Haley Pritchard, Frank Gallaugher, Rebecca Shipkosky, and Marti Saltzman. And finally, a special thanks to my wife, Carol, without whom this book would never make it to the printer.

Getting Started

PREPARING THE CAMERA

The Canon Rebel T2i is a sophisticated piece of equipment. With proper setup, good handling practices, and careful maintenance, this technology can help take your photography to the next level. There are several things you'll want to take care of before you get into the shooting functions and start photographing.

DATE/TIME

To set date and time, press the MENU button and use the main dial to scroll to \(\psi^2\). Use \(\psi^\neq\) to select [Date/Time]. Press SET to enter the adjustment mode. Once there, use \(\psi^\neq\) to step through each parameter on the screen. When you are on a setting, press SET to enter the adjustment mode and use \(\psi^\neq\) to adjust the value. Press SET again to accept the setting. Continue using \(\psi^\neq\) and SET to adjust the date, time, and/or to format the date/time display. Once the date and time are correct, use \(\psi^\neq\) to highlight [OK], then press SET again to confirm your selections and exit the adjustment mode.

NOTE: When traveling, keep your camera set to local time. This will help you if you need to figure out when a picture was taken. If the time zone change is a significant one and you don't change to local time, your image's time/date might make you think the picture was taken the day before or after you actually took it.

The T2i holds the date and time in its memory even when you remove the LP-E8 battery. If you leave the LP-E8 out of the camera for an extended period of time, the camera may lose this memory. Simply insert a charged LP-E8 and the camera will recharge the memory system from the battery.

AUTO POWER OFF

All digital cameras automatically shut off after a period of inactivity to conserve power. The Rebel T2i has a selection for [Auto power off] in the (Set-up 1) menu that can be used to turn off the power after a set duration of idleness.

Although this feature helps to minimize battery use, you may find it frustrating when you try to take a picture, to find that the camera has shut itself off. For example, you might be shooting a football game and the action may stay away from you for a couple of minutes. If IAuto power off] is set to [30 sec.], the camera may have shut itself off by the time the players move back toward you. When you try to shoot, nothing happens because the camera is powering back up. You may miss the important shot. For cases like this, try changing the setting to [4 min.] or [8 min.] so the camera stays on when you need it.

Access the auto-power-off function through the camera's menus. Press MENU and advance to \(\mathbf{f}\) using \(\omega_{\text{\text{.}}}\). When \(\mathbf{f}\) is highlighted, use To highlight [Auto power off], the first item in this menu, and press **SET**. You are given seven different choices, ranging from 1 – 30 minutes (including the [Off] option that prevents the camera from ever turning off automatically). Scroll with AV to highlight the desired duration and press SET to select it.

BATTERIES

Canon has included a high-performance battery for the T2i. At 1220mAh in capacity, the lithium ion LP-E8 battery is a great improvement over previous Canon batteries. Milliampere hours (mAh) indicate a battery's capacity to hold a charge. Higher mAh numbers mean longer-lasting batteries.

Although the camera is designed for efficient use of battery power, it is important to understand that power consumption is highly dependent on how long features such as flash, autofocus, the LCD, live view, and movie recording are used. In short, the more the camera is active, the shorter the battery life. Be sure to have backup batteries. And it is always a good idea to shut the camera off if you are not using it.

Canon estimates that at 73°F (23°C), the battery will last approximately 550 shots when flash is not used (or 470 shots with 50% flash usage). Lower temperatures reduce the number of shots. In addition, it is never wise to expose your camera or its accessories to heat or direct sunlight (i.e., don't leave the camera sitting in your car on a hot or a cold day!).

When you use the live view feature, the number of shots drops to 200, or 180 shots with 50% flash usage. The approximate length of time you can shoot continuously with live view is an hour and a half at 73°F (23°C) with a fully charged battery. When shooting video, the battery lasts approximately an hour and 40 minutes at 73°F (23°C).

I recommend that you carry one or two extra batteries, particularly when you travel. If you own a total of three, one battery can be on the charger, one in the camera, and one in your pocket. For safety, when the battery is not on the charger or in the camera, be sure to use the battery cover that came with the battery. If you don't use the cover, the contacts could short and lead to damage to the battery or even a fire—not something you want to happen in your pocket!

The battery cover can act as a good reminder of whether or not a battery is charged. There is a small rectangular opening that reveals either the blue portion of the battery label or the dark gray portion. I place the cover so the blue portion shows on all of my batteries that are charged and ready to go.

The LP-E8 is rated at 7.2 volts and it takes about two hours to fully charge on the LC-E8 charger included with the camera. Rechargeable batteries lose a bit of charge every day, but this doesn't mean you should leave the battery on the charger all the time. Get in the habit of just charging your battery the day you need it or possibly the day before.

CAUTION: Never operate the T2i with very low battery power (when the battery icon is blinking). If the T2i is writing to the memory card and the battery runs out of power, it could corrupt the directory on the memory card and possibly cause you to lose all the pictures on the card.

The charger has a built-in voltage and frequency converter, so it is not necessary to use a transformer when you travel—the charger handles voltages from 100-240 and 50-60 hertz frequencies. You will, however, need an adapter to change the physical layout of the plug, depending on the country you travel to.

An optional battery grip, BG-E8, attaches to the bottom of the camera and can be used with one or two LP-E8 batteries. If two batteries are loaded, power is initially drawn from the battery with the higher voltage. Once the voltage level of the two batteries is the same, power is drawn from both batteries. When attached to the camera, the BG-E8 replaces the T2i's internal battery. The grip also comes with an adapter, which allows six AA-size batteries to be used.

A nice feature of the battery grip is that it duplicates several controls on the camera so that they are just as easily accessed whether the camera is being held vertically or horizontally. The duplicated controls include a shutter button, AE lock button \bigstar , and the main dial (\bigtriangleup).

The AC adapter kit (ACK-E8) is useful for those who need the camera to remain consistently powered up (e.g., for scientific lab work, in-studio use, and lengthy video shooting).

> When you attach the battery grip to the T2i, it makes the camera feel the same in your hands, whether you are shooting horizontally or vertically.

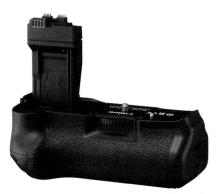

©Canon Inc.

NOTE: There are a couple of limitations if you use AA batteries with the grip: The T2i will not let you perform a manual cleaning of the image sensor, and the battery indicator may not be as accurate.

The Canon EOS Rebel T2i uses Secure Digital (SD) memory cards. You need a card of sizeable capacity to handle the image files of this camera; anything less than 512 MB fills up too quickly (see page 78 for specifics). SD cards are sturdy, durable, and difficult to damage. One thing they don't like is heat; make sure you store them properly.

There are three different kinds of SD cards: SD, SD high capacity (SDHC), and the new SD extended capacity (SDXC). The T2i supports all three cards; in fact the T2i is the first Canon EOS camera to support the SDXC format. While the T2i can use any of the cards, it is important to know the difference when you start downloading your images to the computer. Both SDHC and SDXC cards fit into an SD slot, and other than the distinction in logos, they are impossible to visually distinguish from an SD card. (The regular SD card was developed first; SDHC came later, and the SDXC was introduced in 2009.)

The design difference between SD, SDHC, and SDXC doesn't affect the Rebel T2i. However, SDHC cards cannot be used with older SD devices, and SDXC cards may have problems with SDHC devices. By "devices," I mean items such as card readers and printers. If you deliver an SDHC or SDXC card directly to someone for printing rather than printing your images yourself, make sure they have the right device for an SDHC or SDXC memory card.

SDHC/SDXC-capable slots, including the one in the Rebel T2i, have no problem using regular SD cards. This simple rule applies: SDXC-capable devices can use SDXC, SDHC, and SD cards; SDHC devices can use either SD or SDHC cards; and SD devices can only use SD cards. Remember to look for the SDHC label on all your devices if you plan to use SDHC cards (the same applies for SDXC). If this is your first camera and card reader, I would just stick to SDHC.

NOTE: Be wary of SD cards that are greater than 2GB but that don't have the SDHC icon. They may not be reliable. When you try to use an SD reader to read the memory card, your computer may be unable to read the data.

Besides a capacity rating, SDHC and SDXC cards also have a speed class that specifies how quickly the card can read and write data. If you are shooting video with your T2i you'll need to make sure that the memory card you are using has a speed class of at least 6.

To insert the memory card, open the memory card slot cover on the right side of the camera body. Align the card with the slot with the card label facing towards the back of the camera. Gently push the card into the camera until it clicks into place. To remove the memory card from your camera, press gently on the edge of the memory card to release it from the camera. Carefully grab the edge of the card to remove it.

> For trouble-free use, never format your memory card via a computer, always format it using the format option in the T2i.

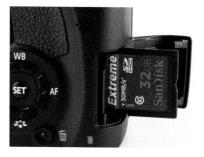

CAUTION: Before removing the memory card, it is a good idea to turn the camera off. Even though the Rebel T2i automatically shuts itself off when the memory card door is opened, make sure the access lamp on the back of the camera near the bottom right is not illuminated or flashing. This habit of turning the camera off allows the camera to finish writing to the card. If you should open the card door and remove the card before the camera has written a set of files to it, there is a good possibility you will corrupt the directory or damage the card. You may lose not only the image being recorded, but all of the images on the card.

Formatting your memory card: Before you use a memory card in your camera, it must be formatted specifically for the Rebel T2i. To do so, go to \ref{T} and then use \ref{T} to highlight [Format]. Press SET and the Format menu appears on the LCD. It tells you how much of the card is presently filled with data and how big the card is. Use \ref{T} to move the choice to [OK], press SET, and formatting begins. You will see a screen showing the progress.

CAUTION: Formatting your memory card erases all images and information stored on the card, including protected images. Be sure that you do not need to save anything on the card before you format. (Transfer important images to a computer or another downloading device before formatting the card.)

The format screen also gives the option of performing a low-level format of the card. Low-level formatting rebuilds the card's file structure and flags any memory locations that are unreliable. While low-level formatting takes more time, it is a good idea to do this if you feel the writing speed of the memory card is slowing down—I do it frequently. Press the $\tilde{\mathbb{D}}$ (delete) button, located on the back of the camera in the lower right corner, to put a check mark in the [Low level format] box.

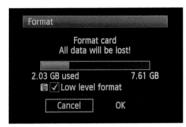

Formatting the memory card in the T2i will assure that the directory structure is set up properly. Simply erasing your image files does not alter the structure at all, so if there are problems with the directory, there will continue to be problems.

It is important to routinely format a memory card to keep its data structure organized. Simply erasing all of the images doesn't refresh the data structure on the card. Also, never format the card in a computer. A computer uses different file structures than a digital camera and may either make the card unreadable for the camera or may cause problems with your images. So, for trouble-free operation, always format your card rather than just erasing all the images and always use the camera to do it.

NOTE: My experience is that if memory cards are going to fail, they usually do so early on. Always test a new card by formatting it, taking a lot of pictures and/or video, and then downloading the images / video to a computer. Resist the temptation to buy a new card and pop it, unopened, in your camera bag at the start of a long trip. Open it up and test it to make sure it works.

RESETTING CONTROLS

The Rebel T2i's menu system and Quick Control screen provide many opportunities to fine-tune and customize its many settings. If at some point you want to reset everything, you can restore the camera to its original default settings by going to the **\(\varepsilon**: (Set-up 3) menu and selecting [Clear settings], then pressing SET. You can clear all camera settings or just the custom function (C.Fn) settings.

> When you are first getting used to your T2i, don't be afraid to experiment with all of the menu options. Use [Clear settings] to get back to square one.

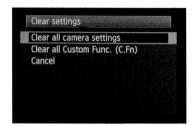

CIFANING THE CAMERA

A clean camera minimizes the amount of dirt or dust that can reach the sensor. A good kit of cleaning materials should include the following: A soft camel hair brush to clean off the camera, an antistatic brush and micro-fiber cloth for cleaning the lens, a lint-free towel or chamois for drying the camera in damp conditions, and a small rubber bulb to blow debris off the lens and the camera.

Always blow and brush debris from the camera before rubbing it with any cloth. For lens cleaning, blow and brush first, then clean with a micro-fiber cloth. If you find there is residue on the lens that is hard to remove, you can use lens-cleaning fluid, but be sure it is made for camera lenses. Never apply the fluid directly to the lens, as it can seep behind the lens elements and get inside the body of the lens. Apply with a cotton swab, or just spray it onto your micro-fiber cloth. Rub gently to remove the dirt, and then buff the lens with a dry part of the cloth, which you can wash in the washing machine when it gets dirty.

HINT: If your lens came with a lens shade, always use it. If your lens didn't come with one, buy a properly sized one. There is no better protection for your lens than a lens shade.

You don't need to be obsessive, but remember that a clean camera and lens help ensure that you don't develop image problems. Dirt and residue on the camera can get inside when changing lenses. If these end up on the sensor, you will have image problems. Dust on the sensor appears as small, dark, out-of-focus spots in the photo (most noticeable in light areas, such as sky).

Your T2i came with a body cap to protect the shutter chamber from dust. Never leave a D-SLR without a body cap for any length of time. Lenses should be capped when not in use and rear caps should always be used when the lens is not mounted on a camera.

You can minimize problems with sensor dust if you turn the camera off when changing lenses (preventing a dust-attracting static charge from building up). If you only own one lens, resist the temptation to take the lens off. And you should regularly vacuum your camera bag so that dust and dirt aren't stored with the camera.

Lastly, watch where you put the lens cap when you take it off your lens. Placing it in a linty pocket is a good way to introduce dust onto your lenses. These practices help to prevent dust from reaching the sensor.

AUTOMATIC SENSOR CLEANING

The T2i has a built-in system to combat the dust that is inherent with cameras that use removable lenses. This system uses a two-pronged approach: (1) The camera self-cleans to remove dust from the sensor, and (2) it employs a dust detection system to remove dust artifacts from images using software on your computer.

The low-pass filter in front of the sensor is attached to a piezoelectric element. When the camera self-cleans, the element rapidly vibrates at camera power-up and power-down. While self-cleaning at power-up just before taking pictures seems like an obvious time to clean the sensor, why clean it at power-down? Cleaning at power-down prevents dust from sticking to the sensor when the camera sits for long periods of time.

Self-cleaning can be enabled and disabled under **f**:. Use **T** to highlight [Sensor cleaning] and press SET. In the [Sensor cleaning] submenu, select [Auto cleaning :] and press SET. From there you can choose to enable or disable self-cleaning, then press SET to accept your selection. You can also engage the self-cleaning function immediately ([Clean now :]) or start the manual sensor cleaning procedure (see page 29).

> Canon gives you full control over the cleaning system built into the T2i. The [Clean manually] option should only be used as a last resort and requires special cleaning tools.

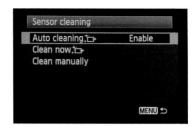

NOTE: In order to prevent overheating, the self-cleaning operation cannot be engaged within three seconds of any other operation. After a brief delay (usually ten seconds) it will be available for use.

DUST DELETE DATA

In the event that there is still dust on the sensor, the Rebel T2i's Dust Delete Data feature can be used. By photographing an out-of-focus, patternless, solid white object (such as a white sheet of paper), the image sensor is able to detect the shadow cast by dust stuck to the low-pass filter. Coordinates of the dust are embedded into the metadata of each future image. Canon's Digital Photo Professional software (supplied with the T2i) can use this data to automatically remove the dust spots in images.

To store the Dust Delete Data in the T2i:

- 1. Set up a well-lit white card.
- 2. Use a lens with a 50mm focal length or greater.
- 3. Set the lens for manual focus (MF).
- 4. Set the lens focus to infinity (∞). If the focus scale is not printed on the lens, turn the focus ring clockwise (while viewing the lens from the front of the camera) as far as it will go.
- In O:, select [Dust Delete Data] and press SET. Highlight [OK] and press SET.
- The T2i will execute an auto cleaning cycle and then ask you to press the shutter when ready.
- 7. Stand about a foot away from the card $(20-30 \, \text{cm})$. Compose the frame so that the white card entirely fills the frame and press the shutter. If the camera is not able to capture the data properly, it will ask you to try again. If the camera is new, there may be no dust on the sensor and the process will fail.

To use the Dust Delete Data, use Canon's Digital Photo Professional software to open an image that has Dust Delete Data embedded in it. In the Adjustment menu, choose Apply Dust Delete Data. The software will attempt to repair the dust spots in the image. You should update the Dust Delete Data from time to time as the amount and location of dust on the sensor will change.

Dust on your camera's sensor is most likely to show up as dark spots in your pictures, which are especially visible in skies or other primarily light-toned subjects. You can save yourself a lot of post-processing work by using the T2i's Dust Delete Data feature.

MANUAL SENSOR CLEANING

The Rebel T2i allows you to clean the sensor, but there are precautions to be taken. You must do this carefully and gently, indoors, and out of the wind—and at your own risk! Your battery must be fully charged so it doesn't fail during cleaning (or you can use the optional AC adapter). The sensor unit is a precision optical device, so if the gentle cleaning described below doesn't work, you should send the camera to a Canon Service Center for a thorough cleaning.

To clean the sensor, turn the camera on and go to **f**:. Using **A**, highlight [Sensor cleaning] and press SET. Use **A** in the [Sensor cleaning] submenu to highlight [Clean manually] and press SET, then follow the instructions. You'll see options for [OK] and [Cancel]. Using **A**, select [OK] and press SET. The LCD turns off, the mirror locks up, and the shutter opens. Take the lens off. Then, holding the camera face down, use a blower to gently blow any dust or other debris off the bottom of the lens opening first, and then blow off the sensor. Do not use brushes or compressed air because these can damage the sensor's surface. Turn the camera off when done. The mirror and shutter will return to normal. Put the lens back on.

CAUTION: Canon specifically recommends against any cleaning techniques or devices that touch the surface of the imaging sensor. If manual cleaning doesn't work, contact a Canon service center for cleaning.

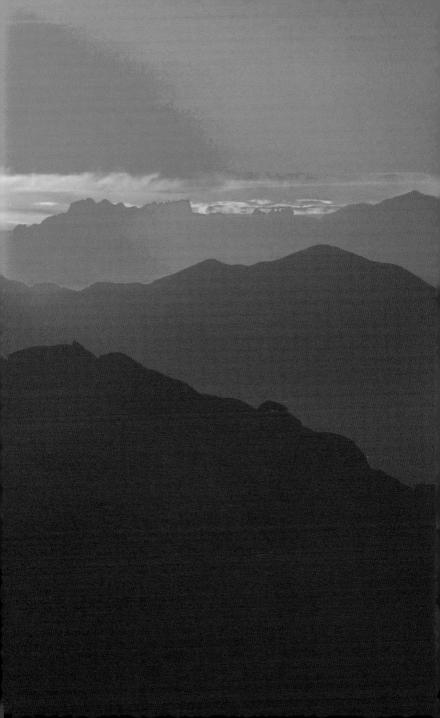

Camera Controls

It is easy to be overwhelmed by the variety of controls when you first take a look at the T2i. You may find there are some that you do not need or will not use. This book explains all the features on the Rebel T2i, and helps you master those that are most important to you. Don't feel guilty if you don't use every option packed into the camera. Learn the basic controls, then explore any additional features that work for you. You can always delve further into this book and work to develop your Rebel T2i techniques and skills at some point in the future. But remember: the best time to learn about a feature is before you need it—you can't "waste film" with digital cameras, so shoot as much as you want, and then erase those images that don't work.

BUTTONS AND DIALS OVERVIEW

It seems like when you are holding the T2i, everywhere your fingers land there is a button or a dial. The T2i is designed so that they're close to your fingers for quick access to the camera's many features. The following section provides a summary of the controls found on the camera. This overview reveals what the controls do; later chapters explain more in depth how to use them.

The Rebel T2i uses icons that are common to all Canon cameras to identify various buttons, dials, and switches found on the camera. Some controls work alone—for instance, press DISP, to change the display on the LCD monitor. Other controls work as half of a pair—for example, sometimes works in conjunction with buttons that are pressed and released, or that are held down while is turned.

RESETTING CONTROLS

With all the controls built into the Rebel T2i, it is possible to set so many combinations that at some point you may want to reset everything. Before you delve into learning these controls, you can take comfort in knowing that it is easy to restore the camera to its original default settings: Go to the **\fi**: (Set-up 3) menu, select [Clear all camera settings], and then press SET. This menu option clears all but language, date/time, video system, copyright data, custom functions, and My menu settings.

MODE DIAL

Located on the top right shoulder of the camera, the mode dial is used to select the T2i's shooting mode. It is useful to think of this control as having three zones as outlined below. (For more complete information about the modes found on the dial, see pages 130-142.)

> The mode dial is the control for transforming the T2i from a pointand-shoot snapshot camera to highly sophisticated photography tool.

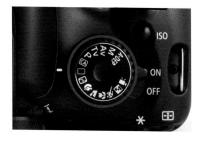

Basic Zone: The Basic Zone on the mode dial is the automatic section. It contains two fully automatic settings—full auto — and creative auto ——along with several scene modes. When set to —, the only shooting adjustments you can make are to select a particular image-quality recording (a combination of pixel count, which is resolution; and quality, also known as level of compression) and to determine whether you want

to use the self-timer. \square is a useful mode if you hand the camera to someone else to take a picture. Very few buttons will operate, so they can't accidentally put the camera into the "wrong" mode.

With \triangle , you are given access to a few more settings, including Picture Styles and continuous drive modes. \triangle also gives access to two easy-to-use exposure adjustments available through the \bigcirc (Quick Control) button: background and exposure.

The six scene modes (Canon calls this the Image Zone) can be used for specific shooting situations like taking portraits, landscapes, action, close-up shots, shooting at night, and when you don't want the built-in flash to fire

Creative Zone: This zone differs from the Basic Zone because these modes only affect exposure settings. (In contrast, the fully-automatic selections control such functions as white balance, focus, etc., in addition to the exposure settings.) There are four modes in this section that are common to every SLR, whether a film-type or digital camera, from Canon or another manufacturer. While the icons or acronyms may be slightly different among the various cameras, they all perform the same duties. The four modes are program autoexposure (P), shutter-priority AE (Tv), aperture-priority AE (Av), and manual exposure (M). In addition, there is a mode unique to Canon (and even then, not available on all EOS cameras) called automatic depth of field (A-DEP).

Movie Shooting: This last mode dial option puts the T2i into movie recording mode. (See pages 180-187 for more information.)

SHUTTER BUTTON

The Rebel T2i features a soft-touch electromagnetic shutter release. When you partially depress the shutter button, you activate such functions as autoexposure and autofocus. But this camera is fast enough that there is minimal speed advantage in pressing the button halfway before exposure. It does help, however, when you are dealing with moving subjects, to start autofocusing early, so the camera and lens then have time to find your subject.

Located behind the shutter button on the top right of the camera, the main dial allows you to use your shooting finger to set exposure as well as other functions. works alone when setting shutter speed and aperture when in **Tv** and **Av**, respectively. For a number of other adjustments, it works in conjunction with buttons that are pressed and released, or that are held down while it is turned.

> Practice finding the main dial without taking your eye away from the viewfinder.

Move your index finger from the shutter button to the main dial. This will help you make quick exposure adjustments without having to take your eye away from your composition in the viewfinder.

ISO SPEED SETTING

The ISO button is located behind ⚠. After pressing ISO, use ⚠ or ◆ to adjust ISO speed. The range varies depending on how you have set C.Fn-2 (ISO expansion). Normally it ranges from 100 – 6400 and has an additional auto mode. With ISO expansion enabled, the ISO range is 100 – 12800, including in auto. The highest ISO setting in this mode is labeled "H" and represents 12800. When the Rebel T2i is in any of the Basic Zone modes—□, ☒, ☒, ☒, ☒, ☒, ☒, , ☒, — the ISO button does not function. The camera will be in ISO auto.

◆ CROSS KEYS

These four dual-purpose keys, arranged in a cross pattern around the SET button, are located on the back of the camera to the right of the LCD monitor. The primary purpose of the keys, as a group, is to control navigation by allowing you to scroll up/down and left/right through menus. In addition, each key has a secondary function that allows quick access to a specific menu item.

When the camera is set for picture taking (not live view or movie recording), individual keys provide instant access to autofocus mode **AF**, Picture Style selection ***, drive mode settings ***, and white balance settings WB. When live view shooting or movie recording is enabled, the cross keys control the focus point; their normal secondary

function is disabled. Instead, the ① button must be pressed instead of the cross keys to access control of a number of features available in the live view and movie modes. (The ② button is used to access the Quick Control screen in normal shooting modes.)

The cross keys are dual purpose. When in the T2i menu system, consider them like the arrow keys on a keyboard. Think of the SET button as the button on a mouse. You'll use it to accept or reject menu settings.

SET SET BUTTON

Centered within �, this button is used like a mouse button to "click" or accept menu options presented on the LCD, as well as settings during other operations. Since **SET** really has no normal function while shooting, it can also be programmed to handle other functions while in Shooting mode, using C.Fn-10 (see page 125). Possible functions include setting image quality or flash exposure compensation, turning the LCD on/off, selecting the menu display, and setting ISO speed.

WB WHITE BALANCE SELECTION BUTTON

AF AUTOFOCUS MODE SELECTION

To select an autofocus mode, make sure your lens is switched to AF and press the camera's **AF** button. Use to choose from **ONE SHOT**, **AI FOCUS**, and **AI SERVO**. Then press **SET** to accept the setting. When the camera is in \square , \square , \square , \square , AF mode is locked to **AI FOCUS** mode.

Kevin Kopp

^ Use AI SERVO and □ for shooting action. AI SERVO allows the camera to "track" a moving subject by continuously looking for focus, and □ sets the camera to keep taking pictures, up to a maximum burst of 34 JPEGs, as long as you hold down the shutter button.

□ 8 DRIVE MODE SELECTION

Select the drive mode by first pressing □ 10, then use △ or ◆ to select one of five drive modes. Options include single shooting □, continuous shooting □, self-timer/remote (10-second self-timer) 10, 2-second self-timer 02, and continuous self-timer 05. Finally, press SET to accept the setting. The drive options are more limited when the Rebel T2i is in any of the Basic Zone modes. (See pages 143-144 for more information on drive modes.)

PICTURE STYLE SELECTION BUTTON

This button is a quick way to access the six built-in image effect settings (Picture Styles) and the three user-defined styles. Press ♣ to display the list of Picture Styles, and then use either ▶ or ६ to highlight the Picture Style you want to use. Press **SET** to accept the setting. You can

also access Picture Styles with this button during live view shooting. This button does not function when the Rebel T2i is any of the Basic Zone modes. However, you can access a limited number of Picture Styles when in

via the Quick Control screen.

⊞/@ AUTOFOCUS POINT SELECTION / MAGNIFY BUTTON

The button on the back of the camera in the upper right corner is the \boxdot /② button. When shooting, press \boxdot /② to display the currently selected AF points. In the Creative Zone modes and movie shooting, you can use a combination of △ and ♦ to select AF points. Press **SET** once to select the center AF point, and a second time to switch to automatic selection, where all points are active and the T2i will intelligently choose the AF points to use based on the scene. Press **SET** again to return to manual selection. When the Rebel T2i is in any of the Basic Zone modes, the camera is automatically set for 9-point AF auto-select and \boxdot /② will not function. Learn more about AF on pages 148-151.

This button has a different purpose during live view shooting. 1/2 can be used to magnify the focus frame. With the first press of 1/2, the display magnifies about 5x; a second press magnifies the display about 10x. The third press returns the display to normal view. This is a powerful tool. Even if you normally use the viewfinder for composition, turning on live view shooting and using this focus-checking method is a great option when you are facing difficult focusing situations.

The \boxdot/\mathbb{Q} button offers yet another function when the Rebel T2i is in playback mode in both the Basic and Creative Zones. During image playback, press \boxdot/\mathbb{Q} to magnify the image from 1.5 – 10x the original size. To move around the magnified image, use \diamondsuit (cross keys). Use the \blacksquare (playback) button to return to an unmagnified display.

NOTE: You cannot magnify the image during image review (immediately after image capture). You can only magnify it during playback.

This button is also used during direct camera printing to crop the image before printing. Press $\boxdot/@$ to increase trimming and use \diamondsuit to move the trimming frame around the image. (Learn more about direct camera printing on pages 244-246.)

This button is duplicated on the optional BG-E8 battery grip to allow for easy access when you hold the camera in a vertical shooting position. (In this case, the corresponding button is in the same relative position as the one intended for horizontal shooting.) The vertical shooting version is only active when the vertical grip's on/off switch is in the on position.

NOTE: This button is one of several on the T2i that have dual functions. The buttons are labeled with white and blue icons. The blue icons represent functions used during playback, file transfer, or printing. For example, the AF point selection/magnify button can be thought of as two buttons: the AF point selection button - and the magnify button -.

You should get used to pressing this button with your thumb while still looking through the viewfinder. This makes AE lock easy to use.

With \square (center-weighted average), \square (spot), and \square (partial), the exposure lock uses a meter reading taken from the center AF point. With \square (evaluative), AE lock is set for the selected AF point, whether selected manually or by the camera. If the lens is in manual focus, the center focus point is used, regardless of metering mode. $\cancel{*}/\square \square$ will not function when the Rebel T2i is any of the Basic Zone shooting modes.

When a flash is used—either the built-in flash or an external Speedlite— $\#/\boxtimes \bigcirc$ can be used to lock the exposure of the flash too. Press $\#/\boxtimes \bigcirc$ and the flash will fire a low power pre-flash in order to judge exposure. $\* will display in the viewfinder indicating that flash exposure has been locked. If \$ is blinking, the flash is not powerful enough to light up the scene.

During playback in both the Basic and Creative Zones, press $\#/\boxtimes \mathbb{Q}$ once to display a grid of four images (index display). Press $\#/\boxtimes \mathbb{Q}$ again to display a nine-image grid. In both displays, a blue border surrounds the currently selected image. Use \diamondsuit or \triangle to move the blue highlight to select a different photo. This allows you to jump quickly through your pictures four or nine images at a time.

Press $\boxdot/$ Q to return to single-image display from the four-image index display; press $\boxdot/$ Q twice to return to single-image display from the nine-image display. During playback, if the image has been magnified by pressing $\boxdot/$ Q, use $\bigstar/$ Q \boxdot Q to reduce the magnification. $\bigstar/$ Q \blacksquare Q is also used during direct camera printing to crop the image before printing. Press $\bigstar/$ Q \blacksquare Q to increase the trimming frame (less of the image will be cropped), and use \diamondsuit to move the trimming frame around the image.

Again, this button is duplicated on the optional BG-E8 battery grip to allow for easy access while holding the camera in a vertical shooting position. (In this case, the corresponding button is in the same relative position as the one intended for horizontal shooting.) The vertical shooting version is only active when the vertical grip's on/off switch is in the on position.

□ LIVE VIEW SHOOTING / MOVIE SHOOTING BUTTON

When the T2i is enabled for live view shooting in $\mathbf{f}^{:}$, use this button to turn on live view and display the live image on the LCD. Press the button again to turn off live view. When the camera is in movie recording mode, use \Box to start and stop video recording.

< The red dot on this button represents the red recording indicator found on most video cameras. This indicates that this button is used to start video recording when the T2i is in movie shooting mode.

This control engages the Quick Control screen on the LCD monitor, a powerful feature that makes photographing with the T2i quick and easy. Find it on the back of the camera to the right of the LCD. Once the Quick Control screen is displayed, use \$\displayed\$ to highlight each of the displayed shooting parameters. When a parameter is highlighted, use at to change the value that appears on the LCD monitor. The Quick Control screen is explained later in this chapter (see pages 50-51). When the T2i is directly connected to a printer, press 🗅 to quickly print an image.

> If you want to be quick about changing settings on your T2i, there is no better way than getting familiar with using the Quick Control screen.

NOTE: Like ★/♀ and /@, this button has two labels. The blue one indicates the function used during playback.

MENU BUTTON

The Digital Rebel T2i has several menus for use when capturing and viewing images, as well as for setting up the operation of the camera. This button, located near the top left corner of the LCD monitor, is used to display any of the camera menus on the LCD monitor, and to exit menus and submenus.

The menu structure consists of nine menu tabs: three red shooting menus dealing with image capture; two blue playback menus to control LCD display options, image transfer, and printing; three yellow set-up menus; and a green "My" menu that lets you build your own set of options. When in movie recording mode, the menu structure changes. There are four red shooting menus, the first two dealing specifically with video settings. Although there are still two blue playback menus, the set-up menus are down to two and My menu is no longer accessible. Once you have pressed MENU, navigate through the menu tabs by using or ◆▶, and use ▲▼ to navigate to each menu item.

Press **SET**, located in the center of \diamondsuit , to select a menu item and view its options. When adjusting settings in the menus, be sure to press **SET** to accept the setting; otherwise, the T2i reverts to the previous setting.

NOTE: If you are in any of the Basic Zone shooting modes, several menus and many menu items will not be available. If you can't find a particular menu item, check to see if the camera is in the Basic Zone.

< The menu and display buttons are on the other side of the camera, since they are not generally used when you are shooting with your eye to the viewfinder.

DISP. BUTTON

The first duty of DISP., which is located to the right of MENU, is to cycle through the various display modes during image review and playback. Press DISP. repeatedly to cycle through these four options:

- O Single-image display
- O Single-image display including aperture, shutter speed, current/total number of images captured, and folder / file number
- Shooting information display with histogram and extensive metadata about the image
- **O** A dual histogram display that shows the RGB and brightness histograms, along with pared down shooting information

When you are shooting, DISP. toggles on/off the shooting settings display on the LCD monitor. The T2i shooting settings display covers items like Picture Style, color space, white balance shift or bracketing, and rotation settings, just to name a few. This is also the best place to check to see approximately how many more images can be stored on the memory card. The shooting settings display is also used as the Quick Control screen. When ① is pressed, various parameters on the screen can be adjusted.

allows you to more accurately evaluate

exposure.

8/130

> The four display modes allow you to concentrate on various aspects of your image. The first display lets you concentrate on compensation, while other displays give you more and more metadata. The histogram display

NOTE: An auto-off sensor located below the viewfinder shuts off the display on the LCD when your eye approaches the viewfinder. This is to conserve battery power and prevent distracting light from the LCD from hitting your eye when you are trying to compose your shot. There may be cases when the auto-off sensor doesn't work properly—like when you are wearing sunglasses and the infrared beam the sensor uses is reflected. In this case, use DISP, to turn off the display.

When the T2i is in live view shooting mode, DISP. cycles through four displays, including a plain display, exposure display, controls display, and a histogram. During movie shooting mode, the displays are similar, except there is no histogram display.

The DISP. button also has two other uses. When the T2i is directly connected to a printer, the DISP. button is used when you are cropping your image for printing. Press DISP. to change the trimming frame from horizontal to vertical orientation. The other function is available when the LCD is displaying a menu. Pressing DISP. brings up a status screen that summarizes key camera settings. This makes it easy to see how the camera is set for options not directly related to the shooting settings screen.

Freespace	5.58 GB
Color space -	Adobe RGB
WB Shift/BKT	0.0/±0
Live View shoot	. Enable
Enable	Enable
🕇 2 mín.	ô On∰
•))) Enable 0	: Enable
	6/04/2010 22:33:42

C This display is only available when the T2i is displaying one of the menu screens. Pressing DISP calls up the camera settings. This summarizes many camera settings that aren't displayed on the shooting settings screen.

► PLAYBACK BUTTON

Located near the lower right-hand corner of the LCD screen, the button puts the camera into playback mode and displays the last image captured. Press the button again to return to shooting mode. You can also use the playback button to exit from magnified playback of images. To play back video, first press \blacksquare , select a movie, then press SET to bring up the movie controller. Finally, press SET to start playback.

NOTE: While image review and playback appear the same on the LCD monitor, there are differences. Image review occurs automatically after you take the picture; playback occurs only after you press **.** But probably the biggest difference is that you can't magnify the image during image review, only during playback.

m ERASE BUTTON

To the right of ▶ is the m button, which is used to delete an image or video during either image review or playback. When you press m, you are given the choice to [Erase] or [Cancel]. Select the appropriate option using ◆▶ and press SET to confirm. Protected images can't be erased. You can select multiple images for deletion by first going to the

☐ (Playback 1) menu, selecting [Erase images], scrolling through your images using ◀▶ (or ☐ to jump through images 10 at a time), then pressing SET to select each image you want to delete. When all images have been selected, press ☐ to delete the images. You can also use ☐ to lengthen the review time after image capture. If you normally work with a short review time, press ☐ to keep the just-captured image on the LCD monitor until you press either the shutter release button or ☐ (again) to cancel the delete function.

AVE APERTURE / EXPOSURE COMPENSATION BUTTON

When the T2i is set for **M** mode on the mode dial, the main dial () adjusts the shutter speed. Hold down the AV button, and will now adjust aperture. When the camera is set for P, Tv, Av, or A-DEP, you can override the exposure setting calculated by the camera. This function is called exposure compensation. Press and hold AV , then turn to override the exposure in either 1/2- or 1/3-stop increments (depending on how you've set C.Fn-1; see page 118). The T2i's range of exposure compensation has expanded from the T1i's +/- 2 stops to +/- 5 stops. Although the exposure compensation scale in the viewfinder only goes up to +/- 2 stops, the LCD will show the expanded scale when you get past 2.

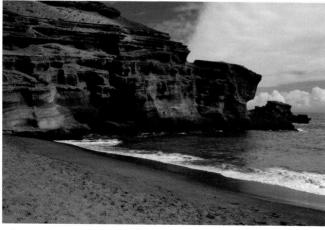

Exposure compensation can be a life-saver in mixed lighting like this. The light meter, depending on what mode it is set to, will likely factor the light from the sky in choosing an exposure, but if it is factored too heavily, the rest of the frame may be underexposed. You can use exposure compensation to try different exposures until you get one you like.

Danielle Andes

This unassuming control allows you to quickly adjust the automatic exposure set by the T2i or adjust aperture when the camera is in manual exposure mode.

DFPTH-OF-FIELD PREVIEW BUTTON

Located on the front left of the camera near the lens release button, the depth-of-field preview button is used to stop down the lens to the current aperture setting. Although this darkens the image in the viewfinder, this button can be a good tool to check which elements in the scene will be in focus.

POWER SWITCH

The power switch is found on the top right of the camera next to the mode dial. In the ON position, the camera will operate as long as the battery contains a charge and as long as the auto-power-off setting allows (see page 20).

FLASH BUTTON

Located on the left side of the front of the camera is the flash button. In the Basic Zone, the T2i will pop up the built-in flash as needed. In the Creative Zone modes, the flash will never pop up automatically. Use this button to use flash in the Creative Zone.

< Press the 4 button to pop up the built-in flash in the Creative Zone modes.

The Rebel T2i uses a standard, eye-level, reflex viewfinder with a fixed pentaprism. Images from the lens are reflected to the viewfinder by a quick-return, semi-transparent half-mirror. The mirror lifts for the exposure, then rapidly returns to keep viewing blackout to a very short period. The mirror is also dampened so that its bounce and vibration are essentially eliminated. The viewfinder shows about 95% of the actual image area captured by the sensor, so check the edges of the frame on the LCD after you take the picture for critical evaluation of the composition. The eyepoint is about 19 mm, which is good for people with glasses. (The higher the eyepoint number, the farther your eye can be from the viewfinder and still see the whole image.)

The viewfinder features a non-interchangeable, precision matte focusing screen. It uses special micro-lenses to make manual focusing easier and to increase viewfinder brightness. The viewfinder provides 0.87x magnification and includes superimposition display optics to make information easy to see in all conditions. The camera's nine autofocus (AF) points are superimposed on the focusing screen, and the solid band at the bottom of the screen shows most of the shooting information that you need.

NOTE: See the diagram under the back flap for details of information displayed in the viewfinder.

There is no eyepiece shutter to block light entering the viewfinder when it is not against the eye (such as when shooting long exposures from a tripod, or using the self-timer), which affects exposure metering. However, an eyepiece cover, conveniently stored on the camera strap, is provided instead. It is necessary to remove the eyecup to attach the eyepiece cover.

VIEWFINDER ADJUSTMENT

The Rebel T2i's viewfinder features a built-in diopter (a supplementary lens that allows for sharper viewing). It is surprising how often this control is overlooked. The diopter helps you get a sharp view of the focusing screen so you can be sure you are getting the correct sharpness as you shoot. For this to work properly, you need to adjust the diopter

for your eye. The adjustment knob is just above the eyecup, slightly to the right. Fine-tune the diopter setting by looking through the viewfinder at the AF points. Then rotate the dioptric adjustment knob until the AF points appear sharp. You should not look at the subject that the camera is focused on, but at the actual points on the viewfinder screen. If you prefer, you can also use the information at the bottom of the screen for this purpose.

Refore you start using your T2i, make sure the diopter adjustment is set properly. Without a proper setting, it is practically impossible to tell if your image will be in focus.

While some people can use this adjustment to see through the camera comfortably with or without eyeglasses, I have found that the correction isn't really strong enough for most who wear glasses regularly (like me). But Canon sells accessory dioptric adjustment lenses that give you an additional range of correction. They replace the standard one that comes with the camera, which gives you a range from -3.0 to +1 of diopter correction. There are ten different individual dioptric adjustment lenses that range from -4 to +3.

THE LCD MONITOR

The LCD monitor is probably the one digital camera feature that has most changed how we photograph. Recognizing its importance, Canon has put a three-inch (7.6-cm), high-resolution LCD screen on the back of the camera. With about 1.04 million dots, this screen has excellent sharpness, making it extremely useful for evaluating images. The LCD features a special fluorine coating to reduce smudges, three anti-reflective coatings, and an extremely durable scratch-resistant coating.

NOTE: This is the first EOS camera to have an LCD that matches the aspect ratio of the image sensor. When you play back a still image on the LCD it fills the entire display. Previous models would always have a horizontal black band at the top and bottom of the display.

The Rebel T2i's LCD monitor can also display a graphic representation of exposure values, called a histogram (see pages 164-165). The ability to see both the recorded picture and an exposure evaluation graph means that under- and overexposures, color challenges, lighting problems, and compositional issues can be dealt with on the spot. Flash photography in particular can be checked, not only for correct exposure, but also for other factors, such as the effect of lighting ratios when multiple flash units and/or reflectors are used. No Polaroid film test is needed like in the old days. Instead, you can see the actual image that has been captured by the sensor.

In addition, the camera can rotate vertical images in the LCD monitor. Some photographers love this feature, others hate it, but you have the choice. The auto-rotate function (see pages 99-100) displays vertical images properly without holding the camera in the vertical position but at a price: The image appears smaller on the LCD. On the other hand, you can keep the image as big as possible by not applying this function, but a vertical picture will appear sideways in the LCD.

You can also magnify an image up to 10x in the monitor by repeatedly pressing 4 when in playback mode. Using the cross keys 4, you can scroll through the enlarged photo to inspect it. It is a good practice to check focus using this method.

While the image is magnified in playback, you can use 🕮 to scroll back and forth through your other images. This way, you can compare details in images without having to re-zoom on each one. Use <a>□ to reduce magnification of the image. While you can repeatedly press 록. ♀. to get back to normal display, the quickest way is to press . If you press ■ when the image isn't magnified, it brings up an image display of four images with the first press of the button and nine images with the second press. This allows you to jump quickly through your pictures four or nine images at a time. (See page 38 for more on the ➡⊖ button.)

Since the LCD is such an essential tool to help evaluate images, it is important to adjust it properly. You can manually set a level of LCD

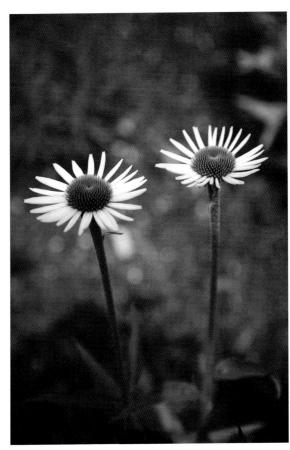

As good a display as the LCD is, resist the temptation to use it to evaluate exposure and focus without using the histogram and magnifying the image respectively. All images look good on a small screen.

brightness by using the **f**: (Set-up 2) menu. Use ▲▼ to select [LCD brightness] and press SET. The last image displayed on the LCD will be shown along with a grayscale. Use ◀▶ to select from seven different levels of brightness. Press SET to accept the setting.

The LCD is not just for displaying images. It is also designed to display shooting information and is always operational when the camera is on. When not used to change menu settings or to play back an image, the LCD displays the current camera settings: exposure, white balance, drive settings, metering type, focusing type, resolution, and much more. And, of course, in live view and movie shooting, the LCD displays a live image.

Although the LCD is always available when the camera is on, a display-off sensor below the viewfinder turns off the display when you bring the camera up to your eye for shooting. This saves power and minimizes distraction when you look through the viewfinder. The sensor works by emitting infrared light that is reflected back to an infrared sensor by any object that passes close to the viewfinder. To save power, you can also turn off the display manually by using the DISP. button, located on back of the camera to the left of the viewfinder.

QUICK CONTROL SCREEN

As mentioned above, when the T2i is not in menu mode, live view, movie mode, or playing back an image, it displays the shooting settings on the LCD monitor. This display expands on the information that is shown in the viewfinder. In addition, it also provides quick access to many of the camera's settings. By pressing ②, you can turn this display into an interactive camera-setting menu called the Quick Control screen. Once the Quick Control screen is displayed, use ❖ to highlight any of the displayed shooting parameters. When a parameter is highlighted, use ☼ to change the value that appears on the LCD monitor.

This Quick Control screen offers easy access to some settings that would normally require multiple button presses to change. For example, to set flash exposure compensation, normally you would need to first press MENU, then use to select of, use to select [Flash control], press SET to enter the submenu. Then you would use to select [Built-in flash func. setting], and press SET to enter that submenu. Then once again you would use to select [Flash exp. comp] and press SET. Lastly you would use to set the flash exposure compensation and then press SET.

That is a lot of button presses, particularly when the birthday candles are about to be blown out and you just want to lower the amount of flash in the scene. The steps for making the same change using the Quick Control screen are as follows: Press ②, use ❖ to highlight the flash exposure compensation value on the shooting screen and then use to change the value.

When you use the Quick Control screen, it as simple as highlighting the parameter and using to change the value—it is not necessary to press **SET** to accept the setting. Just tap the shutter release button to exit and the setting is accepted. If you want a little more guidance when using the Quick Control screen, press **SET** when a parameter is

highlighted. This will call up the normal menu options for that parameter (if there is a menu). For example, use the **SET** button when the ISO value is highlighted to see a list of all the possible ISO speeds.

NOTE: In \square , \square , \square , and \square shooting modes, you can only use the Quick Control screen to choose image recording quality and to select certain drive modes (single shooting \square , self-timer/remote-control \lozenge 0, and self-timer/continuous \lozenge 0c). \lozenge and \lozenge shooting modes add continuous \square shooting to the list of drive mode options. When in \square , you also have access to continuous shooting \square , as well as a limited selection of Picture Styles, flash mode control (auto flash \diamondsuit 4, flash on \diamondsuit 5, and flash off 50), and special background and exposure adjustments (see page 131).

CAMERA SETTINGS SCREEN

When the camera is displaying a menu, you can press DISP. to view a camera settings status screen. You can gain a great deal of information about how the T2i is configured from this one display, rather than diving into various menus. This information includes:

- O Remaining capacity on the memory card in megabytes (MB) or gigabytes (GB)
- Current color space
- O Current white balance shift and bracketing setting
- O Live view shooting enabled status
- O Automatic sensor cleaning enabled status
- O Red-eye reduction enabled status
- O Auto-power-off timer setting
- O Auto display rotate status
- O Beeper enabled status
- O LCD auto off enabled status
- O Date and time

Shooting at night has always been a challenge. The T2i allows you to use high ISO speeds, while keeping the noise that comes with increased ISO to a minimum.

THE SENSOR

The Rebel T2i has a newly designed, 18-megapixel (MP) sensor (5184 x 3456 pixels), which is remarkable in a camera of this class, especially given the Rebel T2i's attractive price. It can easily be used for quality magazine reproduction across two pages.

Because the Rebel T2i's APS-C sized CMOS sensor (22.3 x 14.9 mm) covers a smaller area than a 35mm film frame, it records a narrower field of view than a 35mm film camera. To help photographers who are used to working with 35mm SLRs visualize this narrower field of view, a "cropping factor" of 1.6 is often applied to the lens focal length number (you may hear this factor referred to as "effective focal length"). For example, on the Rebel T2i, a 200mm lens has a field of view similar to that of a 320mm lens on a 35mm camera. Remember, the focal length of the lens doesn't change, just the view seen by the Rebel T2i's sensor.

This focal length conversion factor is great for telephoto users because a 400mm telephoto lens acts like a 640mm lens on a 35mm camera. However, at the wide-angle end, a lens loses most of its wide-angle capabilities. For example, a 28mm lens acts like a 45mm lens.

But since the Rebel T2i accepts Canon EF-S lenses (see page 217), which are specially designed for this size image sensor, you can use the Canon 10-22mm zoom if you want to shoot wide-angle pictures. It offers an equivalent 16-35mm focal length.

Though small-format, the sensor in the Rebel T2i demonstrates improvements in sensor technology. One of the big changes involves the "microlenses" embedded above each light-sensitive photodiode on the chip. The T2i uses gapless microlenses. This means that the lens covers the entire photosite (or pixel). This increases the low-light performance of the image sensor. In addition, the sensor offers great signal-to-noise performance, dynamic range, and ISO speed range. And despite the larger number of pixels, the continuous shooting speed for JPEG images is impressive.

Low-noise characteristics are extremely important to advanced amateur and professional photographers who want the highest possible image quality. The Rebel T2i gives an extraordinarily clean image with exceptional tonalities, and images can be enlarged with superior results.

In addition, the camera has an improved low-noise, high-speed-output amplifier as well as power-saving circuitry that also reduces noise. With such low noise, the sensor offers more range and flexibility in sensitivity settings. ISO settings range from 100-6400 (expandable to 12800).

The on-chip RGB primary color filter uses a standard Bayer pattern over the sensor elements. This is an alternating arrangement of colors with 50% green, 25% red, and 25% blue; full color is interpolated from the data. In addition, an infrared-cutoff, low-pass filter is located in front of the sensor. This two-part filter is designed to prevent the false colors and wavy or rippled appearance of surfaces (moiré) that can occur when photographing small, patterned areas with high-resolution digital cameras.

File Formats and Processing

Canon has long offered particularly strong in-camera processing capabilities. Like other recent Canon D-SLRs, the Rebel T2i delivers exceptional JPEG images because it employs Canon's latest version of their high-performance processor, called DIGIC 4.

THE POWER OF DIGIC 4 PROCESSING

The DIGIC 4 processor intelligently translates the image signal as it comes from the sensor, optimizing that signal as it is converted into digital data. In essence, it is like having your own computer expert making the best possible adjustments as the data file is processed. DIGIC 4 works on the image after the shutter is released but before the image is recorded to the memory card, improving color balance, reducing noise, refining tonalities in the brightest areas, and more. In these ways, it has the potential to make JPEG files superior to unprocessed RAW files, reducing the need for RAW processing. (See pages 73-75 for more information about JPEG and RAW files.)

The DIGIC 4 handles data so quickly that it does not impede camera speed. The T2i has a single chip with image data processing that is appreciably faster than earlier units. Color reproduction of highly saturated and bright objects is also considerably improved. Auto white balance is better, especially at low color temperatures (such as tungsten light). In addition, false colors and noise, which have always been a challenge of digital photography, have been reduced (something that RAW files cannot offer). The ability to resolve detail in highlights is stronger, as well.

DIGIC 4 also enhances the Rebel T2i's ability to write image data to the memory card in both JPEG and RAW, enabling the camera to utilize the benefits offered by high-speed memory cards. It is important to understand that this does not affect how quickly the camera can take pictures. Rather, it affects how fast it can transfer images from its buffer (special temporary memory in the camera) to the card. It won't make a difference in the number of shots per second, but it will improve the quantity of images that can be taken in succession. Even at maximum resolution, the camera has a burst duration of 34 JPEG or 6 RAW frames, or 3 RAW + Large/Fine JPEGs.

During the continuous shooting drive mode, each image is placed into a buffer before it is recorded to the memory card. The faster the memory card is, the faster the buffer is emptied, allowing more images to be taken in sequence. If the buffer becomes full, **buSY** appears in the viewfinder and the camera stops shooting until the card-writing can catch up.

PICTURE STYLES

In addition to the optimizing technology of DIGIC 4, the T2i possesses options that you can choose to control how the camera performs additional image processing. These are Picture Styles, which can be especially helpful if you print image files directly from the camera without using a computer program to process them. Some photographers compare Picture Styles to shooting with a particular film. They are applied permanently to JPEG files—if using RAW files, the Picture Style can be changed during computer processing using Canon's Digital Photo Professional software.

Display Picture Styles via (Shooting 2 menu), [Picture Style], or by pressing the button (in the cross keys to the right of the LCD). If you display the Picture Styles options via (style you wish to use. If accessing via (style you wish to use. If accessing via (style you are also access Picture Styles via the Quick Control screen: press the Quick Control button (styles via the Quick Control screen: press the Quick Control button (styles), then use to highlight the Picture Style parameter. Use to select the Picture Style. It is not necessary to press SET in the Quick Control screen to accept the setting, the change is immediate. There are six preset Picture Styles and three user-defined styles:

STANDARD

This is the default style for the \square and \square shooting modes. During in-camera processing, color saturation is enhanced and a moderate amount of sharpening is performed on the image. \square offers a vivid and crisp image with a normal amount of contrast.

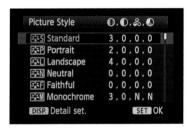

At a glance, you can tell which Picture Styles have been modified in the Picture Style screen. Modified parameter numbers will be in blue.

PORTRAIT

The setting places an emphasis on pleasing skin tones. While the contrast is the same as sightly warmer look. Sharpening is reduced in order to produce a pleasing, soft texture for the subject's skin.

LANDSCAPE

With [35], saturation is high with an emphasis on blues and greens. The image is sharpened even more than the [35] mode in order to display details. Don't be afraid to use this during cloudy days to help bring out more color.

NEUTRAL

If you plan to process the image on your computer, either through Canon's Digital Photo Professional software or another image-processing program, this may be the mode to choose. There is virtually no sharpening. Color saturation is lower than other modes, and contrast is lower, too. Since other Picture Styles increase saturation, way be a good style to choose when you shoot in bright or high-contrast situations. Picture details may be more prevalent with this setting. Don't rule it out for candid portraits that may occur in bright lighting situations.

FAITHFUL

This is the choice when you need to accurately capture the colors in a scene. Saturation is low and almost no sharpening is applied to the image. Contrast is also toned down. Accurate color reproduction is achieved when the scene is lit with 5200K lighting (K stands for Kelvin, see pages 63-64 for explanation). Otherwise, you might think of this setting as similar to [25], except that the color tone is a bit warmer. Like [25], this mode is designed with further image processing via computer in mind.

MONOCHROME

This allows you to record black-and-white images to the memory card and to automatically view the image in black and white on the LCD. Sharpness is the same as the first mode, and contrast is enhanced. As with the other Picture Styles, first permanently changes JPEG files—you can't get the color back. Another option is to shoot in color and then convert images to black and white in an image-processing program—and do so with more control.

PICTURE STYLE PROCESSING

With all of the Picture Styles (except [354]), you can control the degree of processing applied to four aspects of an image:

- O $[\mathbb{O}]$ Sharpness]: Refers to the amount of sharpening that is applied to the image file by the camera
- [€ Contrast]: Increases or decreases the contrast of the scene that is captured by the camera

- O [Saturation]: Influences color richness or intensity
- O [Color tone]: When rendering skin tones, this selection helps the photographer decide the degree of red or of yellow. However, note that it also affects other colors

With , the & and o settings are replaced with [Filter effect] and [Toning effect]. The parameters for offer four tonal effects that mimic what a variety of colored filters do to black-and-white film. A fifth setting, [N:None], means that no is applied. Each o color choice makes the colors similar to your selection look lighter, while colors opposite your selection on the color wheel will appear darker. Aside from [N:None], the several of choices are:

Kevin Kopp

- Each black-and-white filter effect, generally speaking, increases darkness in its opposite colors; so, a red filter effect will make greens and blues appear darker, while the green filter renders red subjects darker.
 - O [Ye:Yellow]: This is a modest effect that darkens skies slightly and gives what many black-and-white aficionados consider the most natural looking grayscale image.
 - O [0r:0range]: This is next in intensity. It does what red does, only to a lesser degree. It is better explained if you understand the use of red (see next description).

- O [R:Red]: This is dramatic. It lightens anything that is red, such as flowers or ruddy skin tones, while darkening blues and greens. Skies turn quite striking, and sunlit scenes gain in contrast (the sunny areas are warm-toned and the shadows are cool-toned, so the warms get lighter and the cools get darker).
- [G:Green]: This makes light skin tones look more natural, and foliage gets bright and lively in tone.

Of course, if you aren't sure what these filters will do, you can take the picture and see the effect immediately on the LCD monitor.

The other parameter, ②, adds color to the black-and-white image so it looks like a toned black-and-white print. Your choices include: [N:None], [S:Sepia], [B:Blue], [P:Purple], and [G:Green]. Sepia and blue are the tones we are most accustomed to seeing in such prints.

The term "toning" comes from old chemical darkroom days when black-and-white prints were toned with chemicals to give them color tints.

MODIFYING PICTURE STYLES

You can modify the Picture Styles, but only if you access them via \square :
Once the Picture Styles are listed on the LCD monitor, highlight the one you want to adjust and press DISP, located above the LCD to the left of the viewfinder. A series of adjustment sliders will be displayed. Highlight the parameter you want to adjust using \blacktriangle V, and press SET. Then use \spadesuit D to adjust the parameter. A white pointer shows the current setting, while the gray pointer shows the default setting for that Style. You must use SET to accept the setting. If you leave this menu screen without pressing SET, the adjustment is cancelled.

At the bottom of the screen is a [Default set.] option that you can highlight to reset the parameters that you have altered. Parameter numbers displayed in blue indicate a setting that has been changed from the default values. Use MENU (above the top left corner of the LCD monitor) to return to the Picture Style menu.

The adjustment slider for $\mathbb O$ sharpness is set up differently than the other sliders. Sharpness is generally required at some point when recording digital images. It overcomes, among other things, the use of a low-pass filter in front of the image sensor (to reduce moiré problems caused by the image sensor's pixel grid). The low-pass filter (used in all digital cameras) introduces a small amount of image blur, so image sharpening compensates for this blur. The $\mathbb O$ adjustment slider's setting indicates the amount of sharpness already applied to the style. A setting of zero means that almost no sharpening has been applied to the image. You'll notice that the $\mathbb O$ parameter's default setting is the only one that changes from Picture Style to Picture Style.

< While sharpness can't overcome an out-of-focus image, some degree of sharpening is needed to compensate for image blur caused by the low-pass filter attached to the image sensor.

USER-DEFINED PICTURE STYLES

The T2i allows you to use a particular Picture Style as a base setting and then modify it to meet your own photographic needs. This allows you to create and register a different set of parameters that you can apply to image files while keeping the preset Picture Styles. You do this under the options for [User Def. 1], [User Def. 2], and [User Def. 3]. While specific situations may affect where you place your control points for these flexible options, here are some suggestions to consider:

Create a Hazy or Cloudy Day Setting: Make one of the user-defined sets capture more contrast and color on days when contrast and color are weak. Increase the scales for $\mathbb O$ contrast and $\mathcal S$ saturation by one or two points (experiment to see what you like when you open the files on your computer or use the camera for direct printing). You can also increase the red setting (adjust the scale to the left) of $\mathbb O$ color tone.

Create a Portrait Setting: Make a setting that enhances flesh tones. Start with say our base, then reduce to by one point while increasing by one point (this is quite subjective; some photographers may prefer less saturation), while also warming the flesh tones (by moving toward the red—or left—side) by one point.

Create a Velvia Look: Start with $\blacksquare S$, increase \blacksquare two points, \blacksquare one point, and \clubsuit by two points to create photos that are highly saturated.

You can also download custom Picture Styles from Canon's Picture Style website at http://web.canon.jp/imaging/picturestyle/index.html. These custom styles can be uploaded into any of the T2i's three user-defined styles by using the USB connection to the camera. (You'll need Canon's EOS Utility software that is included with the camera.) The custom styles can also be used with Canon's Digital Photo Professional software to change styles after capture in RAW images.

With Picture Styles, you can turn your T2i into a custom camera, producing images unique to your camera.

NOTE: Downloaded Picture Styles can only be loaded into the user-defined styles and will be deleted if you reset all camera settings using [Clear settings] in *****: (Set-up 3 menu).

The T2i has a color space setting in the \Box menu. A color space is the range of colors, or gamut, that a device can produce. Cameras have color spaces, monitors have color spaces, and printers have color spaces. (While not technically accurate, you can think of different color spaces as different sized boxes of crayons.)

The two choices for [Color space] on the T2i are [sRGB] and [Adobe RGB]. [sRGB] is the default setting for the camera and is used as the color space for all of the Basic Zone modes including, — and . It is also the color space for most computer monitors. If you are capturing images for the web, [sRGB] will work fine. [Adobe RGB], as the name implies, was developed by Adobe to deal with creating images for print output. Even so, this larger color space (think bigger box of crayons) contains more colors than can be produced by most of today's printers.

Choosing between [sRGB] and [Adobe RGB] is not as complicated as determining a choice between JPEG and RAW. [Adobe RGB] doesn't take up more room on the card or require special RAW processing software. But you do need to check to make sure that your image-processing program can handle Adobe RGB—most do.

There are many times when it is difficult to see the difference between the two color spaces. Try an experiment with some test shots in both. You won't see the difference on the LCD, so print them out and then see if you can tell the difference.

NOTE: When you use [Adobe RGB], image file names begin with "_MG" rather than "IMG."

WHITE BALANCE

White balance (WB) is an important digital camera control. It addresses a problem that has plagued film photographers for ages: how to prevent the different color temperatures of various light sources from producing unwanted color casts in your photos. WB settings fall within certain color-temperature values, corresponding to a measurement of how cool (blue) or warm (red) the light source in the scene is. The measurement is in degrees Kelvin, abbreviated K. Unlike air temperature, a higher

K number represents a cooler light source, such as shade with its bluish color. Conversely, lower color temperatures represent warmer light sources, for example a rising sun with its reddish hue.

To set white balance, press WB—the up-arrow cross key to the right of the LCD monitor—to display a list of white balance choices on the LCD monitor. Next, use ☐ or ◀▶ to choose the WB setting you want, then press SET. The display of shooting settings on the LCD monitor shows an icon of the WB setting that you selected.

While color adjustments can be made in the computer after shooting, especially when recording RAW, there is a definite benefit to setting WB properly from the start. The Rebel T2i helps you do this with an improved auto white balance WB setting that makes colors more accurate and natural than earlier D-SLRs. In addition, improved algorithms and the DIGIC 4 processor make WB more stable as you shoot a scene from different angles and focal lengths (which is always a challenge when using this setting). Further, white balance in general has been improved to make color reproduction more accurate under low light.

While **WW** gives excellent results in a number of situations, many photographers find they prefer the control offered by presets and custom WB settings. With **WB**, sad, and six separate white balance presets, plus WB compensation and bracketing, the Rebel T2i possesses an outstanding ability to carefully control color balance. It is well worth the effort to learn how to use the different white balance functions so you can get the best color with the most efficient workflow in all situations (including RAW). This is especially important in strongly colored scenes, such as sunrise or sunset, which can fool **WB**.

In Basic Zone shooting modes like \square and \square , white balance is set for \square and cannot be changed. In the Creative Zone shooting modes, you can apply the preset white balance settings (continue reading to next section). These are not difficult to learn, so using them should become part of the normal photography decision-making process. However, in order to capture the truest color in all conditions, the more involved but more accurate custom WB \square setting is a valuable tool to understand (see pages 68-69).

NOTE: When shooting using live view or when recording movies, the \triangle WB button is used to move the focus point. The only way to access the white balance setting is by pressing \bigcirc .

Auto (~3000K – 7000K): This setting examines the scene for you, interprets the light it sees (in the range denoted above) using the DIGIC 4 processor (even with RAW), compares the conditions to what Canon's engineers have determined works for such readings, and sets a white balance to make colors look neutral (i.e., whites appear pure, without color casts, and skin tones appear normal).

of light to another, or whenever you hope to get neutral colors and need to shoot fast. Even if it isn't the perfect setting for all conditions, it often gets you close enough so that only a small adjustment is needed later using your image-processing software. However, if you have time, it is often better to choose from the white balance settings listed on the following pages, because colors are more consistent from picture to picture. While AWB is well designed, it can only interpret how it "thinks" a scene should look. If the camera sees your wide-angle and telephoto shots of the same subject differently in terms of colors, it readjusts for each shot, often resulting in inconsistent color from shot to shot.

Auto white balance is a good setting to use when first starting out with the T2i. But scenes with strong colors can quickly add unwanted color casts to your images. You'll want to start using white balance presets as you get to know your camera.

- ** Daylight (~5200K): This setting adjusts the camera to make colors appear natural when you shoot in sunlit situations between about 10 A.M. and 4 P.M. (depending on the time of year). At other times, when the sun is lower in the sky and has more red light, the scenes photographed using this setting appear warmer than normally seen with our eyes. This setting makes indoor scenes under incandescent lights look very warm.
- ➡ Shade (~7000K): Shadowed subjects under blue skies can end up quite bluish in tone, so this setting warms the light to make colors look natural, without any blue color cast. (At least that's the ideal—individual situations affect how the setting performs.) The ➡ setting is a good one to use any time you want to warm up a scene (especially when people are included), but you have to experiment to see how you like this creative use of the setting.

You don't have to stick with the literal meanings of the white balance presets. For example, try using the cloudy setting when shooting sunrises and sunsets for a warm look. Experiment with different presets, even the flash WB setting, in outdoor situations.

Cloudy (−6000K): Even though the symbol for this setting is a cloud, think of it as the Cloudy/Twilight/Sunset setting. It warms up cloudy scenes as if you had a warming filter, making sunlight appear warm, but not quite to the degree as the setting. You may prefer

- to ♠ when shooting people, since the effect is not as strong. Both settings actually work well for sunrise and sunset, giving the warm colors that we expect to see in such photographs. However, offers a slightly weaker effect. You really have to experiment a bit when using these settings for creative effect. Make the final comparisons on the computer.
- ** Tungsten Light (~3200K): This is designed to give natural results with quartz lights. It also reduces the strong orange color that is typical when photographing lamp-lit indoor scenes with daylight-balanced settings. Since this control adds a cool tone to other conditions, it can also be used creatively (to make a snow scene appear bluer, for example).
- White Fluorescent Light (~4000K): Though the Web setting often works well with fluorescents, the ₩ setting is more precise and predictable. Fluorescent lights usually appear green in photographs, so this setting adds magenta to neutralize that effect. (Since fluorescents can be extremely variable, and since the Rebel T2i has only one fluorescent choice, you may find that precise color can only be achieved with the ► setting.) You can also use this setting creatively any time you wish to add a warm pinkish tone to your photo (such as during sunrise or sunset).
- ‡ Flash (~6000K): Light from flash tends to be a little colder than daylight, so this warms it up. According to Canon tech folks, this setting is essentially the same as the Kelvin temperature is the same); it is simply labeled differently to make it easy to remember and use. I find both the to be good, all-around settings that give an attractive warm tone to outdoor scenes.

HINT: Even if you aren't using live view for shooting, you can use it to evaluate different white balance presets for your scene. Press 1 to turn on live view. Bring up the Quick Control screen by pressing 0, then use 1 to make sure the white balance setting is highlighted (top item). Use 1 to move through the presets while viewing the image on the LCD. This is a great way to set white balance in difficult situations. This method also works for movie mode.

A very important tool for the digital photographer, 🛂 is a setting that even many seasoned shooters often don't fully understand. It is a precise and adaptable way to get accurate or creative white balance. It has no specific white balance K temperature, but is set based on a specific neutral tone in the light in the scene to be photographed. However, it deals with a significantly wider range than AWB (between $\sim 2000K-10,000K$). That can be very useful.

The setting lets you use either a white (or gray) target on which the camera sets white balance. First, take a picture of a white or gray card that is in the same light as your subject. It does not have to be in focus, but it should fill the image area. (Avoid placing the card on or near a highly reflective colored surface.) Be sure the exposure is set to make this object gray to light gray in tone, and not dark (underexposed) or washed out white (overexposed).

HINT: I like to use a card or paper with small black print on it, rather than a plain white card. This way, if I can see the type, I know I haven't overexposed the image.

Next, go to a: and highlight [Custom White Balance], then press SET. The last shot you took (the one for white balance) should be displayed in the LCD monitor. If not, use ◆▶ to choose the image you shot of the white or gray object.

When you have the target image displayed in the LCD monitor, push SET. A dialog box asks you if you want to use the white balance and 🛂 is set to measure the color temperature of the light in that stored shot. A note appears, "Set WB to 🛂," as a reminder. This reminds you that there is one more step to this process: You must choose the 🛂 setting for white balance.

To take that final step, press **SET** again to acknowledge the reminder. and either lightly tap the shutter or press MENU to exit a: Then press the WB button to access the WB screen, and use either

or ◆▶ to select 🖳, and press SET. You can also do the same thing by pressing @ and using to highlight the white balance setting, and then use to select 🛰.

You can save a series of white balance reference images on your memory card ahead of time that you can flip through. This is useful if you need to switch between different lighting conditions but don't have the time to set up a card to capture the image.

The procedure just described produces neutral colors in some very difficult conditions. However, if the color of the lighting is mixed (for example, the subject is lit on one side by a window and on the other by incandescent lights), you will only get neutral colors for the light that the white card was in. Also, when you shoot in reduced spectrum lights, such as sodium vapor, you may not get a neutral white under any white balance setting.

You can also use 2 to create special color for a scene. In this case, you set the white balance on a color that is not white or gray. You can use a pale blue card, for example, to generate a nice, amber-colored tint for your image. If you balance on the blue, the camera adjusts this color to neutral, which in essence removes blue, so the scene has an amber cast. Different strengths of blue provide varied results. You can use any color you want for white balancing—the camera works to remove (or reduce) that color, which means the opposite color becomes stronger. (For example, using a pale magenta increases the green response.)

WHITE BALANCE CORRECTION

The Rebel T2i goes beyond the capabilities of many cameras in offering control over white balance: There is actually a white balance correction feature built into the camera. You might think of this as exposure compensation for white balance. It is like having a set of color-balancing filters in four colors (blue, amber, green, and magenta) and in varied strengths. Photographers accustomed to using color-conversion or color-correction filters will find this feature quite helpful in getting just the right color.

The setting is not difficult to manage. First, go to \square^{\bullet} , highlight [WB Shift/BKT] and press SET. A menu screen appears with a graph that has a horizontal axis from blue to amber (left to right), and a vertical axis from green to magenta (top to bottom). You move a selection point within that graph using \diamondsuit . You must press SET before you leave this setting to lock in the value.

As you change the position of the selection point on the graph, an alphanumeric display titled "Shift" on the right of the screen shows a letter for the color (B, A, G, or M) and a number for the setting. For example, a white balance shift of three steps toward blue and four to green displays B3 and G4.

> A setting like A3 G3, shown here, will reduce a bluish red color cast due to poor white balance.

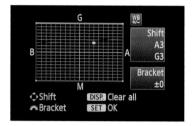

For photographers used to color-balancing filters, each increment of color adjustment equals 5 MIREDS of a color-temperature changing filter. (A MIRED is a measuring unit for the strength of a color temperature conversion filter.) Remember to set the correction back to zero when conditions change. The LCD monitor and the viewfinder information display show white balance correction is engaged.

WHITE BALANCE AUTOBRACKETING

When you run into a difficult lighting situation and want to be sure of the best possible white balance settings, another option is white balance autobracketing. This function operates a bit differently than autoexposure bracketing (see pages 88-89). With the latter, three separate exposures are taken of a scene; with white balance autobracketing, you take just one exposure and the camera processes it to give you three different white balance options.

NOTE: Using white balance bracketing delays the recording of images to the memory card, reducing the number of shots in a row to one-third the normal number. Pay attention to the access lamp in the bottom right corner of the back of the T2i to gauge when the camera has finished recording the extra images.

White balance autobracketing allows up to +/- 3 steps (again, each step is equal to 5 MIREDS of a color-correction filter) and is based on whatever white balance mode you have currently selected. You can bracket from blue to amber, or from green to magenta. Keep in mind that even at the strongest settings, the color changes are fairly subtle. **
appears on the LCD monitor, letting you know that white balance auto bracketing is set.

NOTE: White balance bracketing records an original image at the currently selected white balance setting, then internally creates an additional set of either a bluer (cooler) image and a more amber (warmer) image, or a more magenta and a greener image (useful in fluorescent lighting). Unlike exposure bracketing, you only need to take one shot—and you don't have to set the drive setting to \square .

To access white balance autobracketing, go to and select [WB Shift/BKT], then press SET. The graph screen with the horizontal (blue/amber) and vertical (green/magenta) axes appears on the LCD monitor. Use to adjust the bracketing amount: to the right (clockwise) to set the blue/amber adjustment, then back to zero and to the left (counter clockwise) for green/magenta. (You can't bracket in both directions.) You can also shift your setting from the center point of the graph by using . Press SET to accept your settings.

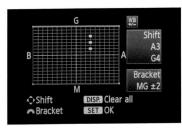

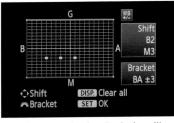

The setting on the left shifts the color balance towards green and amber. Bracketing will give you one image that is more green and one image that is less green. The setting on the right shows a blue / magenta shift. The T2i will bracket so that you have one image with more blue and one image with more amber.

The obvious use of this feature is to deal with tricky lighting conditions. However, it has other uses as well. You may want to add a warm touch to a portrait but are not sure how strong you want it. You could set the white balance to ., for example, then use WB autobracketing to

get the tone you're looking for. (The bracketing gives you the standard white-balanced shot, plus versions warmer and cooler than that.) Or, you may run into a situation where the light changes from one part of the image to another. Here, you can shoot the bracket, then combine the white balance versions using an image-processing program. (Take the nicely white-balanced parts of one bracketed photograph and combine them with a different bracketed shot that has good white balance in the areas that were lacking in the first photo.)

A Because of all the green in this shot, auto white balance would not have been sufficient. The petals of the flower are almost white. Using white balance bracketing, gave me three options to choose from once I was back at the computer.

RAW AND WHITE BALANCE

The RAW file format allows you to change WB after the shot using your computer and RAW-processing software. As a result, some photographers have come to believe that it is not important to select an appropriate WB at the time the photo is taken if they're recording in the RAW format. While it is true that AWB and RAW give excellent results in many situations, this approach can cause consistency and workflow challenges. WB choice is important because when you bring RAW files into software for processing and enhancement, the files open with the settings that you chose during initial image capture. Sure, you can edit

those settings in the computer, but why not make your initial RAW image better by merely tweaking the WB with minor revisions at the image-processing stage rather than starting with an image that requires major correction? Of course there will be times that getting a good WB setting is difficult, and this is when the RAW software WB correction can be a big help.

FILE FORMATS

JPEG OR RAW

The Rebel T2i records images as either JPEG or RAW files. There has been a mistaken notion that JPEG is a file format for amateur photographers, while RAW is a format for professionals. This is really not the case. Pros use JPEG and some amateurs use RAW. (Technically, JPEG is a compression scheme and not a format, but the term is commonly used to denote a format, and that is how we will use it.)

There is no question that RAW offers some distinct benefits for the photographer who needs them, including the ability to make greater changes to the image file before the image degrades from overprocessing. The Rebel T2i's RAW format (called CR2 and originally developed by Canon for the EOS-1D Mark II) includes processing improvements, making it more flexible and versatile for photographers than previous versions. It can also handle more metadata and is able to store processing parameters for future use.

However, RAW is not for everyone. It requires more work and more time to process than other formats. For the photographer who likes to work quickly and wants to spend less time at the computer, JPEG may offer clear advantages and, with the Rebel T2i, even give better results. This might sound radical considering what some "experts" say about RAW in relation to JPEG, but I suspect they have never shot an image with a Rebel T2i set for high-quality JPEGs.

It is important to understand how the sensor processes an image. It sees a certain range of tones coming to it from the lens. Too much light (overexposed), and the detail washes out; too little light (underexposed), and the picture is dark. This is analog (continuous) information, and it

must be converted to digital, which is true for any file format, including both RAW and JPEG. The complete digital data is based on 14 bits of color information, which is changed to 8-bit color data for JPEG, or is placed virtually unchanged into a 16-bit file for RAW. (The fact that RAW files contain 14-bit color information is a little confusing since this information is put into a file that is actually a 16-bit format.) This occurs for each of three different color channels used by the Rebel T2i: red, green, and blue. Remember that the DIGIC 4 processor applies changes to JPEG files, while RAW files have very little processing applied by the camera.

Both 8-bit and 16-bit files have the same range from pure white to pure black because that range is influenced only by the capability of the sensor. If the sensor cannot capture detail in areas that are too bright or too dark, then a RAW file cannot deliver that detail any better than a JPEG file. But it is true that RAW allows greater control over an image than JPEG, primarily because it starts with more data, meaning there are more "steps" of information between the white and black extremes of the sensor's sensitivity range. These steps are especially evident in the darkest and lightest areas of the photo. So it appears the RAW file has more exposure latitude and that greater adjustment to the image is possible before banding or color tearing becomes noticeable.

JPEG format compresses (or reduces) the size of the image file, allowing more pictures to fit on a memory card. The JPEG algorithms carefully look for redundant data in the file (such as a large area of a single color) and remove it, while keeping instructions on how to reconstruct the file. JPEG is therefore referred to as a "lossy" format because, technically, data is lost. The computer rebuilds the lost data quite well as long as the amount of compression is low.

It is essential to note that both RAW and JPEG files can give excellent results. Photographers who shoot both (who use the WH-L quality setting) take advantage of the flexibility of RAW files to deal with tough exposure situations, and the convenience of JPEG files when they need fast and easy handling of images. Which format will work best for you? Your own personal way of shooting and working should dictate that decision. If your shooting situation causes you to deal with problem lighting and colors, for example, RAW gives you a lot of flexibility in controlling both. If you can carefully control your exposures and keep images consistent, JPEG is more efficient.

In addition to the fact that it holds 14 bits of data, the RAW file offers some other advantages over JPEG. Because RAW more directly captures what the sensor sees, stronger correction can be applied to it (compared to JPEG images) without problems appearing. This can be particularly helpful when there are difficulties with exposure or color balance.

The disadvantage to RAW files is that you must process the image on your computer using RAW-processing software. A RAW file needs to be processed: You can't print a RAW file directly from your computer and you can't post it for viewing on a website. Canon supplies dedicated software programs with the Rebel T2i called ZoomBrowser EX (Windows) or ImageBrowser (Mac), along with Digital Photo Professional. All these programs are specifically designed for CR2 files and allow you to open and smartly process them. You can also choose other processing programs, such as Phase One's Capture One, Adobe's Lightroom, or others, which make converting from RAW files easier. These independent software programs can be expensive, although some manufacturers offer less expensive solutions. One disadvantage to using third-party programs is that they may not support Canon's Dust Delete Data system (see pages 28-29) to automatically remove dust artifacts in your images. Also, Picture Styles may not be supported in software other than Canon's.

Whatever method you choose to gain access to RAW files in your computer, you have excellent control over the images in terms of exposure and color of light. The RAW file contains special metadata (shooting information stored by the camera) that has the exposure settings you selected at the time of shooting. This is used by the RAW conversion program when it opens an image. You can make modifications to the exposure without causing too much harm to the image. (However, you can't compensate for really bad exposure in the first place.) White balance settings can also be changed. If you use Canon's software, you can even change Picture Styles after the fact.

The Rebel T2i offers a total of eight choices for image-recording quality, consisting of combinations of different file formats, resolutions (number of pixels), and compression rates. But let's be straight about this: Most photographers will shoot the maximum image size using RAW or the highest-quality JPEG setting. There is little point in shooting smaller image sizes except for specialized purposes. After all, the camera's high resolution is what you paid for!

All settings for recording quality are selected in the \(\textstyle{\textstyle{\textstyle{1}}} \) menu under [\(\textstyle{0}\) uality], or by using the Quick Control screen. If you use \(\textstyle{0}\), once you have selected [\(\textstyle{0}\) uality], press SET and eight image size/quality options will appear. Use \(\textstyle{0}\) to make your selection and press SET to accept the setting. If you use the Quick Control screen, use \(\textstyle{0}\) to highlight the recording-quality parameter, then use \(\textstyle{0}\) to change the setting. While in the Quick Control screen, if you forget the possible options, press SET while the parameter is highlighted to take you directly to a screen with all of the options. When using the Quick Control screen it is not necessary to press SET to accept the setting. A light tap on the shutter button will exit the Quick Control screen.

There are 3 JPEG file sizes along with the two JPEG compression options, for a total of six different options (L, L, M, M, M, S, and S). The symbols depict the level of compression; the letter stands for the resolution size of the image file (large, medium, and small). Less compression (higher quality) is indicated by the smoother curve on the icon, while more compression (lower quality) is indicated by the stair-step look to the curve. The chart on page 78 shows how the different settings affect the number of megapixels used and the image size.

The most useful settings are **L** (the largest image size for JPEG, 18 megapixels, resulting in an approximate file size of 6.4MB) and (always 18 megapixels; since it is uncompressed, no compression symbol is displayed; it results in an approximate file size of 24.5MB).

NOTE: Near the top of the **[Quality]** is a status line that shows the current selection, the size of the image file in megapixels, the dimensions of the image in pixels, and the number of images that will fit in the currently available space on the memory card (at the current image-recording quality).

The Rebel T2i can record both RAW and JPEG simultaneously. This option can be useful for photographers who want added flexibility. It records images using the same name prefix, but the different formats are designated by their extensions: .JPG for JPEG and .CR2 for RAW. You can then use the JPEG file (which takes advantage of the DIGIC 4 processor) for printing at a photo kiosk or sending to a friend via email. And you still have the RAW file for use when you need its added processing power.

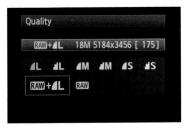

< RAW + JPEG shooting does offer the most flexibility when shooting with the T2i, but it will use up a lot of space on your memory cards.

NOTE: The WH + L setting cannot be used in any of the Basic Zone shooting modes.

If you find yourself frequently switching between quality settings, you can set Custom Function 10 (C.Fn-10, see page 125) to change the functionality of SET. When this function is utilized, you won't have to press MENU to call up the display and then navigate to [Quality]. You simply press SET and the Quality menu appears on the LCD monitor. Then it is just a matter of selecting the desired item using and pressing SET, and you can start shooting at the new setting.

When you shoot AW+ L, the RAW file initially appears in your RAW conversion software with the same processing details as the JPEG file (including white balance, color matrix, and exposure), all of which can be altered in the RAW software. Though RAW is adaptable, it is not magic. You are still limited by the original exposure, as well as by the tonal and color capabilities of the sensor. Using RAW is not an excuse to become sloppy in your shooting simply because it gives you more options to control the look of your images. If you do not capture the best possible file, your results will be less than the camera is capable of producing.

Each recording-quality choice influences how many photos can fit on a memory card. Most photographers shoot with large memory cards because they need the space required by the high-quality files available on this camera. It is impossible to precisely estimate how many JPEG images fit on a card because this compression technology is variable. You can change the compression as needed (resulting in varied file sizes), but remember that JPEG compresses each file differently depending on what is in the photo and how much data is redundant. For example, a photo with a lot of detail does not compress as much as an image with a large area of solid color.

That said, the chart below gives you an idea of how large these files are and how many images may fit on a 4GB memory card. The figures are based on actual numbers produced by the camera using such a card. (JPEG values are always approximate.) Also, the camera uses some space on the card for its own purposes and for file management, so you do not have access to the entire 4GB capacity for image files.

You can immediately see one advantage that JPEG has over RAW in how a memory card is used. Even if you use the highest-quality JPEG file at the full 18 megapixels, you can store nearly four times the number of photos compared to what you can store when you shoot RAW.

IMAGE SIZE AND CARD CAPACITY WITH A 4GB MEMORY CARD

QUALITY	MEGAPIXELS	FILE SIZE (APPROX MB)	POSSIBLE SHOTS	MAX BURST
RAW + 4 L	Approx 17.9 + 17.9	24.5 + 6.4	110	3
RAW	Approx 17.9	24.5	150	6
#L	Approx 17.9	6.4	570	34
#L	Approx 17.9	3.2	1120	1120
⊿ M	Approx 8.0	3.4	1070	1070
. ∎ M	Approx 8.0	1.7	2100	2100
4S	Approx 4.5	2.2	1670	1670
al S	Approx 4.5	1.1	3180	3180

All quantities are approximate, based on the photographic subject, brand, and type of memory card, ISO speed, and other possible factors.

The Menu System and Custom Functions

The heart of the T2i is its menu system, which can be viewed via the LCD monitor on the back of the camera. D-SLR menus are an indispensable way to control a great number of settings found in these sophisticated cameras. Still, in some cameras, menus are more of a "necessary evil" because they are not easy to navigate. Canon, however, has put a great deal of thought into the design of the Rebel T2i's menus so that they can be used easily and efficiently.

USING THE MENUS

Understanding the menu system is necessary in order to get the most from your camera. Press the MENU button, located on the back of the camera near the top left corner of the LCD monitor, to gain access to the Rebel T2i's menus. The camera's 11 menus are grouped into five categories. The first four intuitively-named menu groups, in order of appearance, are the Shooting, Playback, Set-Up, and My menus. The fifth menu category is Movie, but it only appears when the camera is set for \$\frac{1}{27}\$ via the mode dial.

NOTE: When the camera is first used, pressing MENU takes you to the Shooting 1 menu \square . After that, pressing MENU takes you to the last menu you selected, even if you have just powered the camera on.

After pressing MENU to display the menu tabs, you can scroll left or right from one menu to another in a couple of different ways: you can use the main dial , located on the top of the camera just behind the shutter button, or you can opt to use the left and right cross keys , found on the back of the camera to the right of the LCD monitor. To highlight menu items, scroll up or down using . The menus loop back on themselves; in other words, if you are at the bottom of a menu and keep scrolling down, you will go back up to the first menu item. Press the set button SET, located in the middle of , to select and apply the item you want. Additionally, some items have further submenu options to choose from, which require you to again scroll and make selections using , and SET. To back out of a menu, press MENU.

SHOOTING 1 MENU

The Shooting menu category with its three red-coded menus is reserved for controls that affect the shooting functionality of the T2i. As you first start taking pictures with your T2i, the shooting menus will be usedthe most used. They are helpful for controlling how the camera records images, but they also give access to controlling how the camera operates when it takes a picture (i.e., whether it makes a sound during certain operations and how long images are displayed on the viewfinder). And as you start using the flash, you'll find the available flash control to be indispensable.

OUALITY

The T2i has myriad image file-recording options. Use \P to cycle through the various selections. The JPEG options include controls for both quality (higher or lower amounts of compression) and resolution (pixel count—large, medium, or small). When you shoot RAW files, there is only one resolution option.

- [aL]: (Default) Highest possible pixel count (~18MP) with low compression; file size is ~6.4MB
- [』L]: High resolution (~18MP) with high compression; file size is ~3.2MB
- [aM]: Medium resolution (~8.0MP) with low compression; file size is ~3.4MB
- o [\blacksquare M]: Medium resolution (\sim 8.0MP) with high compression; file size is \sim 1.7MB
- O [\blacksquare S]: Low resolution (~4.5MP) with low compression; file size is ~2.2MB
- O [\blacksquare S]: Low resolution (~4.5MP) with high compression; file size is ~1.1MB

HINT: To apply the maximum JPEG file quality and size, choose ▲L (which is the least compressed and offers the highest pixel count, or resolution). For the least resolution and maximum compression, choose ▲S, which results in the smallest file size. You can also choose to shoot RAW+JPEG formats simultaneously.

- O [☑☑+』L]: One RAW file and one best-quality JPEG file; each file uses the T2i's full 18-megapixel resolution, and the combined file size is a whopping 30.9MB (24.5 + 6.4) per shot (i.e., per recording of one RAW and one JPEG file for each shot taken)
- O [MW]: Maximum resolution (~18MP); file size is ~24.5MB

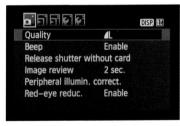

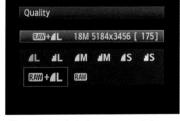

BEEP

Use this menu option for those times when you want to be a bit more discreet in your picture taking. You can control the audible signal normally heard during focusing and self-timer use. There are two options:

- O [Enable]: (Default) Sound is audible
- O [Disable]: No sound when focus locks or when self-timer is used
- Turn off the beep when photographing kids, so they aren't distracted by the

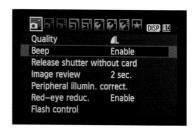

RELEASE SHUTTER WITHOUT CARD

When you first go through the T2i and all of its features and functions, you may not care about capturing pictures when you press the shutter to experiment with the camera's controls. Be sure to switch this menu selection to [Disable], however, if you want to ensure that you don't go through a round of picture taking only to find that you haven't recorded any images.

> Use this function with caution. This possible disappointment is hard to measure.

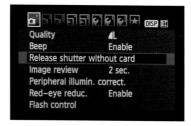

- O [Enable]: (Default) This setting allows you to "take a picture" without a memory card in the T2i. The T2i shows you the image in review, but since it is not recorded anywhere, the image disappears when the review period is over.
- O [Disable]: This setting will not allow you to fire the shutter when there is no memory card in the camera. This is generally the setting to use once you get through that initial learning period. There is probably nothing more frustrating than taking a picture and not realizing that you don't have a memory card installed in the camera.

IMAGE REVIEW

This option controls how long the image stays on the LCD monitor immediately after you take the picture. I typically set this to eight seconds (it really doesn't use that much more battery power than a shorter duration).

- O [0ff]: The image will not be displayed after recording. I use this when I don't want my subjects, most often children, to keep running to the camera to see the image. I find that checking the LCD monitor breaks the mood and stops subjects from doing whatever they are doing when I want to photograph them.
- [2 sec.]: (Default) For me, this is too short to properly evaluate the image.
- O [4 sec.]
- O [8 sec.]: This is the display duration that I prefer.
- [Hold]: The image will display until you press another camera button or until the auto power off function takes effect.

PERIPHERAL ILLUMINATION CORRECTION

Canon introduced this feature into their professional cameras a few years back, and now they have brought it into other models. Peripheral illumination correction refers to the fact that all lenses have some light falloff at the edges of their optics. This appears as subtle (and sometimes not so subtle) vignetting (darkening of the image near its edges and corners). Since Canon builds their own lenses, they know how much falloff each lens model has. When you attach a lens to the T2i, the lens communicates with the camera and registers the lens model that is attached.

- O [Enable]: (Default) The T2i adjusts the image to reduce the vingetting. If you are using a third-party lens or an older Canon lens, this feature will be disabled.
- O [Disable]: No correction will occur even if the data is available to do so.

NOTE: You can select which lenses get correction via the EOS Utility software that came with the camera. See pages 242-243.

RED-EYE REDUCTION

Red-eye is caused when the light from the built-in or camera-mounted flash reflects off the back of people's eyes (retinas). The T2i can emit a strong light from the front of the camera near the shutter button. This causes people's irises to narrow, which reduces the amount of flash light that enters and reflects back from their eyes. See page 201 to learn more.

- O [Disable]: No light is emitted from the front of the camera.
- O [Enable]: (Default) This causes a bright light to shine, reducing red-eye.

FLASH CONTROL

This feature not only provides control for the built-in flash, it also offers extensive control of the EX series II Canon Speedlites. For years, photographers who don't use external flashes on a daily basis have been frustrated because it is hard to remember how to set various settings on a Speedlite. The [Flash control] menu item has solved that problem.

If you shoot with an external Canon Speedlite, this menu is invaluable. If you don't, this menu is still useful, as it is the only access to flash exposure compensation.

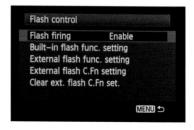

NOTE: This item is not available for use with any of the Basic Zone shooting modes.

Besides allowing access to external Speedlite functions (Speedlite control is model-dependent), this menu item offers options that allow you to disable flash firing, set built-in flash functions, control external Speedlite custom function settings, and clear external Speedlite custom functions. Learn more about this advanced and powerful menu item in the flash chapter.

* SHOOTING 2 MENU

As you read about the features available in this menu, note that there is a special version of that activates when the T2i is in movie shooting mode; the menu options are limited to [Exposure comp.], [Auto Lighting Optimizer], [Custom White Balance] and [Picture Style]. When the menu is limited in this way, the selections you make for these settings will only be applied to movie shooting. For example, if you set the Picture Style to when you switch out of movie shooting mode, the Picture Style will return to whatever the previous setting was for normal picture taking. And when you go back into movie mode, it will again be set for Addition, if you make an adjustment to a particular Picture Style, such as increasing the sharpness setting for Attachment will not carry over when the camera is no longer in mode. One exception is that if you set a custom white balance in movie mode, that data will be in memory if you switch to regular picture taking and use

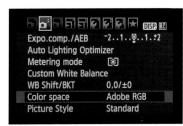

K While the ai menu has important settings in it, once they are set, you don't go back to them very often.

You will use the ai menu more frequently.

NOTE: This menu is not available for any of the Basic Zone shooting modes.

EXPOSURE COMPENSATION / AUTO EXPOSURE BRACKETING

Exposure compensation is a way to override the exposure that the T2i automatically sets when you are shooting in **P**, **Tv**, and **Av** modes. When the [Expo.comp./AEB] option is selected, a scale from -5 to +5 is presented on the LCD monitor (0 is the default). Using \P , you can set the exposure to be brighter (+) or darker (-); press **SET** to apply the exposure adjustment. The compensation value will be displayed on the scale in the viewfinder and the LCD monitor.

The scale shown here only really goes from -5 to +5 stops, but with bracketing, the exposure can dip down to -7 and and rise to +7 stops.

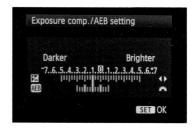

NOTE: Exposure compensation is not reset when you power off the camera. Make sure you keep an eye on the scale to double-check that exposure compensation is not set from a previous shot.

NOTE: The viewfinder scale only goes from -2 to +2. Exposure compensation settings beyond -2 or +2 will be indicated with an arrow.

HINT: You can also set exposure compensation without going into a menu with the Avt button. See page 44.

The T2i can also automatically bracket your exposure. Bracketing involves taking one picture with normal exposure, then one image that is underexposed (from normal) and one that is overexposed. If the camera is set for continuous drive mode (\square – see page 143), the three shots are taken with one shutter button press. Otherwise the shutter release button needs to be pressed three times. Until all three shots are captured, the bracketing icon \square will blink on the LCD monitor and \bigstar will blink in both the viewfinder and the LCD monitor. To set the T2i for AEB, rotate \square to select the amount of bracketing, then press **SET** to accept the setting. Unlike exposure compensation, exposure bracketing is turned off when you power off the camera.

While bracketing was an invaluable tool for shooting with film, its original purpose isn't quite as important now that digital cameras include the histogram display and allow for image review on the LCD monitor. But a new digital technique—high dynamic range (HDR) photography—has brought bracketing (and auto bracketing, in particular) to the forefront. HDR handles difficult exposure situations by merging several identically-composed images that have been recorded at different exposure settings. This is usually done with special software in the computer during post-processing. Using a tripod while shooting is also helpful. (To learn more about HDR imaging, check out the Complete Guide to High Dynamic Range Digital Photography, by Ferrell McCollough.)

NOTE: The Quick Control screen (see pages 50-51) is a quick way to access both exposure compensation and AEB. Once you learn how to use that screen, you'll rarely go back to using this menu item.

AUTO LIGHTING OPTIMIZER

This recent introduction to EOS cameras is an exposure correction mode that makes use of the power and design of the DIGIC 4 image-processing chip in the T2i. By evaluating the image after capture, the camera can help brighten underexposed scenes while still maintaining image details. This setting only affects JPEG images, but you can also apply this correction during RAW processing when you use Canon's software.

> Auto Lighting
Optimizer can be a
nice, subtle effect
when in standard
mode. It works in all
Creative Zone modes.

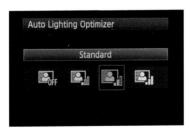

- O $[\mathbb{R}]$ Disable]: This option for brightness correction is disabled.
- O [Low]: A slight amount of correction is applied.
- O [Standard]: (Default) This is a good starting point if you want to experiment with the Auto Lighting Optimizer control.
- O [Strong]: The highest amount of correction is applied.

METERING MODE

The first step towards properly exposed images is to measure the amount of light in your scene. The T2i has a newly-designed, sophisticated, built-in light metering system for just this purpose. And since different shooting situations require different methods of metering, the T2i includes several different metering modes. (See pages 155-159 for more on metering and metering modes.)

- O [Evaluative]: The Rebel T2i's evaluative metering system divides the image area into 63 zones, "intelligently" compares them, and then uses advanced algorithms to determine exposure.
- O [Partial]: Partial metering covers about 9% of the frame, utilizing the exposure zones at the center of the viewfinder.
- O [Spot]: The metering is confined to the center area (about 4%) of the viewfinder. The circle that you see in the viewfinder represents the "spot" that is used for metering.
- O [C] Center-weighted average]: This method averages the readings taken across the entire scene, with extra emphasis on the meter reading taken from the center of the horizontal frame.

CUSTOM WHITE BALANCE

If you use a custom white balance setting, you'll need to tell the T2i which image to use as a basis for white balance (see pages 68-69). Once you have captured an image, select this menu item, scroll to the image you want to use as a reference and press SET. By storing several different white balance reference images ahead of time, you can quickly set new custom white balances as you move from location to location. Once you have created a custom white balance setting, you can then access it as needed using the WB button.

WHITE BALANCE SHIFT / BRACKET

Just like exposure compensation and bracketing, you can adjust how the T2i does white balance by accessing the [WB Shift/BKT] menu item. Learn more about this tool on page 71.

Custom white balance was useful in this situation, where the blue wall behind the subject could have thrown off the camera's reading of the prevailing light color temperature just enough to cause the model's skin tone to appear unnaturally warm.

COLOR SPACE

This setting is for JPEG images. When setting the color space, you decide what palette (range) of colors you want the T2i to use when creating images. Somewhat like choosing between a box of 64 crayons or 128 crayons, choosing a color space can be important depending on how you will use your images.

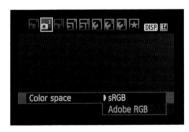

< It can be difficult to see the difference between these two settings because computer monitors use the sRGB color space to display images.

- [sRGB]: (Default) This choice is the smaller color space and is typically the one used by inkjet printers.
- O [Adobe RGB]: This is a wider gamut of colors, but images may look duller on computer displays or in inkjet prints than sRGB color space. However, Adobe RGB gives you more options for image adjustment in the computer, and future printing technology will eventually encompass this range of colors.

When shooting in the RAW file format, color space is selected on the computer during image processing. When the camera is set for Adobe RGB, file names will begin with an underscore: _MG_0201 vs. IMG_0201. During Basic Zone shooting, color space is automatically set for sRGB. When you shoot video, the color space is set automatically to the HD video color space.

> Be sure to check the Picture Style setting when you turn on your T2i. If you left it in monochrome mode, it won't reset back to standard when you power down the camera.

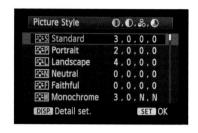

PICTURE STYLE

Much like choosing from assorted film stocks to make images appear differently, the T2i allows you to customize the look of your images and videos via the [Picture Style] menu selections. There are six presets that you can use or modify, with [SS Standard] as the default. Additionally, there are three user-defined Picture Styles that allow you to create your own look. Canon also includes software for creating custom Picture Styles on your computer, and you can visit http://web.canon.jp/imaging/picturestyle/ to download additional Picture Styles. (Learn more about Picture Styles on pages 56-62.)

SHOOTING 3 MENU

DUST DELETE DATA

Canon's Digital Photo Professional software can be used to automatically eliminate persistent dust that may have accumulated on the T2i's sensor. This menu option shows you the date and time of the last Dust Delete Data capture, and it also takes you through the process of capturing the Dust Delete Data reference file. Learn more about dealing with dust beginning on pages 28-29.

Obtain data for removing dust using software.
Refer to manual for details.

Last updated: 00/00/'00 00:00

Cancel OK

For critical and controlled shooting situations, like in a studio, capture a Dust Delete Data reference shot before you begin.

ISO AUTO

In addition to having the T2i automatically control the shutter speed or the aperture, you can have it control the ISO sensitivity. Since image noise increases as you increase the ISO speed you may want to limit the maximum speed that the T2i uses when ISO is set for AUTO. That is the purpose of the options in this menu selection.

- O [Max. 400]
- O [Max. 800]
- O [Max. 1600]
- O [Max. 3200]
- O [Max. 6400]

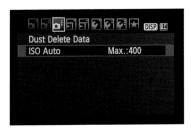

[ISO Auto] gives you more options when shooting in the Creative Zone modes. In previous cameras, you didn't have much control of how high ISO would go. The T2i allows you to limit that range and thereby control noise, even when you're using the automatic setting.

D' PLAYBACK 1 MENU

This blue-coded menu is the first of two Playback menus that offer several choices for viewing images on the LCD monitor.

PROTECT IMAGES

This is a useful tool to prevent images from being erased. Highlight the item and press SET. An image displays in the LCD monitor with a key symbol next to the word SET at the top left of the photo. Go through your photos one by one using ◀▶ (or use ﷺ to jump). Push SET for every image that is a potential keeper. A small ➡ appears in the information bar at the top of the LCD monitor. Press MENU to exit after protecting the desired image files. Although protecting images prevents them from being erased, formatting a memory card ignores protection and deletes all data from the card. If you are using an Eye-Fi card, the [Protect images] function can be used to decide which images to transmit via Wi-Fi. (See page 234.)

ROTATE

If the [Auto rotate] item is not turned on in \P , use this selection to rotate captured images. When selected, the last image displayed is presented. Press SET to rotate the image clockwise, press SET again to rotate it counterclockwise. Press SET again to return to the original orientation. Use \P to scroll through (or use to jump) to other images you wish to rotate. Press MENU to exit after rotating the desired image files.

> With the built-in orientation sensor in the T2i you shouldn't have to use the [Rotate] function but if you've turned off auto rotate, this function is available for manually rotating an image.

In addition to the \tilde{m} button located on the camera back, the T2i has an internal deletion submenu that offers some additional options to simple single-image erasing.

- O [Select and erase images]: To erase individual images, choose this option and press SET. Use ◆▶ to scroll through your images and press ◆▼ whenever you want to delete an image (press again to uncheck). A checkmark is placed next to a in icon in the upper left corner of the display. The total count of how many images you have selected for deletion will also be indicated. Once you have selected the images to delete, press in to erase the images. You'll be asked to confirm the erasure.
- O [All images on card]: This will erase all the images on the card. Why would you erase all the images on the card instead of formatting the card? Formatting the card erases images that are protected (see previous menu item, detailed on pages 24-25); using the [All images on card] selection leaves protected images alone.

NOTE: Once a file is erased, it is gone for good. Make sure you no longer want an image or video before making the decision to erase it.

PRINT ORDER

You can specify which images print when you bring your memory card to a photo retailer, or when you connect the T2i directly to a PictBridge-capable printer. Learn more in the Output chapter (see pages 231-247).

Instead of standing at a photo kiosk trying to decide which image to print, you can use the [Print order] function to make all of your selections right in the camera.

SLIDE SHOW

This option automatically creates a slideshow on the LCD monitor of the images that have been recorded on your memory card. Using the [Set up] submenu, you can set the length of time each image is displayed (from 1 to 20 seconds). The slideshow can be set to repeat, and you can also choose to filter the files you include in your slideshow:

> Make sure you strike a balance between having your image up long enough so people can really view it, and too long so that they are anxious to get up and qo!

- O [All images]: Includes all still photos and movies.
- O [Date]: Select a specific date for stills and movies. Press DISP to select the date.
- O [Movies]: All movies, and only movies, will be played back.
- O [Stills]: All stills, and only the stills, will be displayed.

D: PLAYBACK 2 MENU

HISTOGRAM

The T2i offers two types of histograms for evaluating image exposures. Use this menu selection to choose which will be displayed during Playback.

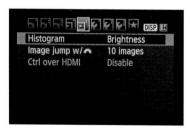

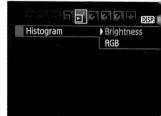

- O [Brightness]: (Default) This shows the overall distribution of tones in the image.
- O [RGB]: Shows the tonal distribution within each color channel.

NOTE: The histogram display is based on a JPEG image. If you are shooting RAW only, the histogram will still be based on a JPEG file display. Learn more about using histograms on pages 164-165.

IMAGE JUMP WITH THE MAIN DIAL

When you are in playback mode, you scroll through images one at a time using � . By using instead, you can navigate more quickly by jumping past multiple images. The [Image jump w/] feature sets the number of pictures that you are jumping past at a time. You can also jump by date, folder, movies, or stills. This is useful if you shoot both stills and movies and want to see just the movies that are scattered about in the image folder. Your options are:

< Image jump using [Date] is a good choice when you are traveling. That way, you can review pictures for each day.

- O [1 image]
- O [10 images] (Default)
- O [100 images]
- O [Date]
- O [Movies]
- O [Stills]

CONTROL OVER HDMI

HDMI is a way of connecting your T2i to a digital TV. Some sets use the HDMI CEC (Consumer Electronics Control), which will allow you to control the playback of the T2i via the television's remote.

- O [Disable]: Control of playback is through the T2i.
- O [Enable]: When enabled, use the left and right arrow buttons of your TV's remote to control playback of images.

The auto rotate setting can initially be confusing. I don't like the default option of having auto rotate on for the camera display and computer display. I like having a larger image on the LCD, so I use the second option.

Y' SET-UP 1 MENU

Color-coded yellow, this is the first of three set-up menus, each of which present selections to control overall camera operation.

AUTO POWER OFF

The T2i shuts itself off after a period of idleness in order to save battery power. The [Auto power off] setting offers six options, ranging from 30 seconds to 15 minutes, plus an [Off] setting (i.e., the camera will not power off). Even when you select [Off]—which you might elect to do, for example, if you shoot in a studio with the optional AC adaptor—the LCD monitor will still turn off after 30 minutes of inactivity, though the camera will stay on.

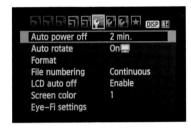

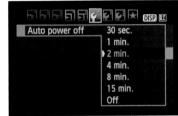

AUTO ROTATE

The T2i has a positional sensor that can determine if you are holding the camera vertically or horizontally. This information is embedded in the image's file header so that, when the image is displayed, it is oriented properly.

- O [On ■]: (Default) Images shot with the T2i in a vertical position are rotated to display correctly on the camera's LCD monitor and on your computer monitor.
- O [On]: The vertical image is only rotated on the computer's display. I like this option because the image is larger on the T2i's LCD monitor when it is not rotated, allowing me to evaluate it more easily. And, since I am usually still holding the camera vertically, I don't have to physically rotate the camera back to a horizontal shooting position to view the image.

O [Off]: The image is not rotated on the LCD monitor or the computer screen. Even if you later set this option to [On ♠ ■] or [On ■], images previously shot will not have embedded orientation data. If you want to rotate the image in-camera at that point, you must use [Rotate] in □ (see page 94).

NOTE: Automatic file rotation on your computer depends on the software you use to view your images.

FORMAT

SD cards need to be formatted for use in the T2i. Format any card the first time it used in your T2i, and on a regular basis after that to keep the card functioning at its best. The [Format] menu item performs this function. It is also a quick (though slightly risky) way to determine how much space (in GB) has been used on your memory card, as that information is displayed on the formatting screen. Formatting should always be done in the camera rather than on the computer. (Learn more about when or how to format starting on pages 24-25.)

> Always format your memory cards in the T2i, not in the computer or any other device.

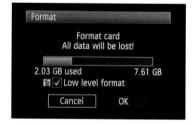

CAUTION: There is no "undo" for formatting. Formatting ignores any file protection settings, and all data will be erased. While you might be able to use a recovery service or software in an attempt to retrieve your data, there is no guarantee, and recovery services are very expensive. If you do run into a situation where you need to retrieve data, make sure that you don't attempt to write any new file information to the memory card in the interim.

The T2i stores image and movie files in folders. Within each folder, the file names must be unique. The [File numbering] menu item determines how the T2i will assign subsequent file names.

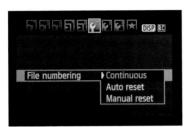

Keep track of important images using the [File numbering] option in the f' menu. Set it to [Continuous] or [Manual reset] to avoid duplicate file numbers on your main storage device.

- O [Continuous]: (Default) File numbers increase by increments of one, no matter what memory card is inserted in the camera. If there is a conflict between a new file and an existing file (i.e., if you use a card with files already on it), the new file picks up the number sequence after the last file in the folder. To avoid confusion, use freshly formatted cards or create new folders.
- O [Auto reset]: This option resets the file name to start at 0001 each time you insert a memory card in the camera. Once again, if there is a conflict with previously existing files on the inserted memory card, the numbering picks up after the last image in the folder. As stated above, use freshly formatted cards or create new folders to avoid confusion.
- O [Manual reset]: This allows you to control when to reset the file numbering. When you select this option, a new folder is created and the file numbering is reset to 0001. This is useful when you are photographing in different locations and want to group your images by location.

When you decide how to set your file numbering, consider how you will deal with the images once they are on your computer. I try to avoid the possibility of duplicate file names, and I use folders on my computer to group my images, so I prefer to use the [Continuous] option. If you want to organize your images into folders before moving them to your computer—for example, you might want to organize by day or location—you'll want to select [Manual reset] to create a new folder.

NOTE: When the camera reaches folder 999 and image 9999, even if it has sufficient space, it will not be able to record another picture until you replace the memory card.

> The LCD on the T2i can be quite bright, especially when shooting at dusk or in other low-light situations. and can be very distracting as you try and look through the viewfinder to compose your shot. Fortunately, you can set it to turn off automatically when your face is near the back of the camera.

LCD AUTO OFF

The LCD can be distracting when you are trying to look through the viewfinder. A small sensor below the viewfinder detects objects that approach the viewfinder. This feature selects whether or not to turn the LCD off when your eye approaches the viewfinder.

- O [Enable]: (Default)
- O [Disable]: If you use the Quick Control screen a lot, you may find that it shuts off as you move your fingers close to the viewfinder. This selection will allow you to avoid having the Quick Control screen disappear.

SCREEN COLOR

You can customize the display colors of the shooting settings screen. This is useful if you are shooting at dusk or dawn and don't want to be "blinded" by the brightness of the LCD screen. There are four options.

< When shooting at sunrise and sunset, consider using one of the less bright LCD color schemes.

- O [1]: (Default) Black type on a white background
- O [2]: White on black
- O [3]: White on brown
- O [4]: Pale green on black

EYE-FI SETTINGS

For the first time in any Canon EOS camera, there is support for Eye-Fi cards. These wireless SD memory cards allow the T2i to transmit images via wireless hotspots to your computer. Learn more about Eye-Fi on page 234.

- O [Eye-Fi trans.]: This selection allows you to enable and disable wireless transmission of images.
- O [Connection info.]: Brings up a status screen giving you detailed information about the Eye-Fi card, including the currently connected Wi-Fi network name, connection status, and the Eye-Fi card firmware version.

NOTE: This menu selection is only displayed when you are using an Eye-Fi card.

Y: SET-UP 2 MENU

Besides making sure the T2i has the correct date and time, you'll mostly access this menu for shooting with live view, keeping the sensor clean, and making sure you can see the LCD properly.

LCD BRIGHTNESS

This menu item allows you to set the LCD monitor's brightness level. Use **◆▶** to choose among seven levels of brightness.

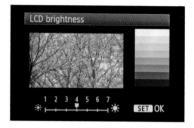

DATE / TIME

Use this option to adjust the date and time that is recorded with images. You should check this setting when you travel so that you are able to keep track of when you took pictures. Date and time information is retained in the camera even when you change batteries. See pages 19-20 for details on setting the date and time.

LANGUAGE

The T2i is able to display menus and information in 25 different languages. If you accidentally change the language and can't read the new language to set it back, just look for the comic-strip-word-bubble icon 9 in the menu. No matter which language the camera is set for, you will see this icon, and selecting it will take you back to the main list of languages.

Up until very recently, countries in North America (and a few other countries) used an analog television system called NTSC; a system called PAL was used outside of North America. While the switch to digital has technically eliminated these terms, there are still a lot of analog televisions (and analog inputs to digital televisions) out there. When you connect the camera using the A/V terminal (not HDMI), you need to match the T2i's video setting to the video monitor system. Don't worry if you are not sure which to use. You can't harm anything by using the wrong setting; the television just won't display the T2i's images.

NOTE: The **[Video system]** option is also used to change the available video frame rates. When set for NTSC, the frame rate options will include 30 and 60 frames per second (fps). When set for PAL, the frame rates will include 25 and 50 fps.

SENSOR CLEANING

The T2i is equipped with an auto cleaning system that vibrates the sensor to shake off any accumulated dust.

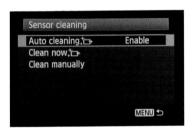

If the auto cleaning function is enabled, the icon will show up in the lower right corner of the LCD each time you turn the camera on, and in the center of the screen when you turn the camera off.

- O [Auto cleaning :]: (Default) This option engages the cleaning function when the camera powers on and off. You should normally leave this option on. Probably the only time you would turn this off is when you are using the [Dust Delete Data] function and are shooting a series of shots (without moving the camera) and don't want to keep shooting reference frames for the detection system.
- O [Clean now :=]: This lets you choose to start the auto cleaning function immediately.
- O [Clean manually]: This option to manually clean the sensor should only be used with care. See pages 27-29 to learn more about sensor cleaning. This menu option is not available in the Basic Zone modes.

LIVE VIEW FUNCTION SETTINGS

When you shoot stills using the T2i's live view feature, the LCD monitor displays the live image from the image sensor. Normally when you are composing your shot with an SLR, the mirror reflects the light coming from the lens into the viewfinder—this also ends up blocking light from the the image sensor. With the T2i's live view feature, the mirror is flipped up and blocks the viewfinder, but the image sensor now sees the image and transmits it to the LCD. Use these menu options to control live view shooting.

> This sub-menu of the ♥ menu allows you to configure how the T2i will operate in live view mode.

- O [Live View shoot.]: The default setting is [Enable]. Whenever you press
 ☐ (located to the right of the viewfinder), the live image is displayed on the LCD monitor. Choose [Disable] to prevent ☐ from working.
- O [Grid display]: There are two grids that can be superimposed over the live view display. One grid is a rule-of-thirds pattern with two vertical and two horizontal lines that divide the image into three rows of thirds. For good composition, place your subjects at the intersections of these lines. The other overlay is five vertical lines and three horizontal lines. When you shoot scenes with a lot of geometrical shapes, like architecture, this is useful in making sure your camera is level and square to your subject.
- [Metering timer]: The metering system for live view shooting can be engaged for as briefly as four seconds to as long as 30 minutes. Choose from six options.
- O [AF mode]: Since the autofocus system is blocked because the mirror is in the up position, there are three options for focusing the T2i. Learn more about the AFIN, AF &, and AFIN selections on page 113.

NOTE: When the Rebel T2i is set for "\textit{\textit{m}} two new menu items ("\textit{\textit{m}}" and "\textit{\textit{m}}") are added at the front of the menu tabs. Although the live view and movie shooting menus appear in two different places, they share some of the same settings. For example, if you set the metering timer for one minute in live view, it will be one minute in the movie shooting menu, as well.

♥: SFT-IIP 3 MFNII

At first glance, this looks like a menu that doesn't offer much. But in reality, buried in the first selection is a great tool for customizing your T2i. In fact it might be a good idea to just think of this menu as the "Custom Function menu."

One you start getting familiar with your T2i, be sure to investigate the custom functions.

NOTE: Set-up 3 menu is not available in the Basic Zone modes.

CUSTOM FUNCTIONS

The T2i has 12 custom functions for customizing how the camera operates. See pages 117-126 later in this chapter for details.

COPYRIGHT INFORMATION

The T2i can embed your name and other copyright information in every image captured by the camera. Entering the data can be a bit tedious using the camera controls. A better option is to use Canon's EOS Utility software that comes with the T2i. See pages 242-243 for more information.

K Even if you don't register the copyright of your images, it is still useful to be able to embed your information in each image.

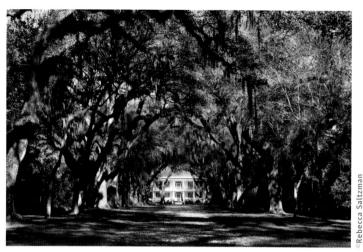

Attaching copyright information to your images is a good habit to get into, especially if you regularly submit images to a magazine or newspaper—in fact, many publications require it.

- O [Display copyright info.]: Use this to display the information that will be embedded in each file.
- O [Enter author's name]: Use this to enter your name. Even if you don't want to deal with copyrighting your images, it is still a good idea to identify yourself as the photographer.
- O [Enter copyright details]: This is where you would enter information about the rights reserved for your image.
- O [Delete copyright information]: Resetting the camera via the [Clear settings] option will not reset the copyright information. This option is the only way to erase this data via camera controls. (It can also be deleted via the Canon EOS Utility software.)

CLEAR SETTINGS

This is a useful tool when you are first trying out your camera. You may activate so many features and options that you'll become a bit overwhelmed! This menu selection allows you to quickly and easily return to the camera's default settings.

 [Clear all camera settings]: While the option says "all," it does not reset the custom functions, [Date/Time], [Language], [Video system], [Copyright information], or My menu items.

- O [Clear all Custom Func. (C.Fn)]: Use this option to reset all 12 of the custom functions to their default settings.
- O [Cancel]: Exit the menu.

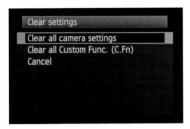

After experimenting
 with all of the settings
 on the T2i, you may
 find it useful to be
 able to quickly and
 easily get back to
 square one.

FIRMWARE VERSION

Cameras run on software, and firmware is the portion of the software that can be updated. This option displays the current firmware version. Check the Canon support site on a regular basis to see if the firmware version has been updated. Once a new firmware update is available, follow the procedure that comes with the update. It usually requires that you copy the update to a memory card, insert it into the camera, and select [Firmware Ver.] to start the update process. Afterwards, confirm the version number to make sure the update installed correctly. Always follow the instructions exactly or you may end up with an unusable T2i.

* MY MENU

If you find yourself returning to certain menu items and custom functions on a regular basis, the T2i allows you to build your own customized menu, called My menu. This is a powerful tool that you can use so camera adjustments are quick and easy. For example, I have built a menu that gives me quick access to [Mirror lockup], [Highlight tone priority] (C.Fn-6), [Flash control], [ISO expansion] (C.Fn-2), and [Long exp. noise reduct'n] (C.Fn-4). Sometimes, I will remove one or two items and add other things. For instance, I might add [Protect], if I am using an Eye-Fi card and want to control when an image is transmitted; or I might load up the menu with video options if I am shooting video all day.

> The My menu is the ultimate tool for quick access to many camera menu options.

NOTE: The My menu items are not available in the Basic Zone modes.

When you first use the Rebel T2i, the My menu display only has one selection: [My Menu settings]. Through this selection, you can build a custom menu using any of the top-level selections in any of the menus, as well as any of the custom functions. My menu can contain up to six selections.

To build a menu, first press MENU and move to the ★ tab. Highlight [My Menu settings], and then press SET. From the submenu that appears, scroll to highlight [Register to My Menu], and press SET again. A list of every top-level menu option and all the custom functions is displayed. Scroll to select the first desired option and press SET again. Highlight [OK] and press SET to confirm the addition of the selected option. Once selected, the option will be grayed-out so that you can't insert the same option twice. Repeat the process until you have selected the options you want, up to a maximum of six. Press the MENU button to exit the selection screen, then press MENU again to see the resulting My menu you have created.

There are myriad ways you can set up your custom My menu. Don't worry about setting up a My menu right away, or completely filling it up. Start using your camera and take note of a menu items that you keep going back to. Add that to your My menu.

The [Sort] submenu under [My Menu settings] allows you to sort your menu items once you've added them. Select [Sort] and press SET. [Sort My Menu] is displayed, showing the current order of your menu items. Scroll to highlight an item you wish to move. Press SET and an up/down arrow appears to the right of the item. Use AV to move the item up or down in the list. Press SET once the item is in the preferred position. You can then repeat these steps to change the position of other items or press MENU to exit.

If you have filled ★ with six items, you must delete an item before you can insert a new one; there is no exchange function. Highlight [Delete item/items] in the [My Menu settings] submenu and press SET, then move to highlight an item you wish to delete. Press SET and a dialog asks you to confirm the deletion. Highlight [OK] and press SET. Repeat this process if you wish to delete other My menu items, then press MENU to exit the [Delete My Menu] screen. Similarly, you can select [Delete all items] to start with an empty My menu.

You can customize your Rebel T2i so that ★ is displayed every time you press MENU (no matter which menu you were last on). To do so, highlight [Display from My Menu] from the [My Menu settings] screen. Press SET, then highlight [Enable], and press SET.

NOTE: You can also use Canon's EOS Utility software that comes with the T2i to build your My menu.

MOVIE 1 MENU

This menu tab is only available when the mode dial is set for movie shooting ${}^{1}\overline{}$. Think of it as similar to the shooting 1 menu ${}^{1}\overline{}$ used when shooting stills. It contains most of the controls for setting up the T2i for recording video.

MOVIE-RECORDING SIZE

Whether your video system is set for NTSC or PAL in \P : (see page 105), there are three high-definition (HD) and two standard-definition settings for recording video. Menu selections when video system is set to NTSC:

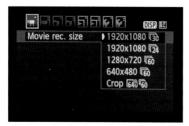

^ Here are the [Movie rec. size] options that will appear when [Video system] is set for NTSC in ♥¹.

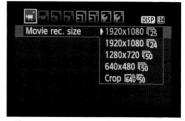

^ These [Movie rec. size] selections are only available when [Video system] is set for PAL in ∀:.

- O [1920x1080 30]: Full HD –The 1920 x 1080 designation represents the number of pixels (horizontal x vertical), and 30 represents the frame rate of the video—30 frames per second (fps). 30 fps is the normal frame rate for high definition video (the actual frame rate being 29.97 fps).
- O [1920x1080 24]: 24 fps is the typical frame rate used in shooting films that you see in a movie theater. Videographers often shoot at this frame rate to achieve a more cinematic look. Be aware, though, that since images are captured less frequently, fast motion can often have a stuttered look to it. (The actual frame rate for this selection is 23.976 fps.)
- O [1280x720 60]: This HD format offers a frame rate of 60 fps, which can capture scenes that contain a great deal of motion. It is also used when you want to slow down the footage as you edit the movie on a computer. In order to achieve the high frame rate, the resolution is reduced. (The actual frame rate is 59.94 fps.)
- O [640x480 60]: At 60 fps, this setting is approximately the size of standard definition video (the television standard before the advent of high-definition recording and viewing). (The actual frame rate is 59.94 fps.)
- O [Crop 640 60]: This is a new format for video recording that is available with the T2i. With all the other formats, the entire image output from the image sensor (5184 x 3456) is scaled down to the video format selected. With [Crop 640 60], the center portion of the image sensor is used to create a 640 x 480 image. This results in an apparent 7x magnification of the image. (The actual frame rate here is 59.94 fps.)

Menu selections when the video system is set for PAL:

- O [1920x1080 25]: Full HD 25 fps is the customary frame rate for countries outside of North America.
- O [1920x1080 24]: 24 fps is the typical frame rate used in shooting films that you see in a movie theater. Videographers often shoot at this frame rate to achieve a more cinematic look. Be aware, though, that since images are captured less frequently, fast motion can often have a stuttered look to it. (The actual frame rate for this selection is 23.976 fps.)
- O [1280x720 50]: This HD format offers a frame rate of 50 fps for countries outside of North America. You can only access this frame rate when [Video system] is set for PAL in ♥: (see page 105).
- O [640x480 50]: At 50 fps, this setting is for countries outside of North America and is available only when [Video system] is set for PAL in ♥: (see page 105).
- O [Crop 640 50]: This setting is for use outside of North America where the frame rate is customarily 50 fps. You can only access this frame rate when [Video system] is set for PAL in

 ** (see page 105).

NOTE: Only use 25/50 fps if you are creating video to be used outside of North America. It is not necessary to change frame rates if you are simply shooting video outside of North America but presenting the video in North America.

AF MODE

During movie recording, the AF sensor is blocked by the reflex mirror. This selection offers alternative AF modes.

- O AFILIDE [Live mode]: (Default) Using the images coming from the image sensor, this selection measures contrasting edges in order to determine proper focus. This method of focusing is slower and not as accurate as AFILIDE.
- O AF & [& Live mode]: This focus mode detects faces in a scene where people are photographed and sets focus to ensure the people are in focus.
- O AFORM [Quick mode]: This selection temporarily flips the reflex mirror down and uses the normal AF sensor for setting focus. While it sounds as if flipping the mirror down and then back up would be slow, it is actually the fastest method of achieving autofocus in live view.

AF DURING

While the T2i does not offer the continuous autofocus capability of a video camcorder, you can still refocus the camera while shooting video.

- O [Disable]: (Default) The camera is prevented from changing focus during recording.
- O [Enable]: You can change focus while recording by pressing the shutter release button halfway. Refocusing does not happen quickly, and that portion of the recorded video will likely need to be edited out.
- > At first glance, this can be a confusing menu. Just remember that the first item is what the shutter button will do and the second is what * does.

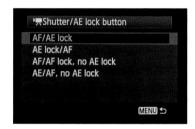

" SHUTTER / AE LOCK BUTTON

You can adjust how the shutter release button and the autoexposure lock button ★ work when shooting video. Since the shutter release button isn't used to start recording, and AF is a bit different when recording movies, this customization can be helpful.

- O [AF/AE lock]: When you press the shutter button halfway, the T2i starts the autofocus process; press * to lock exposure.
- O [AE lock/AF]: This swaps the function of the buttons; the shutter button controls exposure lock, and * activates the autofocus.
- O [AF/AF lock, no AE lock]: This mode allows you to take a still picture during movie recording without executing a refocus. Before taking the still picture, press and hold *, then press the shutter button to take the picture. Since * has been reassigned, autoexposure can't be locked.
- O [AE/AF, no AE lock]: The shutter button just turns on the meter; there is no exposure lock. \star is used to activate autofocus.

T2i movie shooting can be remotely started and stopped with the Canon RC-6 remote control.

- O [Disable]: The camera cannot be controlled by remote.
- O [Enable]: If the RC-6 remote control's shooting timing switch is set to [2] the remote starts and stops the video recording. If the switch is set for [•] the remote will fire off a still photo.

MOVIE 2 MENU

This menu contains a key option that wasn't even available when SLRs first gained the ability to record video. Initially, exposure was set automatically with no option for manual control. Arguably, the most import menu item here is the first one.

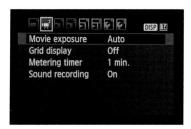

< There is no Av or Tv for video shooting instead, your choice is fully-automatic or manual exposure.

MOVIE EXPOSURE

Since video is not a single image, the lighting will often change when a subject (or the camera) moves, so the exposure must change with it.

- O [Auto]: The camera controls all exposure adjustments (aperture, shutter speed, and ISO speed) automatically in order to achieve proper exposure. You can still override the selected settings with exposure compensation.
- O [Manual]: This option allows for full manual control over exposure. Set shutter speed using △, aperture using Av → . Set ISO speed by pressing the ISO button and using △.

GRID DISPLAY

This option is useful for image composition.

- O [0ff]: (Default) No grids are displayed.
- O [Grid 1]: A rule-of-thirds grid overlays the image on the LCD. For good composition, place your subjects at the intersections of these lines.
- O [Grid 2]: A denser grid displays. When you shoot scenes with a lot of geometrical shapes, like architecture, this is useful in making sure your camera is level and square to your subject.
- > This is the same grid display available with live view shooting.

METERING TIMER

By default, the metering system stays engaged for 16 seconds when you tap the shutter release button. Use this option if you want the meter to shut off earlier or stay on longer. The range is from four seconds to 30 minutes. This is also how long exposure will remain locked when using exposure lock.

- O [4 sec.]
- O [16 sec.]
- O [30 sec.]
- O [1 min.]
- O [10 min.]
- O [30 min.]

SOUND RECORDING

The T2i is capable of recording sound with the video. Audio comes from either the built-in microphone or an external microphone connected to the external microphone IN terminal on the left side of the camera.

- O [0n]: (Default) The camera records sound using the mono builtin microphone or through an external microphone via the external microphone IN terminal.
- O [0ff]: No audio is recorded.

In addition to allowing choices about exposure mode, metering, drive, Picture Style, and so forth, the T2i also permits you to further customize and personalize the camera settings to fit your method of, and approach to, photography. This is done through the Custom Functions [Custom Functions(C.Fn)] submenu. Some photographers never use these settings, while others use them all the time. The camera won't take better photos by itself when you change these settings, but using custom functions may make it easier for you to take better pictures with the camera.

NOTE: Custom functions can only be used in the Creative Zone shooting modes.

The Rebel T2i has 12 different built-in custom functions (though they are not available in the Basic Zone shooting modes). Canon organizes them into four groups: C.Fn I: Exposure, C.Fn II: Image, C.Fn III: Autofocus/Drive, and C.Fn IV: Operation/Others. Since the groupings are small, I usually find it easier to remember them by their number.

To access the T2i's custom functions, highlight [Custom Functions (C.Fn)] in the ♥: menu and press SET. Then use ◀▶ to select the custom function you want to adjust and press SET again. Use ▲▼ to highlight the desired setting and press SET to accept it. The new setting will be displayed in blue. The setting number will appear below the function number in the lower left of the LCD monitor. To exit, press MENU or lightly tap the shutter release button.

The current function number will be displayed in the upper right corner of the LCD monitor when you are navigating through a particular set of custom function options, while all of the function numbers and their current settings are displayed at the bottom of the LCD monitor. Settings displayed in blue indicate that the particular custom function is not set for its default.

NOTE: The first option within each custom function is the default setting for the camera.

C. FN T: FXPOSURE

This group of functions allows you to customize how the T2i controls exposure. You will likely find the most-used function in this group to be ISO expansion, which allows you to increase the T2i's already impressive sensitivity.

C.Fn-1 Exposure Level Increments: Incremental steps for shutter speed, aperture, exposure compensation, and autoexposure bracketing (AEB) can be set here.

> If you do a lot of HDR shooting (see page 89) you might consider setting the increments to 1/2 stop.

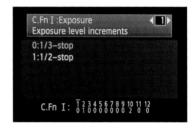

O 0: [1/3-stop] (Default)

O 1: [1/2-stop]

C.Fn-2 ISO Expansion: You can extend the ISO speed range into the expanded ISO values using this custom function.

> There really isn't a downside to setting this to [On], unless you want to make double sure that you don't ever use that high of an ISO speed.

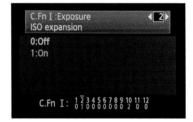

- 0: [0ff]: (Default) The normal ISO range of camera will be used (100 6400).
- O 1: [0n]: An expanded ISO range is made available (100 12800).

C.Fn-3 Flash Synchronization Speed in Av Mode: This sets the flash sync in aperture-priority **Av** mode to either automatic adjustment or to a fixed setting. When set for [Auto] (the default), you can use flash for slow shutter speeds, which may cause blurred elements in your scene. The [1/200-1/60 sec. auto] option limits shutter speed to no slower than 1/60 second, so there is less blurring. To lessen blur even more, the [1/200 sec. (fixed)] option forces the T2i to always use 1/200 second when a flash is engaged.

< Try [Auto] and using slow shutter speeds with flash at night for some fun shots.

- O 0: [Auto] (Default)
- O 1: [1/200-1/60 sec. auto]
- O 2: [1/200 sec. (fixed)]

C. FN II: IMAGE

This series of functions addresses the T2i's image processing. In particular, it offers control over noise reduction and image detail in high brightness situations.

C.Fn-4 Long Exposure Noise Reduction: This setting engages automatic noise reduction for long exposures. When noise reduction is used, the processing time of the image is a little more than twice that of the original exposure. For example, a 20-second exposure takes an additional 20 seconds to complete.

< Noise builds up in digital images when shooting long exposures. Setting this function to [Auto] will cause the DIGIC 4 processor to reduce what noise it can detect.

- O 0: [Off]: (Default) Long exposure noise reduction is turned off.
- O 1: [Auto]: Noise reduction is applied to noise detected on exposures of one second or longer.
- O 2: [On]: Noise reduction is turned on for all exposures one second or longer, even if no noise is detected.

Long exposures on digital cameras generate a lot of heat around the sensor, which can cause digital noise (graininess) in the resulting images. Long-exposure noise reduction helps to keep that effect to a minimum.

C.Fn-5 High ISO Speed Noise Reduction: As you increase the apparent sensitivity of the T2i by using high ISO settings, you increase the noise in the image. This custom function uses the DIGIC 4 processor to further reduce that noise.. If you shoot RAW or RAW+JPEG, the camera doesn't actually apply the noise reduction to the RAW image, it only embeds noise reduction data in the RAW file so that Canon's Digital Photo Professional software can use that data to reduce noise. This means that if you are looking to see the effect of this setting when shooting RAW, you won't see it on the LCD, or if you print directly from the camera, or if you connect the camera to a TV for image playback. Even if you shoot RAW+JPEG, you won't see the effect because the camera uses the RAW file, not the JPEG, to display and print.

O 0: [Standard]

O 1: [Low]

O 2: [Strong]O 3: [Disable]

NOTE: When set to [Strong], it decreases the number of shots that can be captured in a row

C.Fn-6 Highlight Tone Priority: This is one of the Rebel T2i's more interesting custom functions. Enable this option to expand dynamic range near the bright area of the tone curve. If you are shooting scenes filled with white objects, like bridal gowns or snowy landscapes, this custom function will help maintain details in those bright areas. When enabled, the available ISO speed range is limited to 200 – 6400. Also, you may see more noise in the dark areas of the image when using this custom function.

O 0: [Disable]

O 1: [Enable]

NOTE: When the T2i has highlight tone priority enabled, D+ will be displayed in the viewfinder and on the LCD monitor.

C.FN III: AUTOFOCUS / DRIVE

This group contains two unrelated functions, one dealing with flash and one with the T2i's mirror. I probably change the mirror lockup custom function more than any other custom function in order to achieve sharp images at slow shutter speeds.

C.Fn-7 AF-Assist Beam Firing: The AF-assist beam is controlled through this custom function. When autofocus is used in low-light situations, the T2i uses the built-in flash and some Canon Speedlites as an AF-assist beam, firing a series of rapid, low-powered flash bursts. Some Canon Speedlites (i.e., the 580EX II) use an infrared (IR) AF-assist beam instead.

> While the AF system is a remarkable piece of technology, it can't see in the dark. If the flash is in the up position, it will be used to help set focus unless you disable this function here.

- O: [Enable]: (Default) The AF-assist beam is emitted whenever the camera deems it necessary.
- O 1: [Disable]: The camera will not emit the AF-assist beam.
- O 2: [Enable external flash only]: In low light, an accessory Canon EX flash unit fires its AF-assist beam. The built-in flash's AF-assist feature is disabled.
- O 3: [IR AF assist beam only]: In low light, an accessory Canon EX flash unit that has an IR AF-assist beam fires its beam. This is useful when you don't want even a low-power flash to distract your subject. The built-in flash AF-assist will not function.

C.Fn-8 Mirror Lockup: This custom function is used for enabling the T2i's mirror lockup feature. Mirror lockup is used to minimize camera shake during long exposures.

- O 0: [Disable]: (Default) The mirror functions normally.
- O 1: [Enable]: The mirror moves up and locks in position with the first full press of the shutter button. With the second full pressing of the shutter button, the camera takes the picture. After the exposure is made, the mirror returns to its original position.

If you are using slow shutter speeds (and have the T2i mounted on a tripod) mirror lockup will minimize camera vibration.

NOTE: After 30 seconds, the **[Enable]** mirror lockup setting automatically cancels.

Normally, the camera's reflex mirror opens to get out of the way of the shutter right before the beginning of each exposure, which causes a small amount of movement movement that you do not want if you're going to take a long exposure. Mirror lockup allows you to lift the mirror well before the exposure begins, so the camera can be completely still by the time the shutter opens.

C.FN IV: OPERATION / OTHERS

This group really is partially about programming (or reprogramming) some of the buttons on the T2i. It also contains controls for setting the default mode of the LCD display and provides functionality for forensic photography applications.

C.Fn-9 Shutter/AE Lock Button: Unfortunately, this is probably the most confusing custom function, but it is still extremely useful. The easiest way to understand what the display is telling you is to think of the setting in two parts. The part before the slash is what the shutter button does; the section after the slash is what the \bigstar button does. This powerful function really allows you to separate the autofocus function from the autoexposure function instead of initiating them both by pressing the shutter button. If you regularly shoot in situations that require you to have quick and accurate focus, experiment with the non-default options.

> For more and separate control of exposure and focus, use option 1. That way, you can use your thumb on the * button to control focus and your index finger on the shutter to lock exposure.

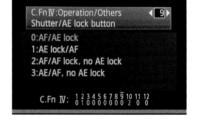

- O 0: [AF/AE lock]: (Default) When you press the shutter button down halfway, the T2i starts the autofocus process. Press * to lock exposure.
- 1: [AE lock/AF]: The functions of the shutter release button and the AE lock * button are reversed; the shutter button controls exposure lock, and * starts autofocus.
- O 2: [AF/AF lock, no AE lock]: The shutter button starts autofocus but, when in AI SERVO mode, you can use *\footnote{\tau}\) to momentarily stop autofocus in case something passes in front of the camera. Exposure is not locked until the picture is taken.
- O 3: [AE/AF, no AE lock]: The shutter button sets exposure but doesn't lock it until the picture is taken; * lets you start and stop autofocus in AI SERVO.

C.Fn-10 Assign **SET** Button: Somewhat surprisingly, the **SET** button really doesn't have a function on its own. You first need to access a menu or press a button before you need or can use **SET**. Rather than let it go to waste, you can use this custom function to give the **SET** button a little more of an active role.

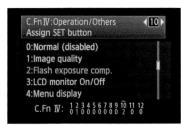

If you find it hard to find the ISO button while looking through the viewfinder, change the SET button so that it accesses ISO. Otherwise, if you shoot with flash, set it to bring up flash exposure compensation.

- O 0: [Normal]: (Default) The SET button is used to accept settings.
- O 1: [Image quality]: The SET button provides quick access to file recording size and quality.
- O 2: [Flash exposure compensation]: The SET button accesses the flash exposure compensation 22 setting. The key to good flash photography is accessing flash exposure compensation. By dialing down the output of the flash, you reduce the "mugshot" look of many flash photographs. Unfortunately, 22 is buried in a submenu of a submenu. In fact, at a minimum, you need 5 button presses to access the setting—not counting pressing MENU first. This custom function allows flash exposure compensation to be a single button press away.
- O 3: [LCD monitor On/Off]: The SET button acts like the DISP. button.
- O 4: [Menu display]: The SET button operates like the MENU button.
- ${\tt O}$ 5: [ISO speed]: The SET button functions like the ISO button.

C.Fn-11 LCD Display When Power ON: The LCD on the T2i is high resolution and very bright, and there might be situations when you don't want the bright display to come on when using the camera.

To conserve battery power, set this item to [Previous display status]. That way, when you turn the camera on, the display will only come on if you had it on the last time you were using the camera.

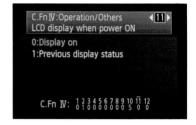

- O 0: [Display on]: (Default) The LCD monitor will always display the shooting settings screen when you first power up the camera.
- O 1: [Previous display status]: If you used the DISP. button to turn off the LCD monitor, the monitor will remain off next time you power up the camera.

C.Fn-12 Add Image Verification Data: This function is used with the Original Data Security Kit OSK-E3, an optional Canon-designed software package. This software provides the necessary authentication of image data needed for use in forensic and other specialized applications.

- O 0: [Disable]: (Default) The captured image is not embedded with any verification data.
- O 1: [Enable]: The image is embedded with verification data.

> Use image verification data if, for documentation or other purposes, it is important to show that an image has not been altered. © Kevin Kopp

Shooting and Drive Modes

SHOOTING MODES

The Rebel T2i offers 14 shooting modes, ranging from completely automatic to entirely manual. The shooting modes are divided into three areas: the Basic Zone, the Creative Zone, and a movie mode that stands alone at the end of the mode dial. The Basic Zone modes allow the camera to be matched quickly to various conditions and subjects. Fast and easy to manage, the Basic Zone modes let the camera predetermine a number of settings. The Creative Zone modes, as the name suggests, allow for complete creative control of the T2i. Lastly, the remaining mode is for movie shooting. In this mode, the T2i can record both high definition and standard definition video.

All shooting modes are selected by using the mode dial, located on top of the camera's right shoulder. Simply rotate the dial to the icon you wish to use. The Basic Zone includes full auto , creative auto , flash off . portrait , landscape , close-up , sports , and night portrait . The five Creative Zone shooting modes are program autoexposure (AE) P, aperture-priority AE AV, shutter-priority AE TV, manual exposure M, and automatic depth of field A-DEP. These are more advanced modes in that you, not the camera, must manage more of the camera settings to achieve the photographic results you're looking for. For most of these settings, the camera only pays attention to the exposure settings—specifically shutter speed, aperture, and sometimes ISO sensitivity. You have to do the rest.

BASIC ZONE SHOOTING MODES

□ Full Auto: Turn your mode dial to the green rectangle for completely automatic shooting. This mode essentially converts the Rebel T2i into a very sophisticated point-and-shoot. The camera chooses everything; you cannot adjust any controls except the file size/format (image quality) and the self-timers. This shooting mode is designed for photographers who aren't familiar with D-SLRs. In □, the Picture Style is set to standard ③⑤, for crisp, vivid images; the white balance is set for ❷⑥; ISO speed is auto, and focus is set for Al FOCUS. The built-in flash pops up automatically and fires if needed.

Green means go! When you first start using your T2i, this fully automatic mode gets you using your camera quickly. Once you have learned the other modes, you might still want to use auto at times, such as when you hand the camera to someone else to take a picture.

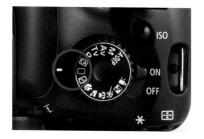

NOTE: Keep in mind that manual focus can be engaged on the lens if you wish to override the focus setting in any shooting mode, including \square .

⚠ Creative Auto: This mode is similar to □, but offers the opportunity to make more adjustments. Press the Quick Control button ② to display the Quick Control screen, then scroll using ❖ to turn the flash on or off, adjust background, exposure, Picture Style, file size/format, or drive mode.

This is a relatively new exposure mode for those who haven't learned all about the other exposure modes, but still want to take some control of their camera.

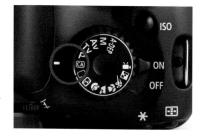

The background and exposure control settings are unique to . Using the background control is another way of adjusting depth of field. Instead of having to worry about which aperture or shutter speed to use, press . and use . as a joystick to navigate to the desired background adjustment. Use the slider to choose whether the background in your image will be blurrier or sharper. A blurry background can be useful when shooting portraits of people standing in front of a busy background. And if you set the background adjustment towards the sharp end, the T2i picks an appropriate aperture (f/stop) to increase depth of field so that a greater part of your photo is in focus.

The exposure control setting is accessed in the same manner as the background control and operates the same way as exposure compensation. The center position on the range represents zero exposure compensation, while the two positions to the right represent overexposure adjustments of +2/3 and +1 1/3 stops, respectively. The two positions to the left indicate underexposure of -2/3 and -1 1/3 stops.

The Picture Style settings that are available in (A) are limited, but there are some options. You can select from standard (A), portrait (A), landscape (A), and monochrome (A). Unlike in the Creative Zone modes, the fully-automatic (A) and (A) shooting modes do not permit you to make adjustments to the Picture Style parameters. In fact, if you make Picture Style adjustments before you enter (A) mode, they will be reset to their default values until you are back in the Creative Zone. (See pages 52-62 for more on Picture Styles.)

There is also some limitation on drive modes when in but for the most part you have access to much more than when the camera is in . The following drive modes are available in single shooting , continuous shooting , self-timer/remote control , and continuous self-timer . The only thing that is missing is the 2-second self-timer.

Flash Off: This shooting mode prevents the flash from firing. It operates the same as , except that the flash will never fire. In fact, you can't even pop up the flash using the \$ button—pressing the button will simply display a message saying, "This function is not selectable in the current shooting mode." If the flash is popped up before you enter mode, it won't fire. This is the mode to use when museums and other sensitive locations do not allow flash photography.

- Portrait: If you like to shoot portraits, this setting is for you. It makes adjustment choices that favor people photography. The drive mode is set to continuous so you can quickly shoot changing gestures and expressions, but you can also change it to so of you want to jump into the picture. AF mode is set to ONE SHOT so you can lock focus with a slight pressing of the shutter release. The meter favors wider f/stops (those with smaller f/numbers) because this limits depth of field, offering backgrounds that are softer, contrasting with the sharper focus of the subject. A wider f/stop also results in faster shutter speeds, producing sharper handheld images. The Picture Style is set to portrait for softer skin tones (see page 57 for more about the portrait Picture Style). The flash will fire if needed.
- Landscape: When shooting landscape photography, it is important to lock focus one shot at a time, so the T2i's landscape mode uses ONE SHOT AF and drive mode (though you can also select &c or &\ \varphi\). The meter favors small f/stops (higher f/numbers like f/8 or f/11) for more depth of field, which is often important for scenic shots. The Picture Style is set to landscape \(\varphi\) for vivid greens and blues, and the flash will not pop up automatically, nor can it be popped up manually in this mode. If the flash is already up when you enter \(\varphi\) mode, it still will not fire.
- Close-Up: This mode also uses **ONE SHOT** AF and □ drive mode (but is and so are also selectable). It favors wider f/stops for faster shutter speeds, giving better sharpness with a handheld camera and far less depth of field in order to set off a sharp subject against a softer background. The Picture Style is set to standard standard far less fires if needed.
- ★ Sports: Designed for action and fast shutter speeds to stop the motion of your subject, sports mode uses AI SERVO AF and ☐ drive mode (but you can change drive mode to ⑤c or Ĩ⑤), both of which allow continuous shooting as action unfolds in front of you. In addition, the beep for AF confirmation is softer than other modes. The Picture Style is (standard), and the flash will not pop up, nor will it fire if it is already in the up position.

Close-up mode gives you sharp pictures by using fast shutter speeds. The fast shutter speeds force a larger aperture, which narrows your depth of field and makes your background go out of focus.

Night Portrait: Despite its name, this setting is not limited to nighttime use. It is very useful, even for advanced photographers, to balance flash with low-light conditions. This mode uses flash to illuminate the subject (which may or may not be for a portrait) and selects exposure settings (shutter speed, ISO, and aperture) to balance the background and capture detail. The exposure settings allow what is called an ambient-light exposure (an exposure of the parts of the scene not illuminated by the flash). A good capture of detail in low-light conditions can require a very slow shutter speed and may result in a blurry background, so you may need a tripod if that is not the effect you are going for. The flash will always pop up and fire in this mode. The Picture Style is (standard). Like most of the Basic Zone modes, night portrait mode defaults to □ drive mode, but can be switched to □ or ⊗c.

CREATIVE ZONE SHOOTING MODES

The appropriately named Creative Zone modes offer you more control over camera adjustments, thus encouraging a more creative approach to photography. In each mode other than manual exposure, the camera only controls aspects of the exposure equation, but settings such as white balance, file type (RAW or JPEG), metering method, focus method, Picture Style, ISO, and drive mode are set manually. Control is usually a good thing, but so many possible adjustments can be confusing and time consuming. However, once you become familiar with the T2i, you will probably want to use the Creative Zone shooting modes most of the time.

P Program AE: In P mode, the camera chooses the shutter speed and aperture combination. This gives the photographer less direct control over the image because the settings are chosen by the camera. However, you can employ a technique known as program shift to alter the automatically selected settings, changing either the selected aperture or shutter speed, and the T2i will compensate the corresponding value to maintain the same exposure value. To shift the program, simply press the shutter button halfway to turn on the camera's built-in light meter, then turn until the desired shutter speed or aperture value is displayed on the LCD monitor or viewfinder.

NOTE: Program shift is not the same as exposure compensation, which actually changes the exposure value by under- or overexposing the scene in relationship to the camera's determination of the "correct" exposure. In contrast, program shift maintains the same exposure value by adjusting the shutter speed or aperture to match the value you have assigned.

NOTE: Program shift only works for one exposure at a time, making it useful for quick-and-easy shooting while providing some control over settings.

The flash will not pop up automatically in **P** mode when light levels are low. You must manually activate the flash by pressing the **5** button on the front of the camera above the lens release button. Also, when any flash is on (be it the built-in flash or an external flash unit), you cannot use the program shift technique.

P selects shutter speed and aperture values steplessly. This means that any shutter speed or aperture within the range of the camera and lens is selected, not just those that are the standard full steps. This has commonly been the case with most SLRs (both film and digital) for many years, and allows for extremely precise exposure accuracy thanks to the lens' electromagnetically controlled diaphragm and the camera's electronically timed shutter.

Tv Shutter-Priority AE: Tv stands for "time value." In this mode, you set the shutter speed using and the camera sets the aperture. If you want a particular shutter speed for artistic reasons—perhaps a high speed to stop action, or a slow speed for a blur effect—this is the mode to use, because even if the light varies, the shutter speed does not. The camera keeps up with changing light by adjusting the aperture automatically.

If the aperture indicated in the viewfinder or the LCD monitor is constantly lit (not blinking), the T2i has picked a useable aperture. If the maximum aperture (lowest number) blinks, it means the photo will be underexposed. Select a slower shutter speed by turning a until the aperture indicator stops blinking. You can also remedy this by increasing the ISO setting. If the minimum aperture (highest number) blinks, this indicates overexposure. In this case, you should set a faster shutter speed until the blinking stops, or choose a lower ISO setting.

The Rebel T2i offers a choice of speeds, from 30 seconds up to 1/4000 second, in 1/3-stop increments. (You may also elect to use 1/2-stop increments via C.Fn-1 [Exposure level increments]—see page 118.) For flash exposures, the camera syncs at 1/200 second or slower (which is important to know, since slower shutter speeds can be used to record the ambient or existing light in a dimly-lit scene).

Let's examine these shutter speeds by designating them as "fast," "moderate," or "slow." These divisions are somewhat subjective, so speeds at either end of a division can really be assigned to the groups on either side of it. I consider fast shutter speeds to be between 1/500 – 1/4000 second. It wasn't all that long ago that most film cameras could only reach 1/1000 second, so having this range of high speeds on a D-SLR is quite remarkable. The obvious reason to choose a fast shutter speed is to stop action. The more the action increases in pace, or the closer it crosses directly in front of you, the higher the speed you will need to freeze it. As mentioned previously, the neat thing about digital cameras is that

you can check your results immediately on the LCD monitor to see if the shutter speed has, in fact, stopped the action.

At these fast speeds, camera movement during exposure is rarely significant unless you try to handhold a super telephoto lens of 600mm (not recommended!). This means, with proper handholding technique, you can shoot using most normal focal lengths (from wide-angle to telephoto) up to about 300mm without blur resulting from camera movement. Besides stopping action, high shutter speeds also allow you to use your lens at its widest opening (such as f/2.8 or f/4) for selective focus effects (i.e., shallow depth of field). This is a useful technique. In bright sun, for example, you might have an exposure of 1/200 second at f/16 with an ISO setting of 200. You can get to f/2.8 by increasing your speed by five whole steps of exposure, to approximately 1/4000 second.

HINT: With exposure settings, there is a balance between shutter speed and aperture. In Tv, the camera takes care of aperture, according to how you set shutter speed. Try this yourself. Go outside and use to set the shutter speed to 1/200. Now, look in the viewfinder, ignore the shutter speed, and just watch the aperture. Keep changing the shutter speed by rotating until the aperture is at the widest setting that the lens will allow. Now look and see how short the shutter speed has become.

Moderate shutter speeds (from 1/60-1/250 second or so) work for most subjects and allow a reasonable range of f/stops to be used. They are the real workhorse shutter speeds, and they really do the job nicely... as long as there isn't any fast action. You have to be careful, though, when handholding cameras at the lower end of this range—especially with telephoto lenses—or you may notice blur in your pictures from camera movement during the exposure. Many photographers find that they cannot handhold a camera with moderate focal lengths (50-150mm) at shutter speeds less than 1/125 second without some degradation of the image due to camera movement. You can double-check your technique by taking a photograph of a scene while handholding the camera and then comparing it to the same scene shot using a tripod. Be sure to magnify the image to check for image blur caused by camera motion. (Even better, check it on the computer.)

NOTE: Lenses with image stabilization (Canon lenses with this feature are labeled IS) can help you shoot handheld with slower shutter speeds, but they may only give you an extra stop of exposure flexibility.

^ These two images have the same overall exposure. This one uses a fast shutter speed, which freezes the motion of the water. Because of the fast shutter speed, a large aperture (bigger opening) is needed. A large aperture means narrow depth of field. Notice the out-of-focus leaves in the foreground.

In this image, the shutter speed is slower and the aperture is smaller. With the slower shutter speed, the water becomes blurred. But, notice the increased depth of field: the foreground leaves are sharp.

Slow shutter speeds (1/60 second or slower) require something to stabilize the camera. Some photographers may discover they can handhold a camera and shoot relatively sharp images at the high end of this range, but most cannot get optimal sharpness from their lenses at these speeds without a tripod or another stabilizing mount. Slow shutter speeds are used mainly for low-light conditions, and to allow the use of smaller f/stops (higher f/numbers) for increasing depth of field.

A fun use of slow shutter speeds, such as in the 1/2 - 1/8 second range, is to photograph movement, such as a waterfall or runners, or to move the camera during exposure, panning it across a scene. The effects can be unpredictable, but again, image review using the LCD monitor helps. You can try different shutter speeds and see what your images look like. This is helpful when you try to choose the best shutter speed for the subject because each speed blurs action differently.

You can set slow shutter speeds up to 30 seconds for special purposes, such as capturing fireworks or moonlit landscapes. Canon has engineered the sensor and its circuits to minimize noise (a common problem of long exposures with digital cameras) and the Rebel T2i offers remarkable results with these exposures. C.Fn-4 [Long exposure noise reduction] can be used to reduce noise even more (see pages 119-120).

In contrast to long exposures using film, long digital exposures are not susceptible to reciprocity—the condition in which, in film exposures beyond approximately one second (depending on the film), the sensitivity of the film declines, resulting in the need to increase exposure to compensate. A metered 30-second film exposure might actually require double or triple that time to achieve the desired effect. Digital cameras do not have this problem. A metered exposure of 30 seconds will perform at exactly the exposure and sensitivity settings you entered into the T2i.

Av Aperture-Priority: In **Av** (aperture value) mode, you set the aperture (the opening in the lens, measured in f/stops) and the camera selects the appropriate shutter speed for a proper exposure. This is probably the most popular automatic exposure setting among professional photographers. One of the most common reasons to use **Av** mode is to control depth of field (the distance in front of and behind a specific plane of focus that is acceptably sharp). While the f/stop, or aperture, affects the amount of light entering the camera, it also has a direct effect

on depth of field. The three variables that affect depth of field are lens aperture, focal length, and focused distance.

A small lens opening (higher f/number), such as f/11 or f/16, increases the range of acceptable sharpness in the photograph. Hence, higher f/numbers are great for landscape photography. A large lens opening, such as f/2.8 or f/4, decreases the depth of field. These lower f/numbers work well when you want to take a photo of a sharp subject that creates a contrast with a soft, out-of-focus background.

A Aperture-priority is a great mode for controlling depth of field. When you want to separate your subject by making the background go out of focus, use a large aperture.

Jessica Anne Baum

If the shutter speed blinks in the viewfinder (or on the LCD monitor), it means the shutter speed the camera wants to use is not available. In other words, good exposure is not possible at the selected aperture, so determine whether you need to change the aperture to let in less light (select a higher f/number) or more light (select a lower f/number). You can also choose to increase or decrease the ISO to change the sensitivity of the T2i to the light.

You can see the effect of the aperture setting on the depth of field by pushing the camera's depth-of-field preview button, located on front of the camera below the lens release button. This stops the lens down to the taking aperture and reveals sharpness in the resulting darkened viewfinder. Using depth-of-field preview takes some practice due to the darkened viewfinder, but changes in focus can be seen if you look hard enough. You can also check focus in the LCD monitor after the shot (magnifying as needed).

NOTE: When you press the depth-of-field preview button, you are only evaluating depth of field; don't worry about how dark things look.

It may sound counterintuitive, but a sports or wildlife photographer might choose **Av** mode in order to stop action, rather than to capture depth of field. To accomplish this, he or she selects their widest lens opening—perhaps f/2.8—to let in the maximum amount of light. The camera automatically selects the fastest shutter speed possible for the conditions. Compare this with **Tv** mode, in which you can set a fast shutter speed, but the camera still may not be able to expose correctly if the light drops and the selected shutter speed requires an aperture larger than the particular lens can provide. (The aperture value blinks in the viewfinder if this is the case.) As a result, photographers typically select **Tv** only when they have to use a specific shutter speed. Otherwise they use **Av** both for depth of field and to gain the fastest possible shutter speed for the circumstances.

NOTE: Another option is to use **Tv** and Auto ISO. For example, if you are shooting a sporting event and you discover that you need a shutter speed of 1/500, you could set that while in **Tv** and then, if the aperture is at the end of its range (largest opening that the lens allows), the Auto ISO function will kick up the camera's sensitivity, allowing you to use your selected shutter speed and still maintain a good exposure.

M Manual Exposure: In **M** mode, you set both the shutter speed (using $A \lor \square + \square$) and aperture (using $A \lor \square + \square$). This option is important for photographers who are used to working in full manual, as well as for anyone who faces certain tricky lighting situations. However, since this camera is designed to produce exceptional fully automatic exposures, I recommend that everyone try the other Creatvie Zone modes to see what they can do before assuming the need to go to full manual.

You can use the camera's exposure metering system to guide you through the manual exposure settings. The current exposure is visible on the scale at the bottom of the viewfinder information display. "Correct" exposure is at the mid-point, and you can see how much the exposure settings vary from that point by observing the scale. The scale shows up to two stops over or under the midpoint, allowing you to quickly compensate for bright or dark subjects (especially when using partial metering). If the pointer on the scale blinks, the exposure is off the scale. (Of course, you can also use a handheld meter.)

The following examples of complex metering conditions might require you to use \mathbf{M} mode:

- O Panoramic shooting: You need a consistent exposure across the multiple shots taken, and the only way to ensure that is with M. Do not adjust white balance or focus from shot to shot.
- Lighting conditions that change rapidly around a subject, such as in a theatre performance
- Close-up photography, where the subject is in one light but slight movement of the camera dramatically changes the light behind it
- O Subjects that tend to confuse light meters, like a black cat or a bride in a white wedding dress

A special feature of manual exposure is available when you get past a 30-second shutter speed: bulb. This allows you to control long exposures, leaving the shutter open as long as you keep the shutter button pressed. Let go, and the shutter closes. A dedicated remote switch, such as the Canon RS-60E3, is helpful for these long exposures. It allows you to keep the shutter open without touching the camera (which can cause movement). The remote switch attaches via the camera's remote control terminal (under the terminal cover on the left side of the camera). You can use the RC-1, RC-5, or RC-6 wireless remote switches for bulb exposures, as well.

When you use the bulb setting, the camera shows the elapsed time (in seconds) for your exposure as long as you keep the shutter release (or remote switch) depressed. Currently, digital camera technology is such that exposures beyond a few minutes may produce excessive noise. It is a good idea to use C.Fn-4 [Long exposure noise reduction] to apply added in-camera noise reduction. Remember, though, that selecting [Long exposure noise reduction] doubles the apparent exposure time, so make sure you have enough battery power to complete the shot.

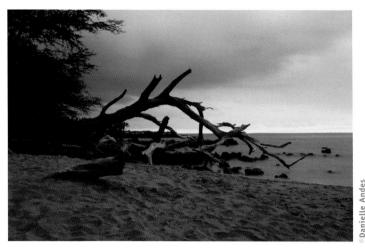

At sunset, consider using manual mode. The camera's metering system will try and average out the exposure, often with producing "average" images. You may find that over-or underexposing will give you the shot you are looking for.

A-DEP Automatic Depth-of-Field AE: This is a unique exposure mode that Canon has used on a number of EOS SLRs (both film and digital) over the years. A-DEP simplifies the selection of an f/stop to ensure maximum depth of field for a subject. The camera actually checks focus, comparing all nine AF points to determine the distance between the closest and farthest points in the scene. The camera then picks an aperture to cover that distance and employs the corresponding shutter speed. (You cannot control aperture or shutter speed in A-DEP mode.) It also sets the focus distance. If the camera cannot get an aperture to match the depth of field needed to cover the near and far points, the aperture blinks. You can check what the depth of field looks like by pressing the depth-of-field preview button.

NOTE: You must use autofocus for A-DEP to work; manual focus makes the camera act like P is set.

NOTE: A-DEP does not work with flash. If you turn on the flash, the camera again acts like P is set.

The term "drive mode" is a throwback to film days when a photographer had to advance the film after every shot. Professional photographers would add a "motor drive" to their camera so that they could take photos in rapid succession without having to manually cock the shutter and advance the film. Even though the film is gone, shutter mechanics are still needed in any D-SLR. The Rebel T2i offers several different drive modes.

To select a drive mode, press 🖳 🖏 and use 🙈 or ◀▶ to select from single shooting □, continuous shooting □, self-timer/remote control 10. 2-second self-timer 02, and continuous self-timer 0c.

NOTE: You can also set the drive mode using the Quick Control screen (see page 51).

☐ SINGLE SHOOTING

This is the standard shooting mode. One image is captured each time you press the shutter release. You'll probably use this mode most of the time. While memory cards are increasing in capacity, you still have to manage all those image files, so you might want to stay in this mode, rather than always being in continuous and taking a burst of shots each time you press the shutter button.

□ CONTINUOUS SHOOTING

When the shutter button is held down, the camera captures at a rate of 3.7 fps (frames per second) for approximately 34 consecutive JPEG images at the highest JPEG resolution and best quality. When the in-camera buffer (or the memory card) fills up, the camera stops capturing images. The T2i resumes taking pictures when the buffer has space again. When you shoot RAW images, a maximum of about six consecutive images can be captured before the buffer fills. With RAW+JPEG, the maximum is three shots.

NOTE: The speed for continuous drive modes is dependent on memory card speed, battery charge, and shutter speed.

SELF-TIMER/REMOTE CONTROL

There are actually two parts to this setting: (1) self-timer and (2) remote control. When you want to be in the picture, the 10-second self-timer is the function to use. Press the shutter button halfway and make sure you have achieved focus. Then, press the shutter release button the rest of the way down. A self-timer lamp (located on the front of the camera. built into the camera grip) flashes once per second to count down the remaining time. By default, a beep is enabled and sounds during the countdown. You can disable the beep in the (Shooting 1) menu. Two seconds before the picture is taken, the lamp lights up continuously and the camera beeps more frequently to let you know the shutter is about to be released. To cancel the countdown, press 🖳 🔊.

When you use one of Canon's optional wireless remote controls (RC-1, RC-5, or RC-6), you must set the drive mode to 10. The RC-1 and RC-6 wireless remotes offer a choice of immediate shutter release or a 2-second delay; the RC-5 always has a 2-second delay. The remotes need to be pointed toward the front of the camera to operate correctly.

32 2-SECOND SELF-TIMER

The two-second self-timer operates similarly to the ten-second timer in that it takes the picture after a set time. When you shoot with a tripod and have longer shutter speeds (1/60 and slower), use this quick timer along with C.Fn-8 [Mirror lockup] to reduce camera shake. (See pages 122-123 for more on mirror lockup.)

Sc CONTINUOUS SELF-TIMER

This drive mode is similar to the self-timer/remote control setting except that, at the end of the countdown, the camera will take several pictures. You can select from two to ten pictures to fire off after the selftimer counts down from ten seconds. This is a great mode to use when taking group shots. You might even avoid the inevitable "my eyes were closed" comments! And you might even get some fun "after" shots when everyone stops posing. If you are using flash, the camera will wait to fire until the flash charges.

NOTE: Remember that the only way to cancel the self-timer once it has started counting down is to press 🖳 🔊.

The "R" in SLR stands for the reflex mirror that reflects the light coming through the lens up and into the viewfinder. When you take a picture, the mirror quickly flips up out of the way so that the light can reach the image sensor. This flipping action is part of the noise you hear when you take a picture, and is relatively jarring to the shutter assembly and the camera.

For really critical work on a tripod, such as shooting long exposures or working with macro and super-telephoto lenses, sharpness is improved by eliminating the vibrations caused by mirror movement. This is accomplished by locking up the mirror in advance using the Rebel T2i's mirror lockup function. However, it also means the viewfinder is blacked out and the drive mode is single shooting \square .

Mirror lockup is set with C.Fn-8 (see pages 122-123). Once set, the mirror locks up when the shutter button is pressed. Press the shutter button again to make the exposure. The mirror flips back down if you don't press the shutter to make the exposure within 30 seconds.

Use a remote switch or one of the self-timer settings to avoid touching the camera, thereby keeping all movement to a minimum. With the self-timer, the shutter goes off after the timer counts down (either two or ten seconds, depending on how it's set, after the mirror is locked up), allowing vibrations to dampen. When you use one of the self-timers with bulb exposure (see page 141) and mirror lockup, you must keep the shutter depressed during the self-timer countdown, or the countdown will stop.

Focus and Exposure

The innovation, thought, and technology that have gone into the T2i are evident as soon as you begin to operate the camera's systems and utilize its many functions. From finding focus on moving subjects to capturing great exposures in low light, the Rebel T2i offers a number of options that enhance your ability to take excellent photographs.

AUTOFOCUS

The Rebel T2i uses an AI (artificial intelligence) AF (autofocus) system based on a special CMOS sensor dedicated to autofocus. The nine AF points give the camera nine distinct spots where it can measure focus. Eight points are positioned in a diamond pattern around a central ninth point. This diagonal arrangement makes for improved focus tracking of moving subjects. The center AF point is a very precise, cross-type point that works best at f/2.8. The AF points work with an EV (exposure value) range of EV –0.5 to +18 (at ISO 100), and are superimposed in the viewfinder. They can be used automatically (the camera selects them as needed), or you can choose one manually.

This camera smartly handles various functions of autofocus through the use of a high-performance microcomputer, along with improvements in AF system design. Its ability to autofocus while tracking a moving subject is quite good. According to Canon, for example, in AI SERVO AF with an EF 300mm f/2.8 IS USM lens, the Rebel T2i can focus-track a subject moving toward the camera at a speed of 31 mph (50 kph) up to about 32.8 feet (10 meters) away.

This specification doesn't just mean that the T2i can track only objects moving 31 mph (50 kph) and slower. For example, AI SERVO can track a racecar traveling at 124 mph (200 kph) until it is about 65.6 feet (20 m) from the camera. The T2i does this by employing statistical prediction while using multiple focusing operations to follow an erratically moving subject. Even if the subject is not moving, the AI SERVO control is notably stable—it will not allow the lens to change focus until the subject moves again.

When light levels are low, the camera activates AF-assist with the built-in flash and produces a series of quick flashes to help autofocus. (External dedicated flashes can also do this. See C.Fn-7 on page xxx.) The range is up to approximately 13.1 feet (4 m) in the center of the frame, and 11.5 feet (3.5 m) at the other AF points. The 580EX II Speedlite includes a more powerful AF-assist beam, effective up to 32.8 feet (10 m).

AF MODES

The camera has three AF modes: **ONE SHOT**, **AI SERVO**, and **AI FOCUS**. With the exception of the Basic Zone shooting modes where the AF mode is set automatically, you can choose among all three settings. They are accessed by pressing **AF**, which displays the AF mode menu on the LCD monitor. Use or **♦** to select the mode you want. Once selected, press **SET** to accept the selection. The selected AF mode is indicated on the camera settings display on the LCD monitor.

> Use the AF cross key to quickly access the AF mode menu.

NOTE: You can also set the AF mode using the Quick Control screen (pages 50-51).

ONE SHOT: This is perfect for recording stationary subjects. It finds and locks focus on the important part of a subject when you aim and press the shutter button halfway. After the T2i achieves focus, the camera beeps and the viewfinder briefly shows the AF point or points that were used for the task. The focus confirmation light glows steadily in the viewfinder when you have locked focus. It blinks when the camera can't achieve focus. Since this camera focuses very quickly, a blinking light is a reminder that you need to change something (you may need to focus manually).

If the camera doesn't focus on the right spot, simply change the framing slightly and press the shutter button halfway again to lock focus. Once you have found and locked focus, you can move the camera to set the proper composition.

Al SERVO: Great for action photography where subjects are in motion, Al SERVO becomes active when you press the shutter button halfway, but it does not lock focus. It continually looks for the best focus as you move the camera or as the subject travels through the frame. Focus and exposure are set only at the moment the shutter opens. This can be a problem when it is used for motionless subjects, because the focus continually changes, especially if you are handholding the camera. However, if you use Al SERVO on a moving subject, it is a good idea to start the camera focusing (depress the shutter button halfway) before you actually need to take the shot, so the system can find the subject.

< You can access the AF setting either via the cross keys or from the Quick Control screen.

If the camera is set for automatic AF point selection (see page 150), then AI SERVO will first use the center AF point for focus. Once the subject moves away from the center, the focus system will track the subject as long as it can be covered by one of the eight other focus points.

NOTE: Since the camera is continually adjusting focus, it will not beep nor will the focus confirmation indicator light up.

ALFOCUS: This mode allows the camera to choose between ONE SHOT and AI SERVO. It can be used as the standard setting for the camera because it switches automatically from ONE SHOT to AI SERVO if your subject should start to move. Note, however, that if the subject is still (like a landscape), this mode might detect other movement (such as a blowing tree), so it may not lock on the non-moving subject.

NOTE: Focus during live view shooting and movie shooting is handled differently. See pages 171-177.

SELECTING AN AF POINT

You can let the T2i select the AF point automatically, or you can manually select a desired point. Manual AF point selection is useful when you have a specific composition in mind and the camera won't focus consistently on the desired area. To manually select an AF point, simply push the 🖭 button (on the back of the camera in the upper right corner; it is also $\ensuremath{\mathfrak{Q}}$ during playback), and use 🖎 or 💠 to make the selection. Points light up in the viewfinder and on the LCD monitor as they are selected. If all points are lit, the camera automatically makes the AF point selection. You can press SET to jump directly to the center AF point. Once there you can use SET to toggle between the center AF point and automatic selection.

Turning rotates through all of the points and is not as direct as selecting points with . However, some photographers find the dial is easier to use while looking through the viewfinder. You can return to shooting mode at any time during AF point selection by either pressing the shutter halfway or pressing . You do not need to press **SET** to have the camera accept your selection.

AUTOFOCUS LIMITATIONS

With its impressive AF sensitivity, the T2i is able to autofocus in conditions that are quite challenging for other cameras. Still, as the maximum aperture of lenses decreases, or tele-extenders are used, the

Autofocus works best when it can detect high contrast edges in your scene. Even so, you will still have to decide which part of your image you want to be in focus. Choose the right AF point to assure sharp images.

©Kevin Kopp

camera's AF capabilities change. AF works best with lenses that have wide maximum apertures (f/2.8 or wider). This is normal, and not a problem with the camera.

It is possible for autofocus to fail in certain situations, requiring you to focus manually. This is most common when the scene is lowcontrast or has a continuous tone (such as sky), in conditions of extreme low light, with subjects that are strongly backlit, and with compositions that contain repetitive patterns. A quick way to deal with these situations is to focus on something else at the same distance, lock focus on it (keep the shutter button pressed halfway), then move the framing back to the original composition. This only works while the camera is in ONE SHOT mode.

It is always preferable to have the best possible exposure when recording your digital images. A properly exposed digital file is one in which the right amount of light has reached the camera's sensor and produces an image that corresponds to the scene, or to the photographer's interpretation of the scene. This applies to color reproduction, as well as tonal values and subject contrast.

ISO

ISO (sensitivity) is one control worth knowing so well that its use becomes intuitive. The first step in getting the best exposure is to provide the camera's meter with information on how it should respond to light. The meter can then determine how much exposure is required to properly record the image. Digital cameras adjust the sensitivity of the sensor's circuits to settings that can be compared to film ISO speeds. (This apparent change in sensitivity actually involves amplifying the electronic sensor data that creates the images.)

The Rebel T2i offers ISO speed settings of 100 – 6400. This range can be expanded from 100 up to 12800 by using C.Fn-2 (see page 118). When the ISO range is expanded, the 12800 ISO speed is represented by the letter "H." The H setting is not a free ride, however, as additional noise is present in the image. (To counteract this, extra noise reduction can be applied by using C.Fn-5, see page 121.)

The full ISO range (expanded or not) is only available in program P, shutter-priority Tv, aperture-priority Av, manual M, and automatic depth-of-field A-DEP shooting modes. In most Basic Zone modes, ISO is set automatically from 100 – 3200, and you cannot override it. In \S , ISO is fixed at 100. There is also an auto ISO setting that lets the T2i select which ISO setting to use (see below).

Setting the ISO: To set the ISO speed, use the ISO button located on the top right shoulder of the camera behind 🙈. The ISO speed menu displays on the LCD monitor and in the viewfinder. Use △ or ◆ to choose the sensitivity that you want, and confirm by pressing **SET**, ISO, or the shutter button. The selected ISO setting appears on the camera settings display on the LCD monitor.

< The ISO button is conveniently placed right near the shutter button so that you can adjust ISO speed without taking your eye away from the viewfinder.

By default, the ISO settings occur in 1/3-stop increments (100, 125, 160, 200 etc.). Most of the time you will want to choose among several key ISO settings: 100 to capture detail in images of nature, landscape, and architecture; 400 when more speed is needed, such as handholding for portraits when shooting with a long lens; 800 and 1600 when you really need the extra speed under low-light conditions.

Auto ISO: You can also let the T2i select the ISO. One of the options in the ISO menu is **[AUTO]**. When selected, the camera chooses an ISO from 100 to 6400. When you use bulb, the ISO is set to 400. When you use flash, auto ISO uses 400 unless the T2i determines there will be overexposure, and then a lower ISO is selected. With a Speedlite set for bounce, the ISO is set in the range of 400-1600.

Auto ISO can be used in combination with aperture-priority \mathbf{Av} and shutter-priority \mathbf{Tv} autoexposure modes to give you enhanced control of exposure settings. For example, if you want to shoot with a high shutter speed, set the mode to \mathbf{Av} , open the aperture to its widest setting, and turn on auto ISO. The T2i will set both shutter speed and ISO speed, with emphasis on high shutter speed.

ISO speed can be set quickly from shot to shot in the P, Tv, Av, M, and A-DEP shooting modes. Since sensitivity to light is easily adjusted using a D-SLR, and since the Rebel T2i offers clean images with minimal noise at any standard setting, ISO is a control you can use freely to rapidly adapt to changing light conditions.

Low ISO settings give the least amount of noise and the best color, while high ISO settings can lead to noise in your pictures. Traditionally, film would increase in grain and decrease in sharpness with increased ISO. This is not entirely true with the Rebel T2i because its image is extremely clean. Noise is virtually nonexistent at ISO settings of less than 800. Some increase in noise may be noticed as settings of 800

You can use high ISO speeds when shooting at dawn and dusk. The T2i will use the DIGIC 4 image processing chip to reduce the noise that occurs at high ISO speeds.

or 1600 are used, but there will be little change in sharpness. (Check the image on a computer to see if the noise is acceptable.) If you use speeds beyond 1600, the noise level in the image can increase, but it may be the only way to get the shot.

You can also set the ISO speed using the Quick Control screen. Press
② and use ❖ to highlight the current ISO setting. Then use △ to scroll through the ISO options, or press SET to bring up the ISO options and then use △ or ► to make your selection. Next, tap the shutter release or press SET to exit.

NOTE: If you use highlight tone priority (C.Fn-6, see page 121) to expand the dynamic range of the T2i, the ISO range is 200 – 6400 and D+ shows up next to the ISO number in the settings display.

Maximum Auto ISO: In \square :, the [ISO Auto] option allows you to limit the maximum ISO speed. This is useful if you still want to use auto ISO but object to the amount of noise present at the higher ISO speeds. The maximum ISO speed allowed ranges from 400 to 6400.

The T2i uses Canon's new iFCL (intelligent Focus Color Luminance) system. This new technology works in conjunction with the 9-point AF system to produce well-exposed images even in difficult lighting situations. The 63-zone iFCL sensor is made up of two layers, one that is sensitive to blue and green light, the other that is sensitive to red and green light. The two layers are compared to minimize errors due to color. Together, they evaluate the color and luminosity (brightness) of light surrounding the active AF point. In addition, the AF points transmit distance information to the metering system to help achieve accurate exposures.

The metering mode is changed in \square : Highlight [Metering mode] and press SET. Use \blacktriangleleft to select the mode you want; once selected, press SET. The symbol or icon for the type of metering in use appears in the camera settings display on the LCD monitor. The camera offers four user-selectable methods for measuring light (metering modes):

- o (inked to any desired AF point)
- o 🖸 partial
- o ⊡ spot
- o □ center-weighted average

NOTE: Use the Quick Control screen for a faster method of setting the metering mode. With the shooting settings displayed on the LCD monitor, press ② and use ❖ to highlight the current metering method. Then use to scroll through the metering options, or you can press SET to bring up the metering mode screen and then use or ■ to make your selection. Tap the shutter release or press SET to exit.

② Evaluative Metering: The Rebel T2i's evaluative metering system divides the image area into 63 zones, "intelligently" compares them in conjunction with the AF system, and then uses advanced algorithms to determine exposure. The zones come from a grid of carefully designed metering areas that cover the frame and complement the nine AF points. Basically, the system evaluates and compares all of the metering zones across the image, noting things like the subject's position in the viewfinder (based on focus points and contrast), brightness of the subject compared to the rest of the image, backlighting, and much more.

As mentioned above, the Rebel T2i's evaluative metering system is linked to autofocus. The camera actually notes which autofocus point is active and emphasizes the corresponding metering zones in its evaluation of the overall exposure. If the system detects a significant difference between the main point of focus and the different areas that surround this point, the camera automatically applies exposure compensation. (It assumes the scene includes a backlit or spot-lit subject.) However, if the area around the focus point is very bright or dark, the metering can be thrown off and the camera may underexpose or overexpose the image. When your lens is set to manual focus, evaluative metering uses the center autofocus point.

NOTE: With $\[eta \]$, after autofocus has been achieved, exposure values are locked as long as the shutter button is partially depressed. However, meter readings cannot be locked in this manner if the lens is set for manual focus. In this case, use the AE lock button $\[\star \]$ to lock exposure (see pages 158-159). It is located on the back of the camera toward the upper right corner.

It is difficult to capture perfect exposures when shooting subjects that are extremely dark or light, that are backlit, or that have unusual reflectance. Because the meter theoretically bases its analysis of light on an average gray scene, it tends to overexpose or underexpose when subjects or the scene differ greatly from that average. Luckily, you can check exposure information in the viewfinder, or check the image itself—and its histogram—on the LCD monitor, and make adjustments as needed.

The main advantage of evaluative metering over the other methods is that the exposure is biased toward the active AF point, rather than the center of the picture. Plus, ③ is the only metering mode that automatically applies exposure compensation based on comparative analysis of the scene.

~ While this appears to be a simple metering situation, the large dark horse could cause the rest of the image, particularly the fence, to be overexposed. Try using evaluative metering for scenes like this, so that the camera will consider the whole scene when choosing an exposure value.

© Spot Metering: Use this mode to further reduce the area covered for metering. The metering is weighted to the center area (about 4%) of the viewfinder. This can give you an extremely accurate meter reading of a single object in your scene. This "spot" is indicated by the circle in the viewfinder.

NOTE: Just because only measures the center of the frame, it doesn't mean your subject has to stay in the center. Use * to lock exposure and then reframe.

Conter-Weighted Average Metering: This method averages the readings taken across the entire scene. In computing the average exposure, however, the camera puts extra emphasis on the reading taken from the center of the horizontal frame. It can be very useful with quickly changing scenes that have an important central subject, such as an outdoor portrait.

HINT: The Rebel T2i's metering system is sensitive to light coming through an open eyepiece. If you shoot a long exposure on a tripod and do not have your eye to the eyepiece, there is a good possibility that your photo will be underexposed. To prevent this, Canon has included an eyepiece cover on the camera strap. It can be slipped over the viewfinder to block the opening in these conditions. It is necessary to remove the rubber eyecup on the viewfinder to attach the cover. This does not apply in live view shooting because the metering occurs from the sensor, not the prism.

* AE LOCK

AE lock is a useful tool for the P, Tv, Av, and A-DEP shooting modes. Under normal operation, the camera continually updates exposure as you move it across the scene or as the subject moves. This can be a problem if there is strong light in the scene that may cause the camera meter to underexpose the shot. For example, if you want to take a photo of a person standing next to a bright window, the meter will overcompensate for the window light, causing the person to be underexposed. In this case, point the camera at the subject, so the window is not in the frame, press X, then reframe the shot so both the person and window are in it. (If you have a zoom lens mounted, you could zoom in to a particular area of the scene, as well.)

AE lock on the Rebel T2i is similar to that used for most EOS cameras. The \bigstar button is located on the back of the camera to the upper right, easily accessed with your thumb. Aim the camera where needed for the proper exposure, then push \bigstar . The exposure is locked or secured, and it won't change, even if you move the camera. \bigstar appears in the viewfinder on the left of the information display until the lock is released.

The exposure stays locked until you take a picture or the camera's metering system shuts down (which takes about four seconds). You can tell that the metering system has shut down when the information display turns off in the viewfinder. If you want to keep the exposure locked longer—even through multiple shots—press and hold \bigstar . The meter stays on and the exposure stays locked until about four seconds after you let go.

C Proper exposure is required to keep the colors in your image. Overexposure leads to washedout color. AE lock and spot metering was used here because the range of exposure just on the flower petals varies dramatically from left to right. The existence of exposure compensation, along with the ability to review images in the LCD monitor, means you can quickly override exposures without using the M shooting mode. Exposure compensation cannot be used in M mode; however, it makes P, Tv, Av, and A-DEP shooting modes much more versatile. Compensation is added (for brighter exposure) or subtracted (for darker exposure) in f/stop increments of 1/3 for up to +/- five stops (1/2-stop increments with C.Fn-1; see page 118).

To use the exposure compensation feature, tap the shutter to turn on the light meter. Press and hold Av while turning to change the compensation amount. The exact exposure compensation appears on the scale at the bottom of the viewfinder information display, as well as on the LCD monitor. You can also adjust exposure compensation by activating to navigate the Quick Control screen. Adjusting exposure compensation via this method allows access to exposure bracketing, too (see pages 161-162).

It is important to remember that once you set the exposure compensation control, it stays set even if you shut off the camera. Check your exposure setting (by looking at the bottom scale in the viewfinder information display) when you turn on your camera to be sure the compensation is not inadvertently set for a scene that doesn't need it. Turn exposure compensation off by holding AVID and turning to set the scale in the LCD monitor or viewfinder back to zero.

With experience, you may find that you use exposure compensation routinely with certain subjects. Since the meter wants to increase exposure on dark subjects and decrease exposure on light subjects to make them both closer to middle gray, exposure compensation may be necessary. For example, say you are photographing a baseball game with the sun behind the players. The camera tends to underexpose in reaction to the bright backlight, but the shaded sides of the players' bodies may be too dark. So you add exposure with the exposure compensation feature. Or maybe the game is in front of densely shaded bleachers. In this case, the players would be overexposed because the camera's meter reads the darkness. In this case, you would use exposure compensation to subtract exposure. In both cases, the camera consistently maintains the exposure adjustments or compensation you have selected until you readjust the exposure settings.

The LCD monitor can come in handy when you experiment with exposure compensation. Take a test shot, and then check the photo and its histogram (see pages 164-165). If it looks good, go with it. If the scene is too bright, subtract exposure; if it's too dark, add it. Again, remember that if you want to return to making exposures without using compensation, you must move the setting back to zero!

AUTOEXPOSURE BRACKETING (AEB)

This control offers another way to apply exposure compensation: AEB tells the camera to make three consecutive exposures that are different: (1) A standard exposure or "base-line" shot (even a shot that already has exposure compensation applied); (2) An image with less exposure; and (3) One with more exposure. The last two shots are said to bracket the base-line exposure.

The difference between exposures can be set up to \pm -two stops in 1/3-stop increments. (C.Fn-1 allows you to change this to 1/2-stop increments—see page 118.) When using AEB, the Rebel T2i brackets using the shutter speed in Δv mode and aperture in Δv mode.

NOTE: If the T2i is in auto ISO mode and AEB needs to use an exposure setting beyond the range of the camera, the ISO speed is adjusted. So you could pick a shutter speed where the aperture doesn't change through the bracketed shots, but the ISO speed does.

AEB is set using Q: Scroll to [Expo.comp./AEB] and press SET. The submenu gives you to the ability to adjust both exposure compensation and bracketing. Use \P to adjust exposure compensation on the center shot (between the under and overexposed images), then use to set the bracketing amount. The short outer lines show the exposure setting for "under" and "over" shots, and the long line is the "center" exposure. Make sure you press SET to accept the changes. If C.Fn-1 is set for 1/2-stop increments, the bracket amount will also use 1/2-stop increments.

HINT: Put the Quick Control screen to work for you. It is the quickest way to access AEB. Press a and use \diamondsuit to highlight the exposure compensation scale. Use a to set exposure compensation for the center shot and press and hold a while rotating a to set the bracket amount. If you forget which control affects which parameter, press **SET** to bring up a more intuitive display.

When in \square drive mode, you must press the shutter button for each of the three shots. The three indicators on the exposure scale will blink as long as there are shots left to be taken for the bracketing sequence. When you turn on the meter by pressing the shutter release button, a single point appears that indicates which shot in the bracket sequence will be captured next. In \square drive mode, when you press and hold the shutter release button, the camera takes the three shots and stops. When you use \square or \square drive modes, all three shots are taken automatically. If you use \square or \square drive modes, all three shots are taken automatically. If you use \square or \square drive modes, all three shots are taken automatically set to take 3 images after the time counts down, each of those 3 images will be bracketed, for a total of 9 images.

NOTE: When set to AEB, the camera continues to bracket exposures until you reset the control to zero or turn the camera off. Also, AEB is turned off for flash, but when you stop using flash, the AEB setting is restored.

AEB can help ensure that you get the best possible exposure. A dark original file always has the potential for increased noise as it is adjusted, and a light image may lose important detail in the highlights. With AEB, however, you can get a few different exposures and choose the best one later. You won't use it all the time, but it can be very useful when the light in the scene varies in contrast or is complex in its dark and light values, or if you don't feel confident with your exposure setting.

AEB is also important for a special digital editing technique called high dynamic range (HDR) photography. This allows you to put multiple exposures together in the computer to gain more tonal range from a scene. You can take the well-exposed highlights of one exposure and combine them with the better-detailed shadows of another. (This works best with 1/2-stop bracketing.)

NOTE: There are software applications that can merge these files and help you choose which parts of which image to use. In order for HDR to be successful, a tripod is an absolute necessity (so the camera's position doesn't change). You'll also need to record using Av or M shooting mode so the depth of field doesn't change. And, use a preset white balance, not (so color doesn't change), and use manual focus or a locked focus (so that focus doesn't change). HDR works best with images that have little or no movement.

163

Examine your recorded images on the LCD monitor during playback. Though it is possible to be fooled, with a little practice you will soon be able to use this small image to evaluate your exposure. Recognize that because of the LCD monitor's calibration, size, and resolution, it only gives an indication of what you will actually see when the images are downloaded into your computer.

The Rebel T2i includes two features—highlight alert and the histogram—that give you a very good indication of whether or not each exposure is correct. These features can be seen on the LCD monitor once an image is displayed there. Push DISP. repeatedly (located on back of the camera above the LCD monitor, to the left of the viewfinder) to cycle through a series of four displays: (1) The image plain; (2) the image with exposure information (shutter speed and aperture), exposure compensation value (if any), protection icon (if the image is protected), the file and folder number, the playback number, and total number of images on the card; (3) a small image with a histogram (brightness or RGB depending on the histogram setting in \mathbb{E}^1), as well as extended image information (including ISO speed, file size, Picture Style, and color space); and (4) a small image with the brightness histogram, the RGB histogram, and reduced image information.

Highlight Alert: The camera's highlight alert is straightforward: Any overexposed highlight areas blink when the histogram screen of the shooting information display is active (accessed by pressing the DISP. button while the camera is in image playback). These blinking areas have so much exposure that only white is recorded, no detail.

Although it is helpful to immediately see what highlights are getting blown out, some photographers are distracted by the blinking. But blinking highlights are simply an indicator, and not necessarily bad. Sometimes the less important areas of the frame become washed out when the most important parts of the scene are exposed correctly. However, if you discover that significant areas of your subject are blinking, the image is likely overexposed and you need to reduce exposure in some way.

The Histogram: The Rebel T2i's histogram, though small, is an extremely important tool. It is the graph that appears on the LCD monitor next to the image when selected with DISP. during image review or playback. The T2i can display two different kinds of histograms: Brightness and RGB. The Brightness histogram allows you to judge the overall exposure of the image, while the RGB histogram focuses on the exposure of the individual color channels.

> While the T2i can display both an RGB and a brightness histogram, the latter is the most useful.

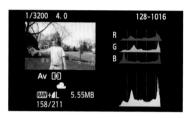

The horizontal axis of the Brightness histogram represents the level of brightness—dark areas are at the left, bright areas are at the right. The vertical axis indicates the pixel quantity of the different levels of brightness. If the graph rises as a slope from the bottom left corner of the histogram and then descends towards the bottom right corner, all the tones of the scene are captured.

Consider the graph from left to right (dark to bright). If the graph starts too high on either end (i.e., so the slope looks like it is abruptly cut off at either side), then the exposure data is also cut off at the ends (also known as being clipped) because the sensor is incapable of handling the areas darker or brighter than those points. An example would be a dark, shadowed subject on a bright, sunny day.

Or, the histogram may be weighted towards either the dark or bright side of the graph (wider, higher "hills" appear on just one side or the other). This is okay if the scene is naturally dark or bright, as long as detail is not lost. However, be careful of dark scenes that have all the data in the left half of the histogram. Such underexposure tends to overemphasize any sensor noise that may be present. You are better off increasing the exposure, even if that makes the LCD image look too bright. You can always darken the image in the computer, which will not affect grain; however, lightening a very dark image usually has an adverse effect and results in added noise.

If highlights are important, be sure that the slope on the right reaches the bottom of the graph before it hits the right edge. If darker areas are important, be sure the slope on the left reaches the bottom before it hits the left axis.

If the scene is low in contrast, the histogram appears as a rather narrow hill in the middle of the graph, leaving gaps with no data toward both left and right axes. To help this situation, check the Rebel T2i's Picture Styles. Boosting contrast expands the histogram—and you can create a customized Picture Style with contrast change and tonal curve adjustment that addresses such a situation. This means better information is captured—it is spread out more evenly across the tones—before bringing the image into your computer to use image-processing software. You could also experiment with the Auto Lighting Optimizer in \Box : (see page xxx). Or, you could record using RAW, since results are best in RAW (versus JPEG) when the data has to be "stretched" to make better use of the tonal range from black to white.

NOTE: When shooting RAW, the effects of the Auto Lighting Optimizer will only be apparent if the RAW file is processed through Canon's Digital Photo Professional software.

RGB Histogram: You can check to see if any of the individual color channels is over-saturated when you use the RGB histogram. Similar to the brightness histogram, the horizontal scale represents each color channel's brightness level. If more pixels are to the left, the color is less prominent and darker; to the right, the color is brighter and denser. If the histogram shows an abrupt cut-off on either end of the histogram, your color information is either missing or over-saturated. In short, by checking the RGB histogram, you evaluate the color saturation and white balance bias.

Live View and Movie Shooting

LIVE VIEW

It wasn't long ago that people who were stepping up to a D-SLR from a point-and-shoot camera were asking, "Why can't I see the image on the LCD before I take the shot? My little camera that was a fraction of the price can do it!" Live view in D-SLRs has changed all that.

Canon was one of the first manufacturers to offer live view shooting in a D-SLR. This technology, which displays an image on the LCD monitor before you shoot, allows you to frame shots when it is difficult to look through the viewfinder. It also permits you to check exposure, composition, color, and focus on a computer display: When you connect the Rebel T2i to a computer and run Canon EOS Utility software, you view images live on the computer.

NOTE: Since live view and movie shooting share the same technology and some of the same camera settings, this chapter deals with both in tandem. But keep in mind that when I refer to live view shooting, I am talking about capturing stills; movie shooting refers to the Rebel T2i's operations when the mode dial is set for $^{\mathbf{IM}}$.

To enable live view shooting, go to **V**:, scroll to highlight [Live View function settings], and press SET. Make sure [Live View shoot.] is highlighted in the subsequent menu screen, and again press SET. Then use **N** to highlight [Enable] and press SET to confirm the setting. Once live view shooting is enabled, press the **D** button, to the right of the viewfinder, at any time to turn it on.

To shoot movies, set the mode dial to '\overline{\overline{\pi}}. Once the switch is set, the image displays immediately on the LCD monitor. \(\beta\) is used to start and stop recordings. Movie mode does not require [Live View shoot.] to be enabled.

All the menu items for live view mode are found under [Live View function settings] in the * menu. When the Rebel T2i is set for *, two new menu items (* and * are added to the front of the menu tabs (Movie 1 and Movie 2 menus, respectively). See pages 106 and 111-116, respectively, for details on live view and movie menus.

NOTE: Although the live view and movie-shooting menus appear in two different places, they share some of the same settings. For example, if you set the metering timer for one minute in the live view menu, it will also be set to one minute in the movie shooting menu.

LCD MONITOR

The LCD monitor is the key to live view and movie shooting. It doubles as a viewfinder for composing your scene, yet it still acts as a status display to show you many of the T2i's settings.

STATUS DISPLAYS

Depending on your camera's settings, you can cycle through up to four display modes (three when shooting movies), by pressing DISP. The first display is just the image with the AF point. (The AF point might not be displayed if the AF mode is set for AF \mathbb{L} .)

Press DISP. in live view to add a status display at the bottom of the LCD that will show exposure information (shutter speed and aperture when the meter is on), an exposure level indicator (including compensation and bracketing indicators if engaged), flash exposure compensation,

shots remaining, ISO speed, highlight tone priority indicator, and battery level. If the camera is in a Basic Zone shooting mode the information is reduced. In movie shooting, this status display is similar except there is no flash exposure compensation.

NOTE: If there is no SD card in the camera or the card is full, the movie-recording size will appear along with the remaining recording time of 00:00, displayed in red. At the top of the screen will be the warning "No card in camera."

Press DISP. again in live view shooting to add information about white balance, Picture Style, Auto Lighting Optimizer, image recording quality, drive mode, AF mode, autoexposure lock \bigstar , flash-ready, autoexposure bracketing (AEB), and exposure simulation (covered later in this chapter). In movie shooting, this display is slightly different. Beneath the image-recording quality are the movie-recording size and the remaining recording time. The available recording time switches to elapsed time when you start recording; and instead of exposure simulation status there is an exposure mode indicator (manual vs. auto). Missing from this display in movie shooting is flash-ready and AEB, since flash cannot be used while shooting movies and bracketing is disabled. Press DISP, again to display a histogram. This histogram displays brightness or RGB, depending on the [Histogram] setting in Ξ^{\dagger} . When recording movies, this status screen is not available—there is no histogram.

OUICK-CONTROL SCREEN

Depending on the status screen display in live view and movie shooting, you may see a special Quick Control screen on the left side of the LCD. If it is not displayed, press ②.

< While it looks like a status screen, the icons on the left are part of the Quick Control screen and offer direct access to many of the shooting functions.

With live view shooting, the Quick Control screen allows you to adjust white balance, Picture Styles, Auto Lighting Optimizer, image-recording quality, and autofocus mode. Use AV to highlight the parameter you want to change, and use 🖎 to change the value. Note that Auto Lighting Optimizer is disabled when C.Fn-6, [Highlight tone priority], is enabled.

Since ⊞/@ is used to magnify the image on the LCD monitor, use the Quick Control screen to pick AF points when the T2i is set for AFQUI. While in the Quick Control screen, press ◆▶ to move to the AF point shutter to exit. The AF-point selection options are the same as non-liveview shooting. When all the AF points are highlighted the T2i will select the AF point automatically based on the subject.

NOTE: The AFORD parameter does not have to be highlighted before you press ◆ to move to the AF point overlays.

When the T2i is in movie shooting mode, the Quick Control screen adds one more control: the movie-recording size. Use 🕮 to cycle through the five options (see pages 182-183).

CAMERA SETTINGS

While in live view shooting, you still have access to many of the same settings that are used for non-live-view shooting, with a few exceptions. The biggest change is that metering is always evaluative 2. Otherwise you still have access to white balance, autofocus, drive mode, ISO, flash exposure compensation, Picture Styles, and exposure compensation. Since the Quick Control screen has fewer options in live view, a number of settings (i.e., autoexposure bracketing) are accomplished via menus.

When you shoot movies, you have access to white balance, autofocus. and exposure compensation. Drive mode relates only to taking still images and is confined to \square (self-timer is not available). Metering is center-weighted average [], and ISO can only be set when the movie exposure mode is set to manual (see pages 177-178).

NOTE: Live view and movie shooting use a lot of power, so make sure you have fully charged batteries on hand. The Rebel T2i is good for about 200 shots using live view (170 when flash is used about half the time). When you record movies, the battery lasts about one hour and 40 minutes. (Battery runtime figures assume a temperature of 73°F or 23°C.)

FOCUS DURING LIVE VIEW SHOOTING

As mentioned previously, when live view is turned on, the reflex mirror pops up, rendering the viewfinder unusable. Since the autofocus sensors are part of the viewfinder, and the mirror is blocking the viewfinder, the Rebel T2i's traditional autofocus method is not immediately functional. Autofocus is accomplished by either flipping the mirror back down or evaluating the image coming from the sensor. You choose the AF mode via the live view Quick Control screen ②. There are three autofocus options:

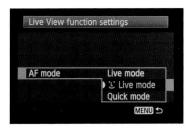

If you are going to do a lot of live view shooting, it is important to understand the differences between its three AF modes.

AFOUL QUICK MODE AF

You might wonder why this is called "quick mode" since it takes a bit of time to achieve focus. In reality, this is often the fastest and most accurate way to achieve focus. The method uses the same autofocus sensors that are used during non-live-view still photography. Remember that during live view, the reflex mirror—reflex is the "R" in SLR—is in the up position, so that light lands on the image sensor and creates an image. But because the AF sensors are located in the viewfinder, the reflex mirror must be in the down position so that the light hits them. In other words, if you use AFOOD, the live view image is temporarily interrupted while the camera sets focus.

When you use *** you must select an AF point selection mode, just as you would if you were not using live view shooting; however, you must use the live view Quick Control screen. Press ① to activate the Quick Control screen. Press ① to highlight the currently selected AF point(s). Use ② to move through the AF points. Once you have highlighted the AF point(s) you want to use, press ②, ◆▶, or tap the shutter to exit AF point selection. The AF point(s) selected are overlaid on the LCD monitor as gray points. The selected AF point carries over from non-live-view shooting. For example, if you have selected the center AF point during normal shooting, the selected AF point is still the center point when you switch to live view with *** Wall, until you change it.

Once the AF point is selected, press the shutter release button halfway and hold it to start the autofocus process. The mirror flips down, interrupting the live view image on the LCD monitor. The camera then sets focus and confirms the focus with a beep (unless the beep was disabled in \square). Once focus is set, the mirror flips back up and you can see the live view image again. The AF point used to set focus is highlighted in red.

To check the focus, a white rectangular magnifying frame can be moved anywhere in the scene with \diamondsuit . Once in place, press @ to magnify the image in that frame. Press once to magnify 5x, press again to magnify 10x, and press a third time to return to normal view. Use \diamondsuit to scroll around the magnified image or press @ to reset the frame to the center of the screen.

Once focus has been set, press the shutter to take the picture. If you let go of the shutter button before you take the picture, the T2i attempts autofocus again when you press the shutter release button. So when shooting with live view, get into the habit of keeping your finger down on the shutter release button (halfway) after focus is achieved.

NOTE: It is critical that you make sure the T2i has set focus before you take the picture. Unlike non-live-view shooting, the focus process takes time. You can't just press the shutter button all the way down to take a picture without first setting focus by pressing the shutter button halfway.

In this mode, the Rebel T2i sets focus by evaluating the image coming from the sensor. The camera uses contrast detection to examine edges in the scene, continually measuring the image while focus is adjusted. This feedback loop takes a bit longer to set focus compared to # but it does not interrupt the live view image.

a hum is a handy feature because there is no interruption in the live view image. It is better for a static subject than for a moving one because it functions more slowly than 小畑.

When you use After, first set the live-mode focus point. When the Rebel T2i is in After, a white frame overlay becomes the AF point. Use to move the AF point to the area of the image on which you want to focus. For quicker and more accurate results, pick an area with high contrast. You can move the AF point around more than 60% of the image with the but you won't be able to get to the very edges. If you press you can reset the AF point to the center of the screen.

Once the AF point is selected, press the shutter release button halfway to start autofocus. The camera indicates that focus is achieved by beeping and turning the AF point green. If the camera fails to find focus, the AF point turns red and there is no beep. You can magnify the image using $^{\tiny \textcircled{Q}}$ to check the focus. Press $^{\tiny \textcircled{Q}}$ once to magnify 5x, twice for 10x, and a third time to return to normal view.

Once AF is set, the picture can be taken. It is critical that you make sure the T2i has set focus before you take the picture. If you let go of the button you used to achieve focus before you take the picture, the T2i attempts focus again when you press the shutter release button.

AF : FACE DETECTION AF

The last live view AF mode uses face detection technology built into the DIGIC 4 chip. The Rebel T2i can detect up to 35 different faces in the scene. Once detected, the camera chooses either the largest or the closest face in the scene and sets the AF point at that location.

> Multiple faces can be a challenge with live view, but you really only need to concentrate on one face in the group if they are the same distance from the camera.

When AF ♥ is selected, simply frame the scene and the camera detects the faces in it. A special face detection AF point ↑ appears over the largest or the closest face on the LCD monitor. If there are multiple faces in the scene, the face detection AF point changes to ♠ Use ▶ if you want to move the AF point to a different face. Once a face has been selected, press the shutter release button halfway to engage autofocus. When focus is achieved, the face detection AF point turns green and the camera beeps. If focus cannot be achieved, the AF point turns red. Once focus has been set, you can take the picture.

NOTE: You cannot magnify the live image to evaluate the focus.

If a face cannot be detected in the scene, the \mathbb{A}^{\square} AF point appears in the center of the screen and is used for focus. You will not be able to move this point. To temporarily leave \mathbb{A}^{\square} so that you can have more control over the AF point, press $\widehat{\mathbb{Z}}$. This toggles the AF mode to \mathbb{A}^{\square} . Then you can use \mathbb{A} to move the AF point. Press $\widehat{\mathbb{Z}}$ again to return to \mathbb{A}^{\square} . This is a useful technique to remember if you want to quickly switch between \mathbb{A}^{\square} and \mathbb{A}^{\square} \mathbb{C} .

Face detection is an impressive technology, but it is not perfect. Faces that are at an angle to the camera, that are tilted, that are too dark or too bright, that are close to the edge of the frame, and those that are too small, will be difficult to detect. Don't expect the face detection AF point to completely overlay the face all the time. Also, if the lens is way out of focus to begin with, the camera will have difficulty detecting faces. If the lens supports manual focusing (via turning the focus ring), manually set the focus while the lens is in AF mode. Once the live view image is in better focus, the Rebel T2i may detect faces.

HINT: For best results with any autofocus mode, consider swapping the functions of the shutter release button and \star using C.Fn-9 [Shutter/AE lock button]. This way you can use your thumb to start focus by pressing \star and keep it depressed to lock the focus. You might find this easier than trying to hold the shutter button halfway for a long period of time. When you are ready to take the picture, just press the shutter button.

AF in live view only occurs near the center area of an image. If the camera detects a face near the edge of the frame, the face detection AF point turns gray. If you attempt autofocus at that time, the center live view AF point is used instead.

A If you find that the face-detection AF doesn't "see" a face you're trying to focus on, try switching to AF To using the find button. AF To mode allows you to select the AF point manually.

MF MANUAL FOCUS

Manual focus is still a good option for live view shooting. When you switch the manual focus switch on the lens, the camera displays a magnification frame. One of the best ways to ensure accurate focus is to use ❖ to position the frame over the area of your scene that you want in focus. Then press ^② to magnify the image either 5x or 10x. You can center the magnification frame by pressing [™]. Use the lens' focus ring to set focus; then press ^③ once or twice to restore the normal image size.

HINT: Even if you don't normally shoot stills using live view, this manual focus procedure is a useful way of checking your focus when shooting in situations that make focus hard to judge—like at dusk.

FOCUS DURING MOVIE RECORDING

Since movie shooting uses the same technology as live view, the AF modes are the same. You can use AF DEED before you start shooting movies, but once recording starts, AF DEED is no longer accessible. Pressing the shutter release button halfway attempts focus using AF DEED in the used during movie shooting just like with live view shooting: Use to move the AF point, then press and hold the shutter release button halfway to set focus. AF DEED is also works for recording movies the same way it does for still shooting.

Don't expect A or AF : to be as smooth as if you had a Hollywoodstyle focus puller—the person whose sole job on a movie set is to adjust lens focus when the camera moves. Since there is a feedback loop, the focus setting "hunts" a little when it gets close to the right setting. Also, the brightness level of the scene may temporarily change while focus is set.

If you are used to the autofocus of camcorders, it will take some time to adjust to the autofocus of the Rebel T2i. In short, I don't recommend that you try to autofocus while the T2i is recording, unless you don't mind if the video image is disturbed (focus and exposure) while the camera sets focus. For best results, consider using manual focus when recording movies. It may be the fastest method to achieve focus. And, with a gentle touch, it can be done while recording.

NOTE: The built-in microphone will pick up the sound of the focus motors in the lens when the camera adjusts focus.

EXPOSURE

While it is tempting to just watch the LCD and set exposure by eye, you should use the same techniques for setting proper exposure that you use while not in live view, such as looking at the review image and its histogram, and paying attention to the exposure scale when in $\bf M$ shooting mode.

ISO IN LIVE VIEW

During live view shooting, the ISO speed setting operates the same way as during normal still shooting: Press ISO and use to select the ISO speed from the status display at the bottom of the LCD monitor.

NOTE: When highlight tone priority has been activated (C.Fn-6), it is indicated by D+ next to the ISO speed display at the bottom of the LCD monitor during live view still shooting.

ISO IN MOVIE SHOOTING

There is no direct control over the ISO setting when shooting movies, except when [Movie exposure] is set for [Manual]. When in manual exposure mode, press ISO and use to select the ISO speed from the status display at the bottom of the LCD monitor. If you set ISO to auto, the T2i automatically fixes the aperture and adjusts the ISO for the best exposure while shooting.

EXPOSURE MODES IN LIVE VIEW

When you capture stills during live view shooting, the P, Tv, Av, M, and A-DEP modes operate the same way as during non-live-view shooting. Exposure compensation is accessed using Av and as with normal shooting. Apply AEB through \Box :

NOTE: Exposure compensation as currently set for non-live-view shooting carries over into live view shooting.

EXPOSURE MODES IN MOVIE SHOOTING

In '\overline{\text{\tex

HINT: Consider using auto ISO for video shooting in manual exposure mode. If your lighting changes, the exposure will be adjusted by the T2i. However, the adjustment will be less noticeable because it will be an ISO speed change, not an aperture change (which would affect depth of field) or shutter speed change (which would affect motion). Instead, the image will have slightly less or more noise depending on the direction the ISO speed changes.

METERING IN LIVE VIEW

Metering during live view shooting is preset to ② because it is linked to the live view AF point and cannot be changed. You can still use all of the exposure and drive modes that would normally be available, depending on whether you are in the Creative or Basic Zone modes. Adjust ISO, aperture, shutter speed, and exposure compensation just as you would when shooting normally. When you use a Speedlite external flash unit, E-TTL II metering uses the normal meter in the viewfinder, so the mirror must drop down briefly. When you take a picture with flash, the Rebel T2i sounds like it is taking two pictures. Flash units other than Canon do not fire.

METERING IN MOVIE SHOOTING

Movie shooting exposure metering is automatically set for center-weighted average metering \square . The one exception is if you use $AF : \square$. When a face is detected, the metering is $[\square]$, and it is linked to the face detection AF point. If you shoot a still in movie shooting mode it will use the same center-weighted average metering \square for exposure.

EXPOSURE SIMULATION INDICATOR

Normally, the T2i tries to display a good image on the LCD monitor, no matter how the exposure is set. In live view, displays to indicate that the image presented on the LCD monitor (in terms of exposure) is close to the actual exposure that will be captured when the shutter release button is pressed. If this icon blinks, it means the image on the screen does not represent the exposure that will be used for the actual image. If you are using flash or bulb shutter speed, will be grayed out since the LCD can't represent flash illumination or an unknown shutter speed length. When the T2i is shooting movies, the camera is always displaying a representation of the video exposure.

©Frank Gallaugher

Live view is designed to show what your exposure will look like based on your current settings, but for an exposure like this one, where bulb was used to take a long exposure, since the camera doesn't know how long the shutter will be open, will blink to indicate that what you see on the LCD is not an accurate representation of the resulting image.

NOTE: Heat can be a problem when you use live view and movie shooting. Thermal buildup on and near the image sensor causes the function to shut down. This is particularly true when you shoot under hot studio lights or outdoors in direct sun. If heat becomes a problem, the temperature icon is displayed. While you can keep shooting, image quality may suffer, so it is best to turn off live view shooting for a while.

One Rebel T2i feature that is improved with live view shooting is depth-of-field preview. Depth-of-field preview normally produces an image that is dim in the viewfinder, making it difficult to see the image. With live view shooting, the depth-of-field preview has a brighter display that allows you to better check depth of field, as long as a reasonably correct exposure is set.

MOVIE SHOOTING

There are ten things you should do to record movies successfully with your Rebel T2i. These steps are important because the process of recording movies can be very different than that of shooting stills. These are just a starting point. As you get used to the camera, you'll develop your own steps.

- 1. Make sure you have plenty of power: If you use batteries, make sure they are charged and make sure you have spares. Running live view and recording movies can use up battery power quickly. Better yet, use the optional AC adapter (ACK-E8).
- 2. Use a large SDHC Class 6 or higher (high-speed) SD memory card: For optimum performance when recording high definition movies, make sure that you format the card in the T2i. If you shoot stills and record movies, consider using different cards for each scenario. This also helps organize files when you download to the computer.
- 3. Pick the movie resolution: Press , highlight the movie-shooting size parameter on the Quick Control screen, and use 🕮 to make your choice. The options are [1920 x 1080 30/25 fps], [1920 x 1080 24 fps], [1280 x 720 60/50 fps], [640 x 480 60/50 fps], or [Crop 640 60/50 fps].

- 4. Enable audio recording: To reduce camera handling noise picked up by the microphone, make sure that you make all camera adjustments before you start recording, or use an external microphone.
- 5. Select a Picture Style: Press 후로 and use 🕮 to choose from 프로, 르타, 르타, 르타, 르타, 르타, 르타, 한타, or one of the three user-defined picture styles 르타. Use 👊 to make adjustments—sharpness, contrast, saturation, and color tone—to the selected Picture Style (see pages 52-62).
- 6. Make a white balance (WB) selection: If in doubt, use \(\text{WB} \), but the live view display on the LCD monitor can help you choose the best white balance setting. To set, press \(\text{\texi{\text{\text{\text{\text{\texi\text{\text{\text{\text{\tex{
- 7. Choose a focus mode: Decide if you want to set focus manually or via one of the three special live view AF modes. If you opt for an AF mode, first make sure your lens is not in manual focus mode. Next, press and use To highlight the current AF mode. Use to select one of the AF options: AF TO, AF TO, or AF TO (see pages 171-175).
- 8. Set focus: The T2i does not automatically set focus before movie recording. Press and hold the shutter release button halfway until you receive a confirmation that focus has been achieved. Depending on the AF mode you have set, this might involve momentary loss of the live view display on the LCD monitor.
- 10. Make a test recording: Press 1 to start recording. Since you can't monitor audio from the Rebel T2i's audio video out terminal while you record movies, make sure that you do a test recording. Listen to the recorded audio to make sure it sounds good, then look at the movie to check exposure. Exposure can be adjusted by using AVID and rotating before and during recording.

MOVIE RECORDING QUALITY

There are four parameters that are important in any digital movie specification: resolution, frame rate, scanning type, and compression. The first two you can control; the last two cannot be changed.

Resolution: Much like still photography, digital video is captured in pixel form. Unlike stills, however, movies cannot be recorded at various sizes and resolutions. Instead, movies are locked into displays that have fixed pixel counts. Rather than talking about how many megapixels a camera has, you specify exactly how many pixels there are in the horizontal and vertical direction.

The T2i offers both flavors of HD video capture as well as two versions of standard definition video.

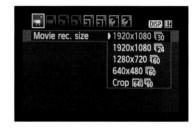

The Rebel T2i has four digital movie resolution options: [1920 \times 1080], [1280 \times 720], [640 \times 480], and [Crop 640]. [1920 \times 1080] and [1280 \times 720] are the two resolutions that comprise high-definition video. It is typical to refer to the resolution by its vertical dimension, so the Rebel T2i can shoot 1080 or 720 HD video.

[640 x 480] and **[Crop 640]** are close to the standard definition digital video specification (which is typically 720 x 486). While **[Crop 640]** is the same resolution as **[640 x 480]** it takes a center cut of the image sensor rather than scaling down the image from the entire sensor. This means that the image will appear to be magnified almost seven times.

The Rebel T2i is a true 1080 camera. Some camcorders (including high-level professional cameras costing thousands more) use pixels that are rectangular. The actual count of their pixels is 1440×1080 , which is later stretched out to create a 1920-wide image. The Rebel T2i uses square pixels.

HINT: While it is easy to print a vertical (portrait format) still image and hang it on the wall vertically, you don't see many televisions mounted on a wall vertically. Avoid shooting movies when the camera is in a vertical position.

Frame Rate: The second parameter is frame rate—the number of frames that the camera can capture per second. This should not be confused with shutter speed or maximum burst rate. In the case of the Rebel T2i, the camera records 30 or 24 frames per second (fps) in 1080, and 60 fps in 720 and standard definition. 24 fps is the standard frame rate for movies and it is used in video cameras to approximate a "film look." In reality, more than just frame rate is involved in creating a film look (i.e., lighting, depth of field, and camera movement) but the T2i can produce some great film-like moving images.

NOTE: The frame rates given are rounded up. The true frame rates for HD video are 29.97, 23.976 and 59.94.

HINT: If you live outside of North America, the frame rates may be different. In ♥¹, set [Video system] to PAL. This changes your recording options to [1920 x 1080 25fps], [1920 x 1080 24fps], [1280 x 720 50fps], [640 x 480 50fps], and [Crop 640 50fps]. 50 and 25 are not rounded up.

Scanning Type: Another parameter important in movies is the scanning type. There is nothing similar to it in still cameras. In the early days of television, bandwidth was a big problem. Transmitting lines of video (think of a line of video as a row of pixels) every 1/30 second required a great deal of bandwidth. Using lots of bandwidth meant fewer television channels, so a system was devised to transmit every other line of video at 1/60 second. This interlace scanning scheme has been used for decades and it fit in very nicely with televisions based on CRTs (cathode ray tubes).

With the advent of computers and computer displays like LCDs, the concept of interlace scanning became problematic. LCDs are more efficient if they get each line sequentially, rather than every other line. LCDs use a type of scanning that is called progressive. The Rebel T2i is a progressive scanning capture device so the high-definition output is sometimes referred to as 1080p or 720p—"p" stands for progressive. There are other movie recorders that are 1080i ("i"stands for interlace).

Compression: Lastly, because movies—particularly high-definition movies—take up a lot of space on memory cards and hard drives, they are usually compressed. Just like the JPEG compression that is used for still images, the video compression is high quality-don't think web movie compression. In video parlance, the compression is referred to as a codec, which stands for compressor/decompressor. The Rebel T2i uses an MPEG4 compression scheme that is most commonly referred to as h.264. There are a variety of quality levels of h.264, from very low file size and low image quality, to large file size and high image quality. This camera uses a very high quality version of h.264 for all resolutions.

SHUTTER

When shooting movies, the T2i does not use the mechanical shutter that is used for taking still photos. Instead, it uses an electronic shutter on the image sensor. This type of shutter is sometimes referred to as a rolling shutter. A rolling shutter does not capture the entire image at one time. This can lead to motion artifacts where fast-moving objects become skewed. If you move the camera quickly—for example, a rapid pan—the image can appear to wobble. To minimize these effects, be careful with panning speed and use a faster shutter speed if it is available. It should be noted that cinematographers face similar challenges with panning speeds when shooting motion picture film at 24 fps.

AUDIO

Audio is recorded simultaneously with the movie. The T2i records two digital audio channels (stereo) at a sampling rate of 48 kHz, which is the normal rate used for video. (CDs use 44.1 kHz.) It uses a linear PCM audio format, which is uncompressed. The audio can be recorded via the built-in microphone (located on the front of the camera above the T2i logo) or from an external audio source plugged into the external microphone jack. You can also turn off audio recording if it is not needed.

The built-in microphone is mono and picks up a lot of the camera noise, i.e., focus motors, stabilization, lens zooming, and any adjustments you make to a camera control. So, the built-in microphone isn't the answer for good audio recording. It is more for background recording, where audio isn't that important. The external microphone connection (located on the left side of the camera) is a stereo mini jack (3.5 mm). It is important that a stereo plug is used; otherwise you may end up with a noisy recording or no audio at all. The microphone input supports condenser or dynamic microphones, but it does not supply power for microphones that require phantom power (+48v).

NOTE: There is an automatic audio gain control (AGC) built into the T2i. Think of AGC as autoexposure for audio. The AGC is used for both the onboard and external microphone inputs. It cannot be turned off.

RECORDING LENGTH

As mentioned before, a large SDHC or SDXC memory card with a speed class of six or higher should be used for recording movies.

MOVIE REC. SIZE	FILE SIZE	4GB CARD	16GB CARD
1920 x 1080	330MB/min.	12 minutes	49 minutes
1280 x 720	330MB/min.	12 minutes	49 minutes
640 x 480	165MB/min.	24 minutes	99 minutes
Crop 640 x 480	165MB/min	24 minutes	99 minutes

The maximum size for a single file is 4GB. If you have installed, say, a 16GB card, the camera will stop recording when the file size of the current recording reaches 4GB. Even though the 16GB card has a 49-minute HD capacity (see the chart above), those 49 minutes must be in several discrete files. The LCD monitor displays movie recording size information and the amount of time left on the memory card. During recording, it indicates the elapsed shooting time.

If the card you are using is slow, a buffer capacity indicator appears on the LCD monitor. As the buffer fills up, waiting to write to the card, the icon indicates when the buffer is close to reaching capacity. When the memory card is full (or not present) the file recording size on the LCD appears in red.

MOVIE PLAYBACK

To access recorded movies, press ▶. Movies are indicated in the upperright corner of the LCD by ♣ ६००; the movie's duration in minutes and seconds is displayed as well. Once a movie is selected via ♣▶, press SET to enter movie playback mode. A set of VCR-style movie controls appears at the bottom of the screen:

> Besides normal playback controls, you can trim the start and stop points of each movie.

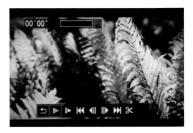

- O **SExit:** Returns LCD to single-image display.
- Play: This button is highlighted by default. Press SET to begin Playback; press it again to pause Playback.
- O I► Slow motion: Once engaged, use ◆► to change the playback speed.
- O IM First frame: Returns to the first frame of the recorded movie.
- O 4II Previous frame: Highlight this button and press SET to move back one frame. If you keep holding down SET, the rate increases until you reach rewind speed.
- O II Next frame: Operates exactly like "Previous frame" except it advances through frames rather than going backwards.
- O > Last frame: Moves to the last frame of the movie.
- O **XEdit:** Allows you to trim the beginning or end of the movie.

While movies are playing back, rotate to adjust the volume of the audio coming out of the camera's speaker. The control will not affect the volume when the Rebel T2i is connected to a TV. In that case, use the volume control on the TV.

* MOVIE TRIMMING

While you would normally transfer your movie to a computer for editing, there is a tool built into the T2i that allows you to remove (trim) some footage at the beginning or end of the movie. To trim your movie:

- O Select the movie you want to edit.
- O Press SET to bring up the playback controller.
- O Highlight

 A and press SET. A timeline appears at the top of the display and the trimming controls appear.
- O Use ◀► to select whether you want [Cut beginning] or [Cut end], and press SET.
- Use ◆▶ to move the trimming pointer a frame at a time, or hold ◆▶
 down to shuttle through the movie.
- Press SET to stop moving the pointer. If you want to trim the other end of your movie, repeat the last two steps.
- O Highlight the play button and press SET to preview your edit.
- O Highlight the ☑ and press SET. You can overwrite the original movie or save it as a new file. If there is not enough room on the memory card, the only option is to overwrite the original file.

STILL CAPTURE WHILE RECORDING MOVIES

While you can extract a still image from a movie using the Canon software that came with the T2i, the still will only be the resolution of the movie: 1920×1080 (at a maximum).

You can capture a higher resolution still while shooting. Just press the shutter release button while recording movies. The image quality/size, white balance, and Picture Style will be whatever has been set on the Quick Control screen. The drive mode will be single shooting \square (you can't use any of the self-timers). The built-in flash and any external Speedlites will not fire.

While the still image is being captured, the movie records a still frame until the high-resolution still image has been written to the memory card. Typically this takes about one second. When you play back the movie you'll see the one second freeze frame.

Flash

Electronic flash is not just a supplement for low light, it can also be a wonderful tool for creative photography. Flash is highly controllable, its color is precise, and the results are repeatable. However, the challenge is getting the right look. Many photographers shy away from using flash because they aren't happy with the results. This is because on-camera flash can be harsh and unflattering, and taking the flash off the camera used to be a complicated procedure with less-than-sure results.

The Canon EOS Rebel T2i's sophisticated flash system eliminates many of these concerns and, of course, the LCD monitor gives instantaneous feedback, eliminating the guesswork. With digital, you take a picture and you know immediately whether or not the lighting is right. You can then adjust the light level higher or lower, change the angle, soften the light, color it, and more. Just think of the possibilities:

Fill flash: Fill in harsh shadows in all sorts of conditions and use the LCD monitor to see exactly how well the fill flash works. Often, you'll want to decrease the maximum output of an accessory flash to make sure the fill looks natural.

Off-camera flash: Putting a flash on a dedicated flash cord allows you to move the unit away from the camera, yet still have it work automatically. Using the LCD monitor, you can see exactly what the effects are so you can move the unit around for the best light and shadows on your subject.

Close-up flash: This used to be a real problem because the light from the flash could overwhelm a close subject. Now you can see exactly what the flash does to the subject. This works amazingly well with off-camera flash, as you can "feather" the light (aim it so it doesn't hit the subject directly) to gain control over its strength and how it lights the area around the subject.

Multiple flash setups: Modern flash systems have made exposure with multiple flash units easier and more accurate. However, since the flash units are not providing continuous light, they could be hard to place so that they light the subject properly. However, with the Rebel T2i it is easy to set up the various flash units and then take a test shot. Does it look good, or not? Make changes as required. In addition, certain Canon EXseries flash units (and independent brands with the same capabilities) offer wireless exposure control with the T2i. This is a good way to learn how to master multiple-flash setups.

Colored light: Many flash photos look better with a slight warming filter. With multiple light sources, you can attach colored filters (also called gels) to the various flashes so that different colors light different parts of the photo. (This can be a very trendy look.)

Balancing mixed lighting: Architectural and corporate photographers have long used flash to even the lighting when different sources are present. With digital, you can double-check the light balance on your subject using the LCD monitor. You can even be sure the added light is the right color by attaching the proper gels to match lights (such as a green filter to match fluorescents).

> There are many flash modifiers available for today's photographers, such as these products from LumiQuest. ©LumiQuest

THE INVERSE SOUARE LAW

This defines how the light from a flash unit (or any point light source) is affected as it travels over distance. The Inverse Square Law states that the power of light is inversely proportional to the square of the distance that light travels. For example, as light travels twice the distance from its source, its power is quartered. This is due to the fact that the light spreads out as it travels.

^ As light travels twice the distance from its source, its power is quartered.

GUIDE NUMBERS (GN)

A guide number is a simple way to state the power of the flash unit. In the early days of flash photography, guide numbers were part of the formula that photographers used to determine the proper flash exposure setting for a given subject distance. While automation has eliminated this necessity, guide numbers are still used to quantify power output, and it is helpful to compare them when you shop for a flash unit. Guide numbers are computed as the product of aperture value and subject distance, and is usually included in the manufacturer's specifications for flash units. High numbers indicate more power; however, this is not a linear relationship. Guide numbers act a little like f/stops (because they are directly related to f/stops). For example, a GN of 56 is half the power of a GN of 80, and 110 is twice the power of 80 (see the relationship with f/5.6, f/8, and f/11?).

192

Since distance is part of the formula, guide numbers are expressed in feet and/or meters. Also, guide numbers are usually based on ISO 100. This can vary, however, so check the ISO reference (and the measurement system in use) when you compare different flash units. If you compare units that have zoom heads (special diffusers built into the flash units to match flash angle of view with the focal length in use), make sure you compare the guide numbers for similar zoom-head settings.

FLASH SYNCHRONIZATION

The Rebel T2i is equipped with an electromagnetically-timed, vertically-traveling, focal-plane shutter that exposes the sensor to light. The shutter works via two curtains. The first curtain opens at the start of the exposure. The second curtain closes at the end of the exposure. With shorter shutter speeds (those shorter than the camera's flash sync rating) the second curtain starts to close before the first curtain has finished opening. This means that the entire surface of the image sensor is never completely exposed by the flash.

When you use a flash to illuminate the scene, the extremely short duration of the flash only reaches the sensor when it is entirely exposed. The fastest shutter speed where the entire image sensor is exposed at once—when the second curtain doesn't start closing until the first curtain is completely open—is called the maximum flash sync speed.

The Rebel T2i's maximum flash sync speed is 1/200 second. If you use a flash and set a shutter speed faster than that in shutter-priority **Tv** or manual **M** exposure modes, the camera automatically resets the speed to 1/200. In aperture-priority autoexposure mode **Av**, the T2i won't go above 1/200. Instead, the shutter speed flashes, showing 1/200 in the LCD and viewfinder displays, if the aperture setting will cause overexposure.

The Rebel T2i uses a flash autoexposure system that measures light coming through the lens (TTL). Canon's first evaluative flash metering system was called E-TTL; the latest version, which is used on the T2i, is called E-TTL II. E-TTL II has improved algorithms and, compared to E-TTL, can better use distance information obtained from the lens to improve control over flash exposure.

NOTE: The terminology can be confusing at times. E-TTL II refers to the evaluative flash metering system available on the Rebel T2i. E-TTL refers to the earlier version of Canon's flash metering system, but it also refers to Canon's wireless flash system, something altogether different (see pages 210-211). Unless noted otherwise, for the remainder of this chapter E-TTL will be used to refer to the wireless flash system.

It is important to understand that E-TTL II is a system—it won't work unless you are using both a flash unit that supports E-TTL II (any Speedlite with EX in the name and some non-OEM units) and a Canon EOS camera that also supports E-TTL II. If you are not sure, speak with your authorized Canon dealer.

To understand the Rebel T2i's flash metering, it is helpful to know how regular E-TTL (non-E-TTL II) flash metering works with a Canon digital camera. When you first start pressing down on the shutter release button, the camera starts metering the ambient light. Once you fully press the shutter button, the camera stores the last ambient metering data, and it tells the flash to emit a pre-flash. During the pre-flash, the camera's metering system measures the pre-flash exposure. The camera also makes note of which AF point is being used to focus the lens. The camera takes these two sets of metering data and calculates the proper exposure placing emphasis on the AF point. All of this happens in a split second, of course.

With E-TTL II, the T2i ignores the AF point and instead uses all the metering zones in the camera to evaluate the ambient light and pre-flash. Any areas in the metering zones with dramatically different readings are given less weight in the overall exposure calculation, since they are likely to come from highly reflective surfaces that may skew the reading and cause underexposure. In addition E-TTL II considers lens distance information in the exposure calculation in order to

determine the location of the subject in the scene. Once the exposure has been calculated, the shutter is triggered, and the Speedlite is fired. The amount of flash that hits the subject is controlled by the duration of the flash emission; close subjects receive shorter flash bursts than more distant subjects. E-TTL II can produce some remarkably accurate flash exposures.

SETTING FLASH EXPOSURE

Though flash can sometimes be confusing when you are trying to set exposure, a few key concepts will help you understand how to adjust exposure when using it. First, shutter speed has no effect on flash exposure other than determining flash sync. The flash burst only occurs for a fraction of a second. Keeping the shutter open longer won't let in any more light from the Speedlite because it has already finished lighting up the scene. Thus, shutter speed only affects exposure for ambient light in the scene.

Changing the aperture affects both the flash and ambient light exposure. If you open up the aperture, you allow more of the light from the flash to reach the sensor. You will also allow more ambient light in, but since the ambient light is generally at a much lower level than the flash, the exposure change may not be as noticeable.

So remember: Adjust the shutter speed to control the amount of ambient light, especially in areas not lit by flash, and adjust the aperture to control the amount of flash illumination. Try it out yourself. Photograph a scene with some ambient light. Use \mathbf{M} exposure mode and adjust only the shutter speed (in both directions). What changes do you see in your image? Now repeat the exercise but only adjust the aperture.

FLASH WITH SHOOTING MODES

With the exception of creative auto mode (A), you have no control over flash when the camera is set to any of the Basic Zone selections. This means you have no say in whether the flash is used for an exposure or how the exposure is controlled. The camera determines it all, depending on how it senses the scene's light values. Depending on the mode selected, when the light is dim or there is a strong backlight, the built-in flash automatically pops up and fires. In (A), you can use the Quick Control screen to force the flash mode to always be off (9) (a useful setting when in a museum), always be on (4), or let the camera decide (4^^).

NOTE: Never assume the flash will always fire if it is popped up (or an external flash is mounted and turned on) when in any of the Basic Zone modes. The flash will only fire if the mode requires it, and some modes will never require it.

In the Creative Zone shooting modes, you either pop up the built-in flash by pushing the flash \$\frac{1}{2}\$ button (located on the front of the camera, on the upper left of the lens mount housing), or you attach an EX Speedlite accessory flash unit and simply switch it to the ON position. The flash operates in the various Creative Zone shooting modes as detailed below:

P (Program AE): Flash photography can be used for any photo where supplementary light is needed. All you have to do is turn on the flash unit—the camera does the rest automatically. Canon Speedlite EX flash units should be switched to E-TTL II and the ready light should be on, indicating that the flash is ready to fire. When you are ready to take your picture, you must pay attention to make sure $\frac{4}{7}$ is visible in the viewfinder, indicating that the flash is charged. The Rebel T2i picks a shutter speed in the range of 1/60-1/200 second automatically in **P** mode, and also selects the correct aperture.

Finding the right balance between flash and ambient light is key to flash photography. There are many times when the flash is just slightly assisting the existing light in your scene.

Tv Shutter-Priority AE: This mode is a good choice in situations when you are using flash and want to control the shutter speed, which affects how ambient light is recorded. In Tv mode, you set the shutter speed before or after a dedicated accessory flash is turned on. All shutter speeds between 30 – 1/200 second synchronize with the flash. (If a faster shutter speed is set, the camera overrides it and uses 1/200 second.) With E-TTL II flash in Tv mode, synchronization with slower shutter speeds is a creative choice that allows you to control the ambient-light background exposure. If you use a fast shutter speed to take a flash portrait of a person in front of a building with its lights on, you would expose the person correctly, but the background would be very dark. However, the ability to set slower shutter speeds using this mode allows you to control background exposure. If you set a shutter speed slower than 1/30 second, the camera automatically uses a Slow sync mode. You can turn this feature off using C.Fn-3, however. (A tripod is recommended to keep the camera stable during long exposures.)

If the aperture value flashes on the LCD or in the viewfinder, the current shutter speed is forcing an aperture value beyond what the lens can produce, indicating that the flash exposure will not be adequate for the focused distance. Adjust the shutter speed until the aperture value stops blinking.

Av Aperture-Priority AE: Using this mode allows you to balance the flash with existing light and control the distance that the flash can reach. The camera calculates the lighting conditions and automatically sets the correct shutter speed for the ambient light. If the shutter speed value flashes on the LCD or in the viewfinder, the camera wants to choose a shutter speed beyond the sync speed of the flash. Either use an external Speedlite that can be set for high-speed sync (see page 202), or close down the aperture. When using an external Speedlite, you can adjust aperture (using the main dial a) until you see the desired distance range in the external flash's LCD panel (if available.)

M Manual Exposure: Using manual mode gives you the greatest number of choices in modifying exposure. The photographer who prefers to adjust everything manually can determine the relationship of ambient light and electronic flash by setting both the aperture, which affects the flash exposure range, and the shutter speed. Any aperture on the lens

and all shutter speeds between 30-1/200 second can be used. If a shutter speed above the normal flash sync speed is set, the Rebel T2i switches automatically to 1/200 second to prevent partial exposure of the sensor, unless you are using an external Speedlite capable of high-speed sync.

M mode also offers a number of creative possibilities for using flash in connection with long shutter speeds. You can use zooming effects that produce a smeared background and a sharply rendered main subject, or take photographs of objects in motion with a sharp "flash core" and indistinct outlines.

A-DEP Automatic Depth-of-Field AE: If you use the flash in A-DEP mode, you will get the same result as if you used P. You will not get the depth-of-field control that A-DEP normally offers when flash is not used.

USING THE BUILT-IN FLASH

The Rebel T2i's built-in flash pops open to a higher position than the flash on many other cameras. This reduces the chance of red-eye in your photos and minimizes problems with large lenses blocking the flash. The flash supports E-TTL II, covers a field of view up to a 15mm focal length, and has a guide number of 43 feet (13 meters) at ISO 100. Like most built-in flashes, it is not particularly high-powered, but its advantage is that it is always available and is useful as fill flash to modify ambient light. This flash, as well as many Canon Speedlites, has the ability to send color temperature data to the camera's processor each time it fires. Just as flash output changes due to exposure needs, the color temperature of the flash can change. By communicating color temperature information to the camera, the T2i can better maintain consistent color.

The flash pops up automatically in low-light or backlit situations in the Basic Zone modes that use flash. In (A), you can use the Quick Control screen to force the flash mode to always be off (5), always be on (4), or let the camera decide (4). In P, Tv, Av, M, and A-DEP, you can choose to use the flash (or not) at any time. Just press the (4) button and the flash pops up. To turn it off, simply push the flash down. You can also disable flash firing using the flash control menu (see page 86).

NOTE: You cannot use the built-in flash while an external flash is mounted in the hot shoe of the T2i.

The P, Tv, Av, M, and A-DEP exposure modes do not all use the same approach with the built-in flash. In P mode, the flash is fully automatic, setting both an appropriate shutter speed and the aperture. In Tv, it can be used when you need a specific shutter speed up to the maximum sync speed. In Av, if you set an aperture that the flash uses for its exposure, the shutter speed controls how much of the ambient (or natural) light appears in the image.

In M, you set the aperture to control flash exposure, then choose a shutter speed that is appropriate for the ambient light in the scene (see flash metering below). Remember, you can use any shutter speed of 1/200 second and slower. If you use flash with A-DEP the camera will operate as if you were in P mode.

ADVANCED FLASH TECHNIQUES

** FE (FLASH EXPOSURE) LOCK

Just as autoexposure lock (AE lock \star , see pages 158-159) on the T2i is a useful tool for controlling exposure in difficult natural light situations, flash exposure lock **FEL** offers the same control in difficult flash situations. When either the built-in flash or an attached flash is turned on, you can lock the flash exposure by pressing the \star button (on the back of the camera toward the upper right corner, below the mode dial).

With a charged external or built-in flash active, pressing \bigstar causes the camera to emit a pre-flash, and the T2i calculates the exposure without taking the shot. **FEL** appears briefly in the viewfinder (replacing the shutter speed) during the pre-flash. The \ddagger changes to \ddagger *, indicating the flash exposure has been locked. You can press \bigstar repeatedly as you change framing. If the subject is beyond the illumination of the flash, \ddagger blinks.

NOTE: FEL can also be used to reduce people's reactions to the pre-flash. They may keep their eyes open during the actual exposure for a change!

Flash exposure lock is a great tool when you are faced with compositions where the subject is offset from center screen. In this case, the bride was first centered in the frame and * was pressed to lock the flash exposure. Then, the scene was recomposed.

To use FE lock, pop up the flash with the \$\frac{1}{2}\$ button (or turn on an external flash unit), and then lock focus on your subject by pressing the shutter button halfway. Next, aim the center of the viewfinder at the important part of the subject and press \$\frac{1}{2}\$ (\$\frac{1}{2}\$* appears in the viewfinder). Now, reframe your composition and take the picture. FE lock produces quite accurate flash exposures. When you use FE lock, the T2i metering system automatically switches to spot metering for the preflash metering. This allows for more accurate measurement of the flash exposure since the camera is only evaluating the center of the frame. You can use FE lock to make a flash exposure weaker or stronger.

Using the same principle, you can make the flash weaker or stronger. Instead of pointing the viewfinder at the subject to set flash exposure, point it at something light in tone or a subject closer to the camera. This causes the flash to provide less exposure. For more light, aim the camera at something black or far away. With a little experimenting, and by reviewing the LCD monitor, you can very quickly establish appropriate flash control for particular situations.

Fill flash is used, among other purposes, to compensate for bright light coming in from windows on interior shots. Use exposure compensation so that the flash isn't trying to light the whole scene, but instead is just filling in the shadow areas.

52 FLASH EXPOSURE COMPENSATION

You can also use the Rebel T2i's flash exposure compensation feature to adjust flash exposure by up to +/- two stops in 1/3-stop increments (or 1/2-stop increments if selected in C.Fn-1). Flash exposure is accessed via the *\Omega** menu: First highlight [Flash control] and confirm with the set button SET. Next, highlight [Built-in flash func. setting] for the built-in flash, or [External flash func. setting] for an external flash, and press SET again. Finally, select [Flash exp. comp] for the built-in flash or for an external flash, and press SET yet again. A flash exposure compensation scale is displayed that operates similarly to the exposure compensation scale. Use the left/right keys *\Dot* to adjust the compensation +/- two stops. The viewfinder displays *\Dot* to let you know flash exposure compensation is enabled.

NOTE: If you have learned to use the Quick Control screen (see pages 50-51), you can quickly set flash exposure compensation. With the shooting settings displayed on the LCD, press the Quick Control button ◎. Use the cross keys ❖ to highlight the flash exposure compensation display. Then use ⚠ to adjust the setting. If you want to have a little guidance for the setting, after it is highlighted, press SET to bring up a more intuitive adjustment screen.

For the most control over flash, use the camera's \mathbf{M} exposure setting. Set an exposure that is correct overall for the scene, and then turn on the flash. (The flash exposure is still E-TTL II automatic.) The shutter speed (as long as it is 1/200 second or slower) controls the overall light from the scene (and the total exposure). The f/stop controls the exposure by the flash. So, to a degree, you can make the overall ambient exposure of the scene lighter or darker by changing shutter speed (up to 1/200 second), with no direct effect on the flash exposure. (Note, however, that this does not work with high-speed sync.)

RED-EYE REDUCTION

In low-light conditions, when the flash is close to the axis of the lens—which is typical for built-in flashes—the light from the unit can reflect back from the retina of people's eyes because their pupils are wide. This appears as red-eye in the photo. You can reduce the chances of red-eye by using an off-camera flash or by having the person look at a bright light before you shoot (to cause their pupils to constrict). In addition, many cameras offer a red-eye reduction feature that causes the flash to fire a burst of light before the actual exposure, resulting in contraction of the subject's pupils. Unfortunately, this may also result in less than flattering expressions from your subject.

Although the Rebel T2i's flash pops up higher than most, red-eye may still be a problem. The Rebel T2i offers a red-eye reduction feature for flash exposures, but the feature works differently than red-eye reduction on many other cameras. The Rebel T2i uses a continuous light from a lamp on the front of the camera next to the handgrip—be careful not to block it with your fingers.

This continuous light (versus a brief, bright flash) closes the subject's iris somewhat and helps your subject pose with better expressions. Redeye reduction is set in the menu under [Red-eye On/Off]. Since the lamp is lower power, it takes a little longer to do the job. The T2i provides a visual countdown in the viewfinder, where the exposure compensation scale would normally display. Once the indicator decrements to nothing and the exposure compensation scale reappears, you can take the picture. In reality, you can take the picture at any time, but for best results you should wait for the countdown.

NOTE: Don't confuse red-eye reduction with the AF-assist beam (see page 148). The AF-assist beam uses a series of brief flashes to help the T2i achieve focus. This function is turned on/off via the Custom Function menu, not the red-eye reduction setting. However, the T2i is smart enough that if the AF-assist beam is fired, it knows that the red-eye reduction lamp doesn't have to be used.

HIGH-SPEED SYNC

If you want to use flash beyond the maximum sync speed of 1/200 second, you'll need to use Canon EX-series flash units that allow flash at all shutter speeds up to 1/4000. This mode is called high-speed sync. Instead of one burst of flash illumination, the Speedlite emits light in several short bursts as the shutter slit moves across the sensor. High-speed synchronization must be activated on the flash unit itself or by using [Flash control] in \square * (see page 86). It is indicated by the $^4_{\rm H}$ symbol on the flash unit's LCD panel and in the T2i's viewfinder. The T2i's built-in flash does not offer high-speed sync.

FIRST AND SECOND CURTAIN SYNC

When you use flash with longer shutter speeds mixed with ambient light, the timing of the firing of the flash can lead to unnatural effects with moving subjects. Imagine a baseball pitcher throwing a ball during a night game. The sequence for a flash picture is: first curtain opens, flash fires, shutter remains open for rest of exposure, second curtain closes. While the shutter remains open, the image sensor still records ambient light in the scene.

When you look at the picture, it will look as though the ball player is pulling the ball back towards himself. This is because the flash fires at the beginning of the exposure, freezing the action of his arm. Then the pitcher's arm travels forward, lit by ambient light. So the final image has a blurry trail preceding the moving arm. This is the opposite of what we are used to seeing—motion expressed as trails following a moving object.

To correct this anomaly, the T2i can be set to fire the flash just before the second curtain closes. This is called second curtain sync. It can be used with the built-in flash and external Speedlites. Use \square , and select [Flash control] and press SET. Select either [Built-in flash func. setting] or [External flash func. setting] and press SET. Select [Shutter sync.] and press SET. Select [2nd curtain] and press SET.

NOTE: Second curtain sync is only necessary at slow shutter speeds (1/30 and below) and only when there is lighting in the scene in addition to the flash. If the T2i uses a shutter speed faster than 1/30, first curtain sync is used.

CANON SPEEDLITE EX FLASH UNITS

Canon offers a range of accessory flash units in the EOS system, called Speedlites. While Canon Speedlites don't have the power of studio strobes, they are remarkably versatile. These highly portable flash units can be mounted in the camera's hot shoe, used off-camera with a dedicated cord, or used wirelessly via Canon's wireless Speedlite system.

The Rebel T2i is compatible with the EX-series of Speedlites. Units in the EX-series offer a wide range of features to expand your creativity. They are designed to work with the camera's microprocessor to take advantage of E-TTL II exposure control, extending the abilities of the Rebel T2i considerably. Speedlite EX-series flash units vary in power from the Speedlite 580EX II, which has a maximum ISO 100 GN of 190 feet (58 m), to the small and compact Speedlite 270EX, which has an ISO 100 GN of 72 feet (22 m).

I strongly recommend Canon's off-camera OC-E3 shoe-mounted extension cord for your Speedlite. When you use the off-camera cord, the Speedlite can be moved away from the camera for more interesting light and shadows. You can aim light toward the side or top of a close-up subject for variations in contrast and color. If you find that your subject is overexposed, rather than dialing down the light output (which can be done on certain flash units), just aim the Speedlite a little farther away from the subject so it doesn't get hit so directly by the light.

Introduced with the EOS 1D Mark III professional camera, the 580EX II replaces the popular 580EX. This top-of-the-line flash unit offers outstanding range and features adapted to digital cameras. Improvements over the 580EX include a stronger quick-locking hot shoe connection, stronger battery door, better dust and water resistance, a shorter and quieter recycling time, and an external metering sensor. The tilt/swivel zoom head on the 580EX II covers focal lengths from 14mm to 105mm, and it swivels a full 180° in either direction.

The zoom positions (which correspond to the focal lengths 24, 28, 35, 50, 70, 80, and 105mm) can be set manually or automatically (the flash reflector zooms with the lens). In addition, this flash knows what size sensor is used with a D-SLR and it varies its zoom accordingly. With the built-in retractable diffuser in place, the flash coverage is wide enough for a 14mm lens. It provides a high flash output with an ISO 100 GN of 190 feet (58 m) when the zoom head is positioned at 105mm. The guide number decreases as the angular coverage increases for shorter focal lengths, but is still quite high with an ISO 100 GN of 145 feet (44 m) at 50mm, or an ISO 100 GN of 103 feet (32 m) at 28mm. When used with other flashes, the 580EX II can function as either a master flash or a slave unit (see pages 210-211).

The 580EX II also offers flash exposure bracketing that you can access via the T2i flash control menu. Flash exposure bracketing (FEB) is similar to exposure bracketing (pages 161-162). The camera takes three exposures, all at different flash output settings. The adjustment scale looks just like the one for exposure bracketing.

Also new to the 580EX II is a PC terminal for use with PC cords. PC cords were the way external flashes were connected to cameras before the hot shoe was developed. The T2i does not have a PC connector, but PC terminals are still used for flash accessories like wireless remotes. For external power, a new power pack, LP-E4, has been developed for the 580EX II that is dust- and water-resistant.

The large, illuminated LCD panel on the 580EX II provides clear information on all settings: flash function, reflector position, working aperture, and flash range in feet or meters. The flash also includes a dial for easier selection of these settings. When you press the T2i's depth-of-field preview button (on the front of the camera, to the lower right of the lens mount housing), a one-second burst of light is

emitted. This modeling flash allows you to judge the effect of the flash. The 580EX II also has 14 user-defined custom settings that are totally independent of the camera's custom functions. Don't hesitate to study the flash manual for more information.

Although the LCD panel on the 580EX II provides a lot of information, it can be a little complicated if you try to adjust the various settings and custom functions when you don't use the flash every day. Canon came up with a great solution: You can use the T2i's menu system to access the 580EX II's controls. The custom functions appear as numeric codes on the Speedlite's LCD, but within the T2i's external flash control system, those custom functions have names and descriptions, just like the T2i's own custom functions. The same is true when you adjust other flash functions such as flash exposure mode, flash exposure compensation, shutter sync, flash exposure bracketing, and many more. You can also adjust the flash zoom head setting and wireless E-TTL II setting from the camera. With this new intelligence, it has never been easier to learn how to use Canon Speedlites to capture great images.

CANON SPEEDLITE 430EX II

Much as the 580EX II improved on the 580EX, the 430EX II, introduced in June 2008, improved on the 430EX. While the ISO 100 GN stayed the same—141 feet (43 m)—the recycle time decreased by 20%. It is also quieter than the 430EX and can be controlled from the T2i, just like the 580EX II. It offers E-TTL II flash control, wireless E-TTL operation, flash exposure compensation, and high-speed synchronization. It does not offer flash exposure bracketing.

The tilt/swivel zoom reflector covers focal lengths from 24mm to 105mm and swivels 180° to the left and 90° to the right. The zoom head operates automatically for focal lengths of 24, 28, 35, 50, 70, 80, and 105mm. A built-in, wide-angle pull-down reflector makes flash coverage wide enough for a 14mm lens.

An LCD panel on the rear of the unit makes adjusting settings easy, and there are six custom functions. Just like the 580EX II, you can control most of the settings and custom functions from the T2i's menus. Since the 430EX II supports wireless E-TTL, it can be used as a remote (slave) unit. A new quick-release mounting system makes it easy to securely attach the 430EX II to the T2i.

CANON SPEEDLITE 270EX

If you are looking for a simple, small flash that fits into just about every camera bag or even your pocket, the 270EX is it. It is a compact basic flash unit that offers a lot of features despite its size. Rather than have a zoom reflector, it has a 2-step selection of 28mm and 50mm. At the 28mm setting it has an ISO 100 GN of 72 feet (22 m). At the 50mm position the ISO 100 GN is 89 feet (27 m). Unlike its predecessor (220EX), the 270EX has a bounce feature, so the flash head can rotate to point straight up. It can also be controlled from the T2i's menu system.

OTHER SPEEDLITES

The Speedlite 220EX is an economy EX-series flash. It offers E-TTL II flash and high-speed sync, but does not offer wireless E-TTL flash, or bounce, and it can't be controlled by the camera's menu. Like the 270EX, it has an ISO 100 GN of 72 feet.

CLOSE-UP FLASH

There are also two specialized flash units for close-up photography that work well with the Rebel T2i. Both provide direct light on the subject.

Macro Twin Lite MT-24EX: The MT-24EX uses two small flashes affixed to a ring that attaches to the lens. These can be adjusted to different positions to alter the light and can be used at different strengths so one can be used as a main light and the other as a fill light. If both flash tubes are switched on, they produce an ISO 100 GN of 72 feet (22 m), and when used individually, the ISO 100 GN is 36 feet (11 m). The MT-24EX does an exceptional job with directional lighting in macro shooting.

Macro Ring Lite MR-14EX: Like the MT-24EX, the MR-14EX uses two small flashes affixed to a ring. It has an ISO 100 GN of 46 feet (14 m), and both flash tubes can be independently adjusted in 13 steps from 1:8 to 8:1. It is a flash that encircles the lens and provides illumination on axis with it. This results in nearly shadowless photos because the shadow falls behind the subject compared to the lens position, though there will be shadow effects along curved edges. The MR-14EX is often used to show fine detail and color in a subject, but it cannot be used for varied light and shadow effects. This flash is commonly used in

medical and dental photography so that important details are not obscured by shadows.

The power pack for both of these specialized flash units fits into the hot shoe of the camera. In addition, both macro flash units offer some of the same technical features as the 580EX II, including E-TTL II operation, wireless E-TTL flash, and high-speed synchronization.

NOTE: When the Rebel T2i is used with older system flash units (such as the EZ series), the flash unit must be set to manual, and TTL does not function. For this reason, Canon EX Speedlite system flash units are recommended for use with the camera.

 Bounce the light from the flash off a ceiling or a nearby wall for a diffuse. natural-looking light that fills the whole scene. Bounce accessories that mount on top of a flash unit are available from companies such as Lumiquest®, which are handy for bouncing outdoors or in a room with very high ceilings.

Jessica Anne Baum

Direct flash can often be harsh and unflattering, causing heavy shadows behind the subject or underneath features such as eyebrows and bangs. Bouncing the flash softens the light and creates a more natural-looking light effect. The Canon Speedlite 580EX II, 580EX, 430EX II, 430EX and 270EX accessory flash units feature heads that are designed to tilt so that a shoe-mounted flash can be aimed at the ceiling to produce soft, even lighting. The 580EX II also swivels 180° in both directions, so the light can be bounced off something to the side of the camera, like a wall or reflector. However, the ceiling or wall must be white or neutral gray, or it may cause an undesirable color cast in the finished photo.

WIRELESS E-TTL FLASH

Canon's Speedlite system allows the Speedlites to communicate with each other via light. A single main controller called the master sends out pulses of light to transmit information on light output (including the ratio between multiple Speedlites) and also triggers the remote Speedlites to fire when the shutter is tripped. You can use up to three groups of Speedlite 580EX IIs, 430EX IIs, 430EXs, or the now discontinued 580EXs, 550EXs and 420EXs, for more natural lighting or emphasis. (The number of flash groups is limited to three, but the number of actual flash units is unlimited.) When set for E-TTL, the master unit and the camera control the exposure.

NOTE: All references to E-TTL in this wireless section refer to Canon's wireless technology, not the earlier version of E-TTL II.

Canon makes four devices that the T2i can use as master controllers: the Speedlite 580EX II, the Macro Twin Lite MT-24EX, the Macro Ring Lite MR-14EX, and the ST-E2 master controller. The ST-E2 doesn't illuminate a scene but simply controls the remote Speedlites. When one of the Speedlites is used as a master controller and is mounted on the T2i, you can use the T2i's menu system to control the wireless setup of the master. (The 430EX II and 430EX can only be used as remote, or slave, units.)

NOTE: The T2i's built-in flash cannot act as a wireless master.

In the event that you are shooting with other Canon photographers and with multiple Speedlites, the wireless Speedlite system runs on transmission channels. There are four channels (1-4) to choose from, which is helpful when others around you are also shooting with flash. All of your Speedlites must be on the same channel in order to operate. Channels can be set via the control buttons on the back of each Speedlite. If you forget how to set the channels, an easy method to set up a newer Speedlite is to mount it on the T2i. Then use the T2i's menu system to set the channel.

To set the channel on a Speedlite mounted on the hot shoe, select [Flash control] and press SET. Select [External flash func. setting] and press SET. Select [Wireless func.] and press SET. Select [Enable] and press SET. Then select [Channel] and press SET. Choose a channel using AV and press SET.

GROUPS

The wireless system divides the Speedlites into groups. Groups can be used to set up ratios between Speedlites. This enables you to have brighter light on one side of your subject and weaker fill light on the other. With E-TTL II, you don't have to worry about setting specific power output. The T2i's metering system handles all the calculations; you just set up how much brighter one flash group should be, compared to the other. This is known as setting the lighting ratios.

Groups can also be used when you want to control the power output of the Speedlites manually. By assigning each Speedlite to a different group, you can dial in each one's output from the camera, rather than from each unit. This makes it easy to take a quick shot, evaluate the exposure, make adjustments from the back of the camera, and quickly make another shot.

Configure external Speedlites in up to three groups, labeled A, B and C. When you first start to use wireless Speedlites (particularly when using ratios), it is helpful to consider group A as your main light, group B as the fill, and group C as the background light.

When you mount an external Canon Speedlite that can act as a master controller, you need to set up the groups. To set up the groups, use ①, [Flash control], and press SET. Make sure [Flash firing] is set to [Enable]. Choose [External flash func. setting] and press SET. Set [Flash mode] to [E-TTL II]. Make sure [Wireless func.] and [Master flash] are set to [Enable].

Firing Group [A+B+C]: This wireless firing mode treats all of the Speedlite groups as one flash. It doesn't matter which group the individual Speedlites are set for; as long as they are set for slave mode, they will be controlled. For example, if you are using two remote 580EX II Speedlites, and one is set for slave group A and the other is set for group B, the two flashes will be controlled as one group. You can control the flash exposure compensation for the entire group with the [Flash exp. comp.] selection.

NOTE: Do not use this mode if you only have one remote Speedlite. The meter expects group B to provide illumination and won't expose properly.

Firing Group [A:B]: The camera-mounted Speedlite (or ST-E2 controller) allows you to set up light ratios from 8:1 to 1:8 using the [A:B fire ratio]. This represents a three-stop difference. When set to 8:1, the A group produces three stops more light than the B group. Just like [A+B+C], there is control of the entire flash exposure compensation with the [Flash exp. comp] selection.

Firing Group [A:B C]: This third firing mode builds on [A:B] by adding a third group: C. Notice the icon doesn't say that the C group has the same ratio setting as A and B. The C group should be used for backgrounds or accent lights. If the C group is used to light the main subject, the E-TTL system may cause overexposure. The ratio between A and B is set using the same function mentioned previously: [A:B fire ratio]. The C group is adjusted using a special control called [Grp C. exp. comp] which allows a +/- three-stop adjustment. The A and B groups, together, have their own exposure compensation setting.

There are times when E-TTL doesn't offer consistent performance. Sometimes you'll end up with underexposures and overexposures. Manual control of Speedlite power output can offer incredible control, particularly in situations where levels don't need to change once they have been set. Instead of running around to each Speedlite, you control all of the units wirelessly from the T2i. To operate in manual, use T[Flash control] and press SET. Make sure [Flash firing] is set to [Enable]. Choose [Built-in flash func. setting] and press SET. Change [Flash mode] to [Manual flash]. The [Firing group] now offers three options, outlined below.

Firing Group [A+B+C]: When the firing group is set for [A+B+C], all of the remote slaves (and the master) are adjusted to the same manual output setting, from 1/128 to 1/1 (full power). The slaves are controlled no matter what group they are set for—A, B, or C. Remember that this is manual mode: you have to set the output level according to how much flash illumination you think the scene needs. The T2i does not control the output of the flash via any type of metering.

NOTE: Controlling a flash means not only triggering it to fire, but also controlling the light output and flash duration.

Firing Group [A:B]: While this option looks similar to a ratio setup, in reality it allows you to set the manual output setting of the A and B groups separately, from 1/128 to 1/1 (full power). The T2i does not control the output of the flash via any type of metering.

NOTE: While the remote slaves are considered a group, you set the output value for each individual Speedlite in the group. You do not set the output value for all the Speedlites in the group combined.

NOTE: Remember to consult the manual that comes with each unit to fully understand the features and operations of Canon's accessory flashes.

Firing Group [A:B C]: This gives you three groups, each individually controlled, from 1/128 to 1/1 output. The T2i does not control the output of the flash via any type of metering.

Lenses and Accessories

Clearly the Rebel T2i is capable of capturing great images right out of the box. But it also belongs to an extensive family of Canon EOS-compatible equipment, including lenses, flashes, and other accessories. With this wide range of available options, you can expand the capabilities of your camera quite easily. Canon has long had an excellent reputation for its optics, and offers over 60 different lenses from which to choose. Several independent manufacturers offer quality Canon-compatible lenses as well.

LENSES FOR CANON D-SLRS

The Rebel T2i can use both Canon EF and EF-S lenses, ranging from wide-angle to telephoto. The lens lineup includes zoom lenses that can change focal length, and prime lenses that offer a single focal length and high performance. Keep in mind, however, that focal lengths act differently on many D-SLRs than they did with film SLRs. This is because many digital sensors are smaller than a frame of 35mm film, so they crop the area seen by the lens, essentially creating a different format. Effectively, this makes the subject appear comparatively larger within the frame. As a result, the lens acts as if it has been multiplied by a factor of 1.6 compared to how it would look on a 35mm film camera or a full-frame digital camera.

The EF 14mm f/2.8 L lens, for example, is a super-wide lens when used with a 35mm film camera or a full-frame sensor like that found in the EOS 5D Mark II; but it offers the 35mm-equivalent of a 22mm wide-angle lens (14 multiplied by 1.6) when attached to the Rebel T2i—wide, but not super-wide. On the other hand, put a long 400mm lens on the Rebel T2i and you get the equivalent of a 640mm telephoto—a big boost with no change in aperture. (Be sure to use a tripod for these focal lengths and heavy lenses!)

It is interesting to note that this is exactly the same thing that happens when one focal length is used with different sized film formats. For example, a 50mm lens is considered a mid-range focal length for 35mm, but it is a wide-angle lens for medium format cameras. The focal length of the lens doesn't really change, but the field of view that the camera captures changes. In other words, this isn't an artifact of digital photography, it's just physics!

NOTE: Unless stated otherwise, I refer to the actual focal length of a lens throughout the rest of the chapter, not its 35mm equivalent.

CHOOSING LENSES

The focal length and design of a lens have a huge effect on how you photograph. The correct lens makes photography a joy; the wrong one makes you leave the camera at home. One approach for choosing a lens is to determine if you are frustrated with your current lens. Do you constantly want to see more of the scene than the lens allows? Then consider a wider-angle lens. Is the subject too small in your photos? Then look into acquiring a zoom or telephoto lens. Do you need more light-gathering ability? Maybe a fixed-focal-length (prime) lens is needed.

Certain subjects lend themselves to specific focal lengths. Wildlife and sports action are best photographed using focal lengths of 200mm or more, although nearby action can be managed with focal lengths as short as 125mm. Portraits look great when shot with focal lengths of 50-65mm. Interiors often demand wide-angle lenses, such as 12mm. Many people also like wide-angles for landscapes, but telephotos can come in handy for distant scenes. Close-ups can be shot with nearly any focal length, though skittish subjects such as butterflies or birds might need a longer lens.

The inherent magnification factor is great news for the photographer who needs long focal lengths for wildlife or sports. A standard 300mm lens for 35mm film now seems like a 480mm lens on the Rebel T2i. It feels like you get a long focal length in a smaller lens, often with a wider maximum f/stop, and with a much lower price tag. But this news is tough for people who need wide angles, since the width of what the digital camera sees is significantly cropped in comparison to what a 35mm camera would see using the same lens. You need lenses with shorter focal lengths to see the same field of view you may have been used to with film.

ZOOM VS. PRIME LENSES

Though you can get superb image quality from either zoom or prime lenses, there are some important differences. The biggest is maximum f/stop. Zoom lenses are rarely as fast (e.g., rarely have as large a maximum aperture) as fixed-focal-length (prime) lenses. A 28-200mm zoom lens, for example, might have a maximum aperture at 200mm of f/5.6; yet a prime lens might be f/4 or even f/2.8. When a zoom lens comes close to a prime lens in f/stop, it is usually considerably bigger and more expensive than the prime lens. Of course, it also offers a whole range of focal lengths, which a prime lens cannot do.

Also, the aperture is not constant with many zoom lenses as you move through focal lengths. A lens that is rated f/3.5-5.6 means that its maximum aperture will be f/3.5 at its widest-angle focal length, compared to f/5.6 when at full telephoto range. This can affect autoexposure if you lock your exposure when the lens is fully wide and then zoom in—your image will be underexposed.

EF-SERIES LENSES

Canon EF lenses include some unique technologies. In order to focus swiftly, the focusing elements within the lens need to move with quick precision. Canon developed the lens-based ultrasonic motor for this purpose. This technology makes the lens motor spin with ultrasonic oscillations, instead of using the conventional drive-train system (which tends to be noisy). This allows lenses to autofocus almost instantly with hardly any noise, and it uses less battery power than traditional systems. Canon lenses that use this motor are labeled USM. (Lower-priced Canon

lenses have small motors in the lenses too, but they don't use USM technology, and can be slower and noisier.)

Canon was also a pioneer in the use of image-stabilizing technologies. Image-stabilized (IS) lenses utilize sophisticated motors and sensors to adapt to slight movement during exposure. It's pretty amazing—the lens actually has vibration-detecting gyrostabilizers that move a special image-stabilizing lens group in response to lens movement. This dampens movement that occurs from handholding a camera and allows much slower shutter speeds to be used. IS also allows big telephoto lenses (such as the EF 500mm IS lens) to be used on tripods that are lighter than would normally be used with non-IS telephoto lenses.

You can't always have a tripod at the ready. Image stabilization helps you get the shot handheld with an exposure one or two stops below the shutter speed you normally think is your limit for hand holding the camera.

The IS technology is part of many zoom lenses, and does a great job overall. However, IS zoom lenses in the mid-focal length range have tended to have smaller maximum apertures than single-focal-length lenses. For example, compare the EF 28-135mm f/3.5-5.6 IS lens to the EF 85mm f/1.8 lens. The former has a great zoom range, but allows less light at maximum aperture. At 85mm (a good focal length for people), the EF 28-135mm is an f/4 lens, more than two stops slower than the

f/1.8 single-focal-length lens, when both are shot "wide-open" (typical of low-light situations). While you could make up the two stops in "hand-holdability" due to the IS technology, that also means you must shoot two full shutter speeds slower, which can be a real problem in stopping subject movement.

FF-S SERIES LENSES

EF lenses are the standard lenses for all Canon EOS cameras. EF-S lenses are small, compact lenses designed for use on digital SLRs with smaller-type sensors—such as the Digital Rebel series, the 50D, and the 7D. EF-S lenses were introduced with the EF-S 18-55mm lens packaged with the original EOS Digital Rebel. They cannot be used with film EOS cameras, nor with any of the EOS-1D cameras, nor with the 5D cameras, because the image circle projected by EF-S lenses is smaller than each of those cameras' full-frame sensors.

NOTE: While these EF-S lenses are designed specifically for EOS cameras with smaller image sensors, focal length is still focal length. It is incorrect to assume that the focal length labeled on the lens has been adjusted for smaller image sensors.

Currently Canon offers eight EF-S lenses; all but one are zoom lenses. The EF-S 15-85mm f/3.5-5.6 IS USM is a recent addition to the EF-S line. It is an image-stabilized zoom in a compact package with a fairly wide angle. The EF-S 17-55 f/2.8 IS USM offers an image-stabilized zoom with a wide aperture. The EF-S 18-55mm f/3.5-5.6 IS is the kit lens that is often sold with the T2i. For those looking for a bit more range, there is the EF-S 18-135mm f/3.5-5.6 IS, which is a popular zoom range with image stabilization. The EF-S 18-200mm f/3.5-5.6 IS lens offers even more telephoto range.

The EF-S 10-22mm f/3.5-4.5 USM zoom brings an excellent wide-angle range to the Rebel T2i. For macro shooting, Canon offers the EF-S 60mm f/2.8 Macro USM that focuses down to life-size magnification. On the opposite end of the lens spectrum is the EF-S 55-250mm f/4-5.6 IS, which offers a very useful telephoto range.

NOTE: The EF-S series offers good value and great performance. The lenses make a great match for the T2i. Remember though, that if you see yourself stepping up to a full-frame sensor EOS camera, you will have to replace an FF-S lens—it will not work on a full-frame camera.

L-SERIES LENSES

Canon's L-series lenses use special optical technologies for high-quality lens correction, including low-dispersion glass, fluorite elements, and aspherical designs. UD (ultra-low dispersion) glass is used in telephoto lenses to minimize chromatic aberration, which occurs when the lens cannot focus all colors equally at the same point on the sensor (or on the film in a traditional camera), resulting in less sharpness and contrast. Low-dispersion glass focuses colors more equally for sharper, crisper images.

Fluorite elements are even more effective (though more expensive) and have the corrective power of two UD lens elements. Aspherical designs are used with wide-angle and mid-focal length lenses to correct the challenges of spherical aberration in such focal lengths. Spherical aberration is a problem caused by lens elements with extreme curvature (usually found in wide-angle and wide-angle zoom lenses). Glass tends to focus light differently through different parts of such a lens, causing a slight, overall softening of the image even though the lens is focused sharply. Aspherical lenses use a special design that compensates for this optical defect.

DO-SERIES LENSES

Another Canon optical design is DO (diffractive optic). This technology significantly reduces the size and weight of a lens, and is therefore useful for big telephotos and zooms. Yet, the lens quality is unchanged. The lenses produced by Canon in this series are an EF 400mm f/4 DO IS USM pro lens that is only two-thirds the size and weight of the equivalent standard lens; and on the other end of the price range, an EF 70-300mm f/4.5-5.6 DO IS USM lens that offers a great focal length range. Both lenses include image stabilization.

Canon also makes a wide variety of macro lenses for close-up photography. Macro lenses are prime lenses optimized for high sharpness throughout their focus range, from very close (1:1 or 1:2) magnifications to infinity. They also provide even resolution and contrast across the entire area of the image. The EF 100mm f/2.8L Macro IS USM lens was introduced at the same time as the T2i. While Canon already had a great quality 100mm macro in their lens lineup, this new lens is the first L-series macro lens, and also the first macro to offer image stabilization (IS).

^ A macro lens coupled with the Macro Twin Lite allowed for an exposure that really brought out the colors of the frog and the flower.

NOTE: This new macro lens requires an adapter—the Macrolite Adapter 67—to use it with Canon's two macro Speedlites: the Macro Twin Lite MT-24EX and the Macro Ring Lite MR-14EX.

In addition to the lens mentioned above, the full line of macro lenses ranges from 50mm to 180mm. The macro line up includes the EF 50mm f/2.5 Compact Macro, the EF-S 60mm f/2.8 Macro USM, the MP-E 65mm f/2.8 Macro 1-5x Macro Photo, and the EF 180mm f/3.5L Macro USM.

TIIT-SHIFT I FNSFS

Tilt-shift lenses are unique lenses that shift up and down or tilt toward or away from the subject. They mimic the controls of a view camera. Shift lets the photographer keep the back of the camera parallel to the scene and move the lens to get a tall subject into the composition. This keeps vertical lines vertical and is extremely valuable for architectural photographers. Tilt changes the plane of focus so that sharpness can be changed without changing the f/stop. Focus can be extended from near to far by tilting the lens toward the subject, or sharpness can be limited by tilting the lens away from the subject (which has been a trendy advertising photographic technique lately).

> This street scene in Las Vegas was shot with a tilt-shift lens. By throwing the plane of focus out of whack, the scene begins to take on a almost toy model look.

Canon has recently updated their tilt-shift offerings. New to the lineup is their first wide-angle tilt-shift, the TS-E 17mm f/4L. They have also enhanced their TS-E 24mm f/3.5L II model by improving optical performance with updated coatings, a wider range of tilt and shift, and new optical elements. The TS-E 45mm f/2.8 and TS-E 90mm f/2.8 complete the tilt-shift line.

INDEPENDENT LENS BRANDS

Independent lens manufacturers also make some excellent lenses that fit the Rebel T2i. I've seen quite a range in capabilities from these lenses. Some include low-dispersion glass and are stunningly sharp. Others may not match the best Canon lenses, but offer features (such as focal length range or a great price) that make them worth considering. To a degree, you get what you pay for. A low-priced Canon lens probably won't be much different than a low-priced independent lens. On the other hand, the high level of engineering and construction found on a Canon L-series lens can be difficult to match.

On the fun side of independent lens brands is the LensBaby (see lensbaby.com). These lenses offer selective focus and replaceable optics to give you a range of creative options when photographing. They offer a host of accessories to change the look of your images.

The LensBaby Composer lens allows you to transform your T2i into artistic tool that stretches your idea of photography.

Close-up photography is a striking and unique way to capture a scene. But how do you create pictures with that special close-up look?

CLOSE-UP LENSES AND ACCESSORIES

It is surprising to me that many photographers think the only way to shoot close-ups is with a macro lens. There are, however, several options for close-up photography. The following are four of the most common:

Zoom Lenses with a Macro or Close-Focus Feature: Most zoom lenses allow you to focus up-close without accessories, although focal-length choices may become limited when using the close-focus feature. These lenses are an easy and effective way to start shooting close-ups. Keep in mind, however, that even though these may say they have a macro setting, it is really just a close-focus setting and not a true macro lens.

Close-Up Accessory Lenses: You can buy lenses, sometimes called filters, which screw onto the front of your lens to allow it to focus even closer. The advantage is that you now have the whole range of zoom focal lengths available and there are no exposure corrections. Close-up filters can do this, but the image quality is not great. More expensive achromatic accessory lenses (highly-corrected, multi-element lenses) do a superb job with close-up work, but their quality is limited by the original lens.

Extension Tubes: Extension tubes fit in between the lens and the camera body of an SLR. This allows the lens to focus much closer than it normally could. While extension tubes are designed to work with many of the lenses for your camera, there may be some combinations that might not have the optical performance you would expect. Read any instructions that came with the extension tube, and experiment. Also, older extension tubes won't always match some of the new lenses made specifically for digital cameras. Be aware that extension tubes cause a loss of light.

Macro Lenses: Though relatively expensive, macro lenses are designed for superb sharpness at all distances, across the entire field of view, and focus from mere inches to infinity. In addition, they are typically very sharp at all f/stops.

Sharpness problems usually result from three factors: limited depth of field, incorrect focus placement, and camera movement. The closer you get to a subject, the shallower depth of field becomes. While you can stop your lens down as far as it will go for more depth of field, it is critical that focus is placed correctly on the subject. If the back of an insect is sharp but its eyes aren't, the photo appears to have a focus problem. At these close distances, every detail counts. If only half of the flower petals are in focus, the overall photo does not look sharp. Using autofocus up close can also cause a real problem with critical focus placement because the camera often focuses on the wrong part of the photo.

d With close-up photography, you should get used to manual focus. The depth of field can be so narrow that being just a little off can ruin a great shot. In this shot, care was taken so that the scallops are sharp, and tasty!

Jessica Anne Baum

When you are focusing close, even slight movement can shift the camera dramatically in relationship to the subject. The way to help correct this is to use a high shutter speed or put the camera on a tripod. Two advantages to using a digital camera during close-up work are the ability to check the image to see if you are having camera movement problems, and the ability to change ISO settings from picture to picture (enabling a faster shutter speed if you deem it necessary).

CLOSE-UP CONTRAST

The best looking close-up images are often ones that allow the subject to contrast with its background, making it stand out, and adding some drama to the photo. Although maximizing contrast is important in any photograph where you want to emphasize the subject, it is particularly critical for close-up subjects where a slight movement of the camera can totally change the background. There are three important contrast options to keep in mind:

Tonal or Brightness Contrasts: Look for a background that is darker or lighter than your close-up subject. This may mean a small adjustment in camera position. Backlight is excellent for this since it offers bright edges on your subject with lots of dark shadows behind it.

Color Contrasts: Color contrast is a great way to make your subject stand out from the background. Flowers are popular close-up subjects and, with their bright colors, they are perfect candidates for this type of contrast. Just look for a background that is either a completely different color (such as green grass behind red flowers) or a different saturation of color (such as a bright green bug against dark green grass).

Sharpness Contrast: One of the best close-up techniques is to work with the inherent limit in depth of field and deliberately set a sharp subject against an out-of-focus background or foreground. Look at the distance between your subject and its surroundings. How close are other objects to your subject? Move to a different angle so that distractions do not conflict with the edges of your subject. Try different f/stops to change the look of an out-of-focus background or foreground.

FILTERS

Many people assume that filters aren't needed for digital photography because adjustments for color and light can be made in the computer. But by no means are filters obsolete! They save a substantial amount of work in the digital darkroom by allowing you to capture the desired color and tonalities for your image right from the start. Even if you can do certain things in the computer, why take the time if you can do them more efficiently while shooting?

Of course, the LCD monitor comes in handy once again. By using it, you can assist yourself in getting the best from your filters. If you aren't sure how a filter works, simply try it and see the results immediately on the monitor. This is like using a Polaroid, only better, because you need no extra gear. Just take the shot, review it, and make adjustments to the exposure or white balance to help the filter do its job. If a picture doesn't come out the way you would like, discard it and take another right away.

Attaching filters to the camera depends entirely on your lenses. Usually, a properly sized filter can either be screwed directly onto a lens or fitted into a holder that screws onto the front of the lens. There are adapters to make a given size filter fit several lenses, but the filter must cover the lens from edge to edge or it will cause dark corners in the photo (vignetting). A photographer may even hold a filter over the lens with his or her hand. There are a number of different types of filters that perform different tasks.

• If you only ever buy one filter, make it a circular polarizer. Polarizing filters improve contrast and color saturation by reducing reflections from non-metallic surfaces like glass and water, and can help to make your subject really stand out.

POLARIZING FILTERS

This important outdoor filter should be in every camera bag. Its effects cannot be duplicated with software because it actually affects the way light is perceived by the sensor.

The filter rotates in its mount, and as you turn it, the strength of the effect changes. One primary use is to darken skies. This effect is greatest when used at an angle that is 90° to the sun. As you move off this angle, the effect diminishes. If your back is to the sun or you are shooting towards the direction of the sun, the polarizer will have no effect. A polarizer can also reduce glare (which often makes colors look more saturated), and remove reflections. While you can darken skies on the computer, the polarizer reduces the amount of work you have to perform in the digital darkroom.

There are two types of polarizing filters: linear and circular. While linear polarizers often have the strongest effect, they can cause problems with exposure, and often prevent the camera from autofocusing. Consequently, you are safer using a circular polarizer with the Rebel T2i.

ND filters simply reduce the light coming through the lens. They are called neutral because they do not add any color tint to the scene. They come in different strengths, each reducing different quantities of light. They give additional exposure options under bright conditions, such as a beach or snow (where a filter with a strength of 4x is often appropriate). If you like the effect when slow shutter speeds are used with moving subjects like waterfalls, a strong neutral density filter (such as 8x) usually works well, allowing you to use long shutter speeds without overexposing the image. Of course, the great advantage of the digital camera, again, is that you can see the result immediately on the LCD monitor, and modify your exposure for the best possible effect.

GRADUATED NEUTRAL DENSITY FILTERS

Many photographers consider this filter an essential tool. It is half clear and half dark (gray). It is used to reduce exposure of bright areas (such as sky), while not affecting darker areas (such as the ground). The computer can mimic its effects, but you may not be able to recreate the scene you wanted. A digital camera's sensor can only respond to a certain range of brightness at any given exposure. If a part of the scene is too bright compared to the overall exposure, detail is washed out and no amount of work in the computer will bring it back. While you could try to capture two shots of the same scene at different exposure settings and then combine them on the computer, a graduated ND might be quicker.

UV AND SKYLIGHT FILTERS

Most people use UV or skylight filters as protection for the front of their lens. Whether or not to use a protective filter on your lens is a neverending debate. A lens hood/shade usually offers more protection than a glass filter and should be used at all times, even when the sun isn't out. Still, UV or skylight filters can be useful when photographing under such conditions as strong wind, rain, blowing sand, or going through brush.

If you use a filter for lens protection, a high-quality filter is best, as a cheap filter can degrade the optical quality of the lens. Remember that the manufacturer made the lens/sensor combination with very strict tolerances. A protective filter needs to be invisible—literally—and only high-quality filters can guarantee that.

A successful approach to getting the most from a digital camera is to be aware that camera movement can affect sharpness and tonal brilliance in an image. Even slight movement during the exposure can cause the loss of fine details and the blurring of highlights. These effects are especially glaring when you compare an affected image to a photo that has no motion problems. In addition, affected images do not enlarge well.

You must minimize camera movement in order to maximize the capabilities of your lens and sensor. A steady hold on the camera is a start. Fast shutter speeds, as well as the use of flash, help to ensure sharp photos, although you can get away with slower shutter speeds when using wider-angle lenses. When shutter speeds go down, however, it is advisable to use a camera-stabilizing device. Tripods, beanbags, monopods, mini-tripods, shoulder stocks, clamps, and more, all help. Many photographers carry a small beanbag or a clamp pod with their camera equipment for those situations where the camera needs support but a tripod isn't available.

Check your local camera store for a variety of stabilizing equipment. A good tripod is an excellent investment and it will last through many different camera upgrades. When buying one, extend it all the way to see how easy it is to open, then lean on it to see how stiff it is. Both aluminum and carbon fiber tripods offer great rigidity. Carbon fiber is much lighter, but also more expensive. Another option that is in the middle in price/performance between aluminum and carbon fiber is basalt. Basalt tripods are stronger than aluminum but not quite as light as carbon fiber.

The tripod head is a very important part of the tripod and may be sold separately. There are two basic types for still photography: the ballhead and the pan-and-tilt head. Both designs are capable of solid support and both have their passionate advocates. The biggest difference between them is how you loosen the controls and adjust the camera. Try both and see which seems to work better for you. Be sure to do this with a camera on the tripod because that added weight changes how the head works. Make sure that the tripod and head you choose can properly support the weight of the T2i and all the lenses you will be using.

When shooting video, it is often necessary to pan the camera left or right, or tilt the camera up and down to follow action. Some tripod heads

allow panning, but many may not have a panning handle that allows you to operate the head while looking at the LCD monitor. If your tripod head does allow panning, it may not have the ability to tilt smoothly while recording video. Consider adding a video head to your tripod. Look for a fluid video head that offers smooth movement in all directions. Once again, make sure that the head is the right size for the T2i and the lenses and lens accessories that you plan to use.

A solid tripod is essential for shooting with long shutter speeds. This sunset shot of the ocean, was taken with a long shutter speed in order to give a painterly look to the water.

LCD HOODS

When shooting video or trying to evaluate your image, it can be almost impossible to see the LCD monitor in broad daylight. There are several manufacturers who make accessory loupes or hoods that can be held up to the LCD screen in order to evaluate still images. They can also be attached to the T2i for hands-free use when shooting video. These devices magnify the LCD display and have an eye cup that blocks out extraneous light. Two manufacturers are www.hoodmanusa.com and www.zacuto.com. There are also LCD hoods without magnification that just block out glare from the sun.

Output

FROM CAMERA TO COMPUTER

In a short time you'll have lots of images and movies on your memory card, so you will need to move them to your computer. There are three primary methods of transferring digital files—both still images and movies—from the memory card. One way is to use a media card reader. Many computers have a built-in card reader where you can insert the memory card for instant download. Card readers are also available as accessories that connect to your computer. They can remain plugged in and ready to download your images or videos. The second way to transfer your images is to download them directly from the T2i using a USB interface cable (included with the camera at the time of purchase). A third method uses a special type of SD card, called an Eye-Fi card, to transfer your photos wirelessly to your computer.

If you use an accessory card reader, you can connect it to your computer via a FireWire or USB port. FireWire (also called iLink or 1394) is faster than USB, but might not be standard on your computer. There are several types of USB: USB 1.0, 2.0, and 2.0 Hi-Speed. Older computers and card readers will have the 1.0 version, but new devices are most likely 2.0 Hi-Speed. This version of USB is much faster than the original. However, if you have both versions of USB devices plugged into the same bus, the older devices will slow down the faster ones.

The primary advantage to downloading directly from the camera is that you don't need to buy a card reader. However, there are some distinct disadvantages. For one, cameras generally download much more slowly than card readers (given the same connections). Plus, a camera has to be unplugged from the computer after each use, while accessory card readers can be left attached. In addition to these drawbacks, downloading directly from a camera uses its battery power (and shortens battery life by using up charge cycles), or requires you to plug it into AC power.

If you do want to download directly from the T2i, you need to install all of the software that came with the camera. One piece of software that is installed is EOS Utility. (On some computers you can see the camera mounted as a drive, but that varies among computer setups.) Once you connect the camera via the USB port to your computer, turn it on. EOS Utility may start up automatically, or you might have to start the application manually. Once it's running, you can download all the images on the card, or select just a few.

NOTE: When downloading from a camera or card reader, EOS Utility will copy the files into separate folders based on when the picture was taken, if you so choose. In this way, you can organize your images during the download process.

Eye-Fi cards, though relatively new, are growing in popularity. Their clear advantage is their ability to transfer files from virtually any location wirelessly. They, too, can automatically separate your images by date during the download process.

THE CARD READER

Accessory card readers can be purchased at most camera or electronics stores. There are several different types, including single-card readers that read only one particular type of memory card, or multi-readers that are able to utilize several different kinds of cards. (The latter are important with the Rebel T2i only if you have several cameras using different memory card types.)

Card readers are a cost effective means of transferring images to your computer without wearing out your camera's battery.

NOTE: If you are going to use SDHC memory cards (as I recommend), you must use a card reader that supports SDHC. Just because the card fits into an SD slot does not mean it will work. See pages 23-24 to learn more about SDHC

After your card reader is connected to your computer, remove the memory card from your camera and put it into the appropriate slot in your card reader. The card usually appears as an additional drive on your computer (on Windows and Mac operating systems—for other versions you may have to install the drivers that come with the card reader). When the computer recognizes the card, it may also give instructions for downloading. Follow these instructions if you are unsure about opening and moving the files yourself, or simply select your files and drag them to the folder or drive where you want them (a much faster approach). Make sure you "eject" the card before removing it from the reader: If using Windows, you right click on the drive and select eject; on a Mac, you can do the same or drag the memory card icon to the trash.

Card readers can also be used with laptops, though PC card adapters may be more convenient when you're on the move. As long as your laptop has a PC card slot, all you need is a PC card adapter for SDHC memory cards. Insert the memory card into the PC adapter, and then insert the PC adapter into your laptop's PC card slot. Once the computer recognizes this as a new drive, drag and drop images from the card to the hard drive. The latest PC card adapter models tend to be faster—but are also more expensive—than card readers.

New to the T2i is support for a special kind of SD memory card called the Eye-Fi card. The card acts like a regular memory card but also has a wireless transmitter. You can have the Eye-Fi card automatically and wirelessly transfer your photos to your computer each time you take a picture. The card can connect to many public Wi-Fi hotspots so that you don't have to wait to return home to start uploading files.

NOTE: Before using this function, you must set up the Eye-Fi card with your computer. Follow the instructions that come with the card or consult the manufacturer's website: www.eye.fi.

The Eye-Fi card is designed to work in most any camera that uses an SD memory card, but Canon has added features to the T2i in order to more fully support the technology. For example, in ** there is an [Eye-Fi settings] option. Use this to enable and disable file transmission. You can also see what network the card is connected to and view status messages about file transmission. But you don't have to use this menu to see when files are being transferred. There is a special icon on the LCD that indicates when a file is being transmitted. It looks like **. The icon flashes when the card is connecting to the network, and then animates when the file is being transferred

Another special feature is that the auto power off function on the T2i is delayed until all images have been transmitted. You can also program the card—using the computer not the camera—to upload only those images that have had the protect flag set (see page 94).

ARCHIVING

Without proper care, your digital images and movies can be lost or destroyed. Many photographers back up their files with a second drive, either added to the inside of the computer or as an external USB or FireWire drive. This is a popular and somewhat cost-effective method of safeguarding your data.

Hard drives and memory cards do a great job of recording image files and movie clips for processing, transmitting, and sharing, but are not great for long-term storage. Hard drives are designed to spin; just sitting

on a shelf can cause problems. This type of media has been known to lose data within ten years. And since drives and cards are getting progressively larger, the chance that a failure will wipe out thousands of images and movies rather than "just one roll of shots or tape" is always increasing. Computer viruses or power surges can also wipe out files from a hard drive. Even the best drives can crash, rendering them unusable. Plus, we are all capable of accidentally erasing or saving over an important photo or movie. Consider using redundant drives for critical data backup.

For more permanent backup, burn your files to optical discs: CD or DVD (recommended). A CD-writer (or "burner") used to be the standard for the digital photographer, but image files are getting too big and high-definition movie files are just about out of the question for CDs. DVDs can handle about seven times the data that can be saved on a CD, but even standard DVDs are becoming inconvenient for larger file sizes. Bluray discs (see below) may be the solution.

There are two types of DVDs (and CDs) that can be used for recording data: R-designated (i.e., DVD-R) recordable discs; and RW-designated (i.e., DVD-RW) rewritable discs. DVD-R discs can only be recorded once—they cannot be erased. DVD-RWs, on the other hand, can be recorded on, erased, and then reused later. If you want long-term storage of your images, use R discs rather than RWs. (The latter is best used for temporary storage, such as transporting images to a new location.) The storage medium used for R discs is more stable than that of RWs (which makes sense since the DVD-RWs are designed to be erasable).

As mentioned above, a new format, Blu-ray, is starting to be an option. This system uses a different colored laser (blue-violet) to read data. The use of a higher frequency light source means more data can be written to the disc. A single-layer Blu-ray disc can hold about 25GB of data, which is more than five times as much data as a single-layer DVD. A dual-layer Blu-ray disc can hold 50GB. This technology is quite new, however, so be aware that there may be some growing pains. As with DVDs and CDs, there are write-once (BD-R) and erasable (BD-RE) discs. Stick to BD-R for archive reliability. Blu-ray discs require a Blu-ray writer.

Optical discs take the place of negatives in the digital world. Set up a DVD binder for your digital "negatives." You may want to keep your original and edited images on separate discs (or separate folders on the same disc).

As previously mentioned, stay away from optical media that is rewriteable like DVD-RW or, for Blu-ray, BD-RE. You want the most reliable archive. At this point rewritable discs, while convenient, are not as reliable for archiving. Also avoid any options that let you create multiple "sessions" on the disc. This feature allows you to add more data to the disc until it is full. For the highest reliability, write all of the data to the disc at once.

Buy quality media. Inexpensive discs may not preserve your image files as long as you would like them to. Read the box. Look for information about the life of the disc. Most long-lived discs are labeled as such and cost a little more. And once you have written to the disc, store and handle it properly according to the manufacturer's directions.

WORKING WITH STILL IMAGES

How do you edit and file your digital photos so they are accessible and easy to use? You can organize your folders alphabetically or by date inside a "parent" folder. The organization and processing of images is called workflow. (If you want to start a heated conversation among digital photographers, ask them about workflow!)

NOTE: Even though the T2i puts both image and movie files into the same folder on the memory card, it is a good idea to divide the files by type and put them in separate folders once you get them on to your computer. This will help when you use the separate image editing and video editing applications.

Be sure to edit your stills to remove extraneous shots. Unwanted files stored on your computer waste storage space on your hard drive. They also increase the time you must spend when you browse through your images, so store only the ones you intend to keep. Take a moment to review your files while the card is still in the camera. Erase the ones you don't want, and download the rest. You can also delete files once they are downloaded to the computer by using a browser program (see pages 238-239).

Kevin Kopp

Come up with a system for organizing your files, and stick to it! If you do this, you will always be able to locate whatever photo you're looking for. As an example, in my filing system, this image might be located in Digital Images>2007>Vineyard Tour.

Here's how I deal with digital still files. (Later in this chapter I cover movies.) First, I set up an image filing system. I use a folder called Digital Images. Inside Digital Images, I have folders by year, and within those, the individual shoots or folders created for specific groups of images (you could use locations, clients, or categories like landscapes, sports, state fair, family, etc.; whatever works for you). This is really no different than setting up an office filing cabinet with hanging folders or envelopes to hold photos. Consider the Digital Images folder to be the file cabinet, and the individual folders inside to be the equivalent of the file cabinet's hanging folders. Next, I use a memory card reader that shows up as a drive on my computer. Using the computer's file system, I open the memory card as a window or open folder (this is the same basic view on both Windows and Mac computers) showing the

images in the appropriate folder. I then open another window or folder on the computer's hard drive and navigate to the Digital Images folder, then to the year folder. I create a new subfolder labeled to signify the photographs on the memory card, such as Place, Topic, Date.

Then, I select all the still images (no movies) in the memory card folder and drag them to the new folder on my hard drive. This copies all the images onto the hard drive and into my "filing cabinet." It is actually better than using a physical filing cabinet because, for example, I can use browser software to rename all the photos in the new folder, giving information about each photo; for example, using the title Woodcliff Lake_Oct10.

I also set up a group of folders in a separate "filing cabinet" (a different folder at the level of Digital Images) for edited photos. In this second filing cabinet, I include subfolders specific to types of photography, such as landscapes, close-ups, people, etc. Within these subfolders, I can break down categories even further when that helps to organize my photos. Inside the subfolders I place copies of original images that I have examined and decided are definite keepers, both unprocessed (direct from the camera) and processed images (keeping such files separate). Make sure these are copies (don't just move the files here), as it is important to keep all original photo files in the original folder that they went to when first downloaded.

IMAGE BROWSER PROGRAMS

Image browser programs allow you to quickly look at photos on your computer, rename them one at a time or all at once, read all major files, move photos from folder to folder, resize photos for e-mailing, create simple slideshows, and more. Some are good at image processing, and some are not.

One of the most popular names in image processing is Adobe, and their flagship application is Adobe Photoshop. While Photoshop is an image processing and enhancement program, it comes with Adobe Bridge, which can help organize photos. There are currently a number of other programs that help you view and organize your images.

NOTE: As manufacturers update their applications, they may add numbers to the application name, such as Photoshop CS5, Lightroom 3, or Final Cut Pro 7. For simplicity, in the rest of this chapter I refer to the basic name, without the version number.

ACDSee is a superb program with a customizable interface and an easy-to-use keyboard method of rating images. It also has some unique characteristics, such as a calendar feature that lets you find photos by date (though the non-pro version is Windows-only). Another program, Apple's Aperture (only available for the Mac), uses a digital loupe to magnify your images while browsing. Aperture is more than just a browser—it offers full image editing too.

Adobe's Lightroom is also an option. Like Aperture, Lightroom is more than just a browser. It has full image processing tools, as well as tools for printing pictures, making slide shows, and building web pages. The concept behind Lightroom (and Aperture) is to build an application that is specifically designed for photographers, rather than a program that has a lot of tools for other uses. There is also a somewhat scaled back version of Adobe Photoshop, called Adobe Photoshop Elements that contains most of the important tools and functionality of Photoshop, but is less intimidating.

All of these programs include some database functions (such as keyword searches) and many operate on both Windows and Mac platforms. Most of them have full-featured trial versions that are useful for checking to see if they will do the job for you.

An important function of browser programs is their ability to print customized index prints. You can then give a title to each of the index prints and list additional information about the photographer, as well as the photos' file locations. The index print is a hard copy that allows easy reference (and visual searches). If you include an index print with every DVD you burn, you can quickly see what is on the DVD and find the file you need. A combination of uniquely labeled file folders on your hard drive, a browser program, and index prints, helps you maintain a fast and easy way to find and sort images.

Once the files—JPEG or RAW—are organized on your computer, you must consider image processing. Of course, you can process the T2i's JPEG files in any image-processing program. One important characteristic of JPEGs is that they are universally recognized: Any program on any computer that reads image files will identify JPEGs. They are often used directly from your camera, but don't overlook that fact that JPEG files can be processed to get more out of them.

On the other hand, RAW—CR2 is the Canon version—cannot be read by just any imaging software, but requires a particular type of program in order to be opened. This format is significant in large part because it does increase the options for adjustment of your images. In fact, when you shoot RAW, you basically have to process every image; otherwise it will look dull and lifeless. This changes your workflow. You might want to take advantage of the T2i's ability to shoot RAW and JPEG simultaneously; that way you can save time and work with RAW only as needed.

A big advantage to the T2i RAW file is that it captures more directly what the sensor sees. It holds more information (14 bits vs. the standard 8 bits, per color) and stronger correction can be applied to it (compared to JPEG images) before artifacts appear. This can be particularly helpful when there are difficulties with exposure or color balance. (Keep in mind that the image file from the camera holds 14 bits of data even though it is contained in a 16-bit file. So while you can get a 16-bit TIFF file from the RAW file, it is based on 14 bits of data.)

NOTE: Rebel T2i RAW files are over 26MB in size so they fill memory cards quite quickly. With larger file sizes comes an increase in processing and workflow times.

Canon offers two ways to convert CR2 files to standard files that can be optimized in an image-processing program like Photoshop: a file viewer utility (ZoomBrowser EX for Windows or ImageBrowser for Mac), and the Digital Photo Professional software. In addition, Photoshop, Lightroom, and Aperture, have built-in RAW processing. There are also dedicated RAW processing applications like Phase One's Capture One. Each application has its own RAW processing "engine" that interprets the images, so there is a slight difference between programs in the final result.

©Kevin Kopp

RAW files allow a lot of flexibility in post processing—some photographers even ignore the white balance settings on their cameras altogether, shoot RAW, and set the white balance later, using the computer. But, I always say you can save yourself a lot of time if you just get the right WB at the time of capture.

NOTE: If you have an older version of any of these programs, you probably need to update your software in order to open the latest version of the RAW CR2 files. Even though all Canon RAW files have the CR2 file extension, they may not all be the same. Each new camera model changes the CR2 file format a bit. Unfortunately, the older versions of some image-processing applications are no longer updated to handle the T2i's new RAW files.

The File Viewer Utility: Canon's ZoomBrowser EX (Windows)/Image-Browser (Mac) supplied with the camera is easy to use. It is a good browser program that lets you view and organize RAW and JPEG files. It will convert RAW files, though it is a pretty basic program and doesn't offer some of the features available in other RAW processing software. Even so, it does a very good job of translating details from the RAW file into TIFF, PICT, BMP or JPEG form. Once converted, any image-processing program can read the new TIFF or JPEG. TIFF is the preferred file format because it is uncompressed; JPEG should only be used if you have file space limitations. You can also use the software to create an image suitable for email, to print images, and even to present a quick slide show of selected images.

Digital Photo Professional Software: This is Canon's advanced proprietary program for processing RAW and JPEG images. Included with the T2i, Digital Photo Professional (DPP) was developed to bring Canon RAW file processing up to speed with the rest of the digital world. This program has a powerful processing engine. It can be used to process both CR2 files and JPEG files. The advantage to processing JPEG files is that DPP is quicker and easier to use than Photoshop, yet it is still quite powerful. For fast and simple JPEG processing, DPP works quite well.

I believe if you are going to shoot RAW, DPP is a program you must try. It is fast, full-featured, and gives excellent results. One big advantage that DPP offers over any other RAW-processing program is the ability to use Dust Delete Data that is embedded in the RAW file (see pages 28-29). It can also read the aspect ratio information embedded in the image files, so it can crop images automatically.

EOS Utility: This application serves as a gateway for several operations with the T2i and accessories. First, it is used to download images (all images or just those selected) when the camera is connected via USB to the computer.

EOS Utility is also used for remote or "tethered" shooting. When you start up this feature, you can use the computer to fire the shutter, adjust shutter speed, aperture, ISO, white balance, metering mode, and file recording type (JPEG/RAW). There is limited access to menus: you can set Picture Style, white balance shift, and peripheral illumination correction in the Shooting menu displayed on the computer. You can use the peripheral illumination correction option to see which lenses have correction data available and are "registered" so that when those lenses are attached the T2i will apply the correction.

NOTE: The T2i can store lens correction data for 40 lenses.

You can remotely pop up the built-in flash on the camera using the EOS Utility Flash menu. Although this is not a very useful feature, if you are using the T2i with multiple Speedlites you have access to the flash function settings (see page 86). More importantly you can actually save different flash ratio setups.

In the EOS Utility Setup menu on the computer, you can set the camera owner's name, enter copyright information, change the date and time, enable live view, and update the firmware.

NOTE: The T2i supports embedding copyright information in the metadata of your images. Your name, a year, and any other text can be added to this metadata field.

Access to My menu * while tethered is a fast way to set up your * choices (see pages 109-111). Even if you never shoot tethered, consider hooking up the camera to set up My menu. Instead of scrolling through seemingly endless options on the T2i's small LCD monitor, use the remote camera control to point and click your way through selections using your computer's much larger display.

While tethered, you can turn on live view or movie shooting for a powerful studio-style, image-preview shooting setup. An instant histogram and the ability to check focus are helpful during tethered live view. You have the choice of capturing the images to the computer, or to the computer and the memory card in the T2i. As you record each picture, it can open automatically in Digital Photo Professional or in the image processor of your choice. Movies are only recorded to the memory card, but after you finish recording, they can be downloaded to the computer using the EOS Utility.

EOS Utility also offers the option of timed shooting. The computer acts as an intervalometer, taking a picture every few seconds (from five seconds to 99 hours and 59 seconds). You can also do a bulb exposure from five seconds to 99 hours and 59 seconds. In most cases, live view shooting—timed or bulb—will require the computer and camera to operate off AC power.

Picture Style Editor: The Picture Style Editor is a program that lets you create your own styles. When you import a RAW image, it allows you to adjust its overall tone curve, as well as the normal Picture Style parameters of sharpness, contrast, color saturation, and color tone. But the Picture Style Editor's most powerful feature is the ability to change individual colors in the image. Use an eyedropper tool to pick a color and then adjust the hue, saturation, and luminance values of the color. You can pick multiple colors and also choose how wide or how narrow

a range of colors (around the selected color) is adjusted. These custom picture styles can then be uploaded to the T2i using the EOS Utility. You can also download new picture styles that have been created by Canon engineers at: www.usa.canon.com/content/picturestyle/file/index.html or www.canon.co.jp/imaging/picturestyle/file/index.html.

Jessica Anne Baum

Canon's Emerald Picture Style is designed to produce bright, vivid blues and greens, reminiscent of Fuji's unique Velvia slide film.

PRINTING

If you use certain compatible Canon printers, you can control printing directly from the T2i. Simply connect the camera to the printer using the dedicated USB cord that comes with the T2i. Compatible Canon printers provide access to many direct printing features, including:

- O Contact-sheet style index prints with 35 images
- O Print date and filename
- O Print shooting information
- Face brightening
- O Red-eye reduction

- O Print sizes (printer dependent), including 4 x 6 inches, 5 x 7 inches, 8.5 x 11 inches (10.1 x 15.4 cm, 12.7 x 17.8 cm, and 21.6 x 27.9 cm, respectively).
- O Support for other paper types
- Print effects and image optimization: Natural, Vivid, B/W, Cool Tone, Warm Tone
- O Noise reduction

NOTE: Because of the wide variety of printers, it is possible that not all the printing features mentioned in this chapter are on your printer. For a detailed list of options available when the T2i is connected to your Canon printer, consult your printer's manual.

The T2i is PictBridge-compatible, meaning that it can be connected directly to PictBridge printers from several manufacturers. Nearly all new photo printers are PictBridge-compatible. (More information on PictBridge can be found at: www.canon.com/pictbridge/.)

To start the printing process, first make sure that both the camera and the printer are turned off. Connect the camera to the printer with the camera's USB cord (the connections are straightforward since the plugs only work one way). Turn on the printer first, then the camera—this lets the camera recognize the printer. Some printers may turn on automatically when the power cable is connected. Depending on the printer, the camera's direct printing features may vary.

Press the button. Once it is successfully connected to the printer, the camera will display a print screen with of in the upper left of the LCD. Use to select an image on the LCD monitor that you want to print. Press SET to display the print setting screen, listing such printing choices as printing effects, whether to imprint the date, the number of copies, trimming area, and paper settings (size, type, borders, or borderless).

Trimming is a great choice because it allows you to crop your photo right in the LCD monitor before printing, tightening up the composition if needed. To trim, first use ▲▼ to select [Trimming] and press SET. Use ④ and ➡□ to adjust the size of the crop; use ❖ to adjust the position of the crop. Use DISP to rotate the crop 90 degrees, and △□ to rotate the image within the crop in 0.5-degree increments. Press SET to accept the crop setting.

Depending on your printer, you can also adjust print effects to print images in black and white—in a neutral tone, cool tone, or warm tone. Other effects include noise reduction, face brightening, and red-eye correction. You can also choose to use a natural or vivid color setting. Press SET to select printing effects (, top listing in the print setting screen), and then use to select the type of printing effect. (Some printers may not support all effects.) Press DISP, to further refine your choices, then MENU to back out.

Continue using \diamondsuit and **SET** to select other settings. These choices may change, depending on the printer; refer to the printer's manual if necessary.

You can preview your trimming and print effect changes in the thumbnail image in the upper left section of the LCD monitor. Once you have selected the options you want, then use \diamondsuit to select [Print] and press SET to start printing. The LCD monitor confirms that the image is being printed and reminds you not to disconnect the cable during the printing process. Wait for that message to disappear before disconnecting the camera from the printer. If you wish to use the same settings for additional prints, use \diamondsuit to move to the next picture, then simply press the \triangle button (located to the right of the LCD monitor) to print it.

NOTE: The amount of control you have over the image when you print directly from the camera is limited solely by the printer. If you need more image control, print from the computer.

If you shoot a lot of images for direct printing, do some test shots and set up the T2i's Picture Styles (see pages 56-62) to optimize the prints before shooting the final pictures. You may even want to create a custom setting that increases sharpness and saturation just for this purpose.

Another of the T2i's printing features is DPOF (Digital Print Order Format) . This allows you to decide which images to print before you actually do any printing. Then, if you use a printer that recognizes DPOF, the printer automatically prints just the images you have chosen. DPOF is also a way to select images on a memory card for printing at a photo lab. After the images on your SD card are selected using DPOF, drop it off at the photo lab—assuming their equipment recognizes DPOF (ask before you leave your card)—and they will know which prints you want.

DPOF is accessible through the Playback 1 menu ☐ under [Print order]. You can choose several options: Select [Set Up] to choose [Print type] ([Standard], [Index], or [Both]), [Date] ([On] or [Off]), and [File No.] ([On] or [Off]). Once you set your print options, press MENU to return to [Print order]. From there you have several ways to select images to print: Select [All image], [By] or select images manually. To select images manually, highlight [Sel.Image], press SET and then use ❖ to scroll through your images. Press SET to "order" a print of the image. Use ▲▼ to increase the number of copies to print for the current image, and press SET to accept the quantity. If you are printing an index print, use SET to select an image to include on the index print. You can also press ➡○ to bring up a three-image display to select images. Use ❖ and SET to go through and mark all of the images to be printed. Press MENU to return to the [Print order] screen. The total number of prints ordered appears on the screen.

NOTE: RAW and movie files cannot be selected for DPOF printing. If you shoot RAW+JPEG, then you can use DPOF. The JPEG versions of the files will be printed.

If you are printing the images yourself, you may now connect the camera to the printer. Press **SET** to start printing. Or go to the [**Print order**] screen in **3** and you will see a [**Print**] button. Use \diamondsuit to highlight, and then press **SET**. Set up image optimization and paper settings, then select [**0K**] and press **SET** to start the printing process. If you are using a photofinisher for DPOF, make sure that you back up your memory card and that the photofinisher supports DPOF.

Workflow for movies is different from that used for still images. File sizes can be extremely large—often gigabytes instead of megabytes—and some editing programs work best if the files are in a certain place. Generally, movie clips need to be edited together, as opposed to an image that may stand alone as a single photograph. In other words, video clips are often "program" based; a single clip won't have the impact that a single photograph does. In addition, video may be scripted or storyboarded.

My workflow for video is very much project-based. It also requires a concerted effort to think about archiving even before I start editing the project. Once I have finished recording, I create a project folder on a high-speed external drive. Depending on the size of the drive, that folder might be within another folder that includes the year or the month, so I can keep projects separate. For example, I might have a structure of 2010/February/Costa_Rica/. Once the file structure is in place, I copy my footage into the new folder.

Depending on the software application I choose for video editing, I may then view each file and rename the files. If I were doing interviews, I would rename the file with the person's last name and then a take number, such as Holly01, Holly02, etc. If I use an editing application like Final Cut Pro, I might leave the file name alone and do all of the descriptive data entry in the editing program.

The nice part about changing the name at the file level is that it is more descriptive. You can search within the file system, rather than opening up an editing application. On the other hand, the advantage of changing the name in the editing program is that you can use longer names and you can include information like take number, comments, camera angle, script notes, whether a clip is good or bad, etc., in columns next to the file name (depending on your editing software).

NOTE: Once you bring the files into your editor and you start to edit, don't change the file names of the movies using the file system. The files may become unlinked from your project. Also, don't move them from the folders that they are in, as this could break the link too. Although there are ways to relink files, they don't always work.

Once I have the file names set, I copy the folder to my archive drive, or—if the folder is small enough—to an optical disc (Blu-ray). This way I have a working copy on the high-speed drive and an untouched copy for archive. When you edit video, you don't change pixels on the original files; to revise a project, all you need is the project file and the original movies the project is linked to.

VIEWING MOVIES

Canon's ZoomBrowser EX (Windows)/ImageBrowser (Mac), supplied with the T2i, can play back individual movie clips, trim them, and even save a still frame, but it can't edit the clips into a sequence. If you merely want to view your files, QuickTime player is a good (and free!) application. The Pro version of QuickTime lets you trim clips and even build a rough sequence, but it is not very intuitive and does not foster much creativity. For that, you need a real editing application for use with your computer.

NOTE: If you are on the Windows platform, you may need to install QuickTime in order to view your movie clips. Download the Windows version at www.apple.com/quicktime/. For simple playback of movies, it is not necessary to buy the QuickTime Pro version or download iTunes with QuickTime. Download just the "plain" version of QuickTime.

MOVIE EDITING

There is quite an assortment of video editing applications for both Windows and Mac computer platforms, and for all budgets. On the Windows side, there are Adobe Premiere and Premiere Elements, Sony Vegas, Pinnacle Studio, and Corel VideoStudio Pro X2. For Mac users, there are Adobe Premiere, Avid's Media Composer and Xpress Pro, Media 100, and Apple's iMovie, Final Cut Express, and Final Cut Pro.

Costs for the software alone range from "included with your computer" to thousands of dollars. The less expensive options can work if you do simple cuts and dissolves, but not much in the way of effects, layering, or complicated projects. The more expensive applications give you more options for the output of your finished project—compression for the web or authoring Blu-ray discs.

Manipulating HD video is very taxing on a computer. These are essentially large image files that are flying by at 30 or 60 frames per second, so you need a computer that can handle it. Bulk up on RAM and processor speed—as much as you can afford.

Several of the editing applications—Premiere and Final Cut Pro, for example—can edit natively (without having to convert to another file format) in the h.264 codec. The h.264 is a highly efficient algorithm. It reduces both file size and the data rate needed to record the movie. Unfortunately, it takes a great deal of computing power to make this happen. You may find that your computer, which worked fine running Photoshop and editing RAW files, can struggle just to play back a single movie file without stuttering frames. Generally this is caused either by a slow disc drive or by a slow processor (CPU).

Will editing natively in the h.264 codec work for you? It all depends on the application you are using, your computer's horsepower, and your tolerance for the process. Since h.264 is not really optimized as an editing format, there are several workarounds to overcome the need for the fastest computer and the most RAM. One method is to "transcode" the file to another codec. Transcoding a file means making a copy and recompressing it. If your computer is slowing down, try a codec that is uncompressed or one that is more suitable for editing (like XDCAM-HD or Apple's ProRes). Some problems with transcoding are that the color space, or dynamic range, might change; some highlights might change; detail may disappear; and/or colors might shift. Make sure you compare the transcoded file to the original. Another issue may be rendering times if you need to output back to an h.264 file. If this is the case, you should perform some test renders so you know how long it will take. You don't want to be surprised if your final project takes three hours to render, especially if it was supposed to be completed an hour ago.

Another option to reduce processor load is to edit in a low-resolution proxy mode. Proxies are to movies what thumbnails are to photos. They are low-resolution video clips. This is the technique that Corel VideoStudio Pro X2 uses. It converts the high-definition movies to smaller movies that are easier to use during the editing process. Once the edit is complete, the software links up to the original high-definition files for output.

It is important to consider the output process before you begin editing.

NOTE: There isn't one "best" solution. Each website or host has its own requirements that, unfortunately, may constantly change. It is important that you do your research before you start shooting, so you know what you need to deliver. In fact, you may need to deliver multiple versions of the file.

If you want to deliver high definition on optical disc, there are two options. First, you can compress your finished program into a codec that is supported on Blu-ray. You then author a Blu-ray disc that can play on a set-top Blu-ray player. Many of the applications above can do this, or can tie into disc-authoring programs from the same manufacturer. Of course this requires your computer to have a Blu-ray drive that can write discs.

A second option is to create a high-definition file that you burn onto a regular DVD. You then play the DVD in an advanced DVD player that is capable of playing HD files. Although this is not a common feature on DVD players, there are some are out there that can do it. Before Blu-ray burners were available, this was one of the few ways to play back HD content in the field.

It is not uncommon for a file to be compressed more than one time, but you should avoid multiple steps of compression, just like when you work with image files. And remember, the large file sizes for movies mean longer times to upload, download, archive, and transfer from one location to another.

В

bounce flash

built-in flash

211, 242

modes)

208

195, **197 – 198,** 200, 203, 208,

bulb exposure mode (see shooting

45, 50, 86, 122, 187,

Index

C Α AC adapter 22, 29, 181 Canon Speedlite EX flash units 86. A-DEP (automatic depth-of-field) 122, 148, 178, 189 - 202, **142.** 197 203 - 207, 208, 209, 211 AE lock 158 – 159 card reader 23, 231, 232 - 233 AE lock/FE Lock/index/reduce button center-weighted average metering 38 - 39, 115, 125, 156, 175 (see metering) AF-assist beam 123, 148, 202 cleaning, camera 26 - 29AF modes 16, **35 – 36,** 107, 114 – cleaning, sensor 22, 27 - 29 115, **148 - 150, 171 - 175,** 176, 181 close-up flash 190, 206 - 207 Al focus 150 close-up photography 132, 141, Al servo 149 – 150 190, 206 - 207, 219, **222 - 225** 63,91 - 92face detection AF 113. 174 - 175 color space live mode AF 113, **173 - 174** compression 73, 74, **76,** 78, 83, one shot 149 184, 251 auick mode AF 113, **171 - 172** CR2 (see RAW) AF point selection 37 - 38, 49, 150,creative auto (see shooting modes) 170, 172 Custom Functions menu aperture-priority (Av) mode 117 - 126, 205 (see shooting modes) custom white balance 68 - 69234 - 23687, 90, 91 archiving audio (see sound recording) autoexposure bracketing (AEB) 88 - 89, 118, 161 - 162 D Auto Lighting Optimizer 89, 165, 170 delete (see erase) depth of field 33, 131, 132, 138,

139, 140, 142, 223, 225

Digital Photo Professional software 28, 29, 56, 58, 62, 75, 92, 121,

41 - 43

45, 140,

16, 46 - 47

40, 244, 245, 246

depth-of-field preview

165, 240, 242, 243

dioptric adjustment

direct printing

display button

25.5

DPOF (digital print order format) 246 – 247 drive modes 16, 36, 143 – 144, 162 continuous 143 self-timer: 10 sec/remote control 144 self-timer: 2 Sec/remote control 144	focus modes (see AF modes) formatting a memory card 24 – 25, 94, 95, 100, 101 frame rate 14, 105, 112 – 113, 178, 183 full auto exposure mode (green mode) (see shooting modes)
single shooting 143, 187 Dust Delete Data detection 14, 28 – 29, 92 – 93	G
·	graduated neutral density filter 227
EF-series lenses 215 – 217	grid display 106, 116 guide numbers 191 – 192, 197, 204
EF-S series lenses 217 EOS utility 242 – 243 erase 25, 43 – 44, 95	н
E-TTL 193, 208 E-TTL II 193, 209 exposure compensation 15, 44, 88 – 89, 118, 160 – 161, 177, 181 exposure lock 38 – 39, 144 – 115, 158 – 159 exposure modes (see shooting modes) exposure simulation 179 – 180	high-definition (HD) video 15, 111 – 113, 182, 183, 185 highlight alert 163 histogram 41, 96 – 97, 163, 164 – 165, 169
evaluative metering (see metering)	1
F face detection 15, 174 – 175, 179 file format 73 – 75, 76 – 78, 241 file viewer utility 241 filters 58 – 60, 69, 70. 71, 222, 225 – 227	image browser programs 238 – 239 image processing 14, 238, 239, 240 – 244 independent lenses 221 ISO 15, 17, 34, 93, 115, 118, 121, 135, 151 – 154, 176, 178
firmware 109 flash photography 48, 125, 189, 195	I
flash exposure compensation 50,	JPEG 15, 16, 55 – 56, 73 – 74,

76 - 78,82 - 83,143,240,241,

242

flash exposure lock 38 – 39, 198 – 199 flash metering 193 – 197 flash synchronization 15, 119, 192, 194, 197 flash units (see Canon Speedlite EX flash units)

125, 200, 210

219, 222

LCD monitor 47 - 51 live view shooting 39, 106, 167 - 168, 170, 177, 178, 180 L-series lenses 218

34, 97

M

macro lenses

main dial

manual focus 38, 130, 156, 176, 224 memory card 21, **23 – 25,** 41, 51, 56, 74, 77, 78, 94, 143, 181, 186, 231 - 237metering 14-17, 90, 116, 141, **155 – 159,** 170, 178, 193, 209, 211 center-weighted average 38, 90, 158, 170, 178 evaluative 16, 38, 90, 155 - 156, 170, 193 flash **193 – 197,** 198 partial 16, 38, 90, 141, 156 spot 16, 38, 90, 155, **158** mirror lockup 109, 122 – 123, 145 mode dial 16, **32 – 33**, 44, 81, 111, 129, 130, 167, 168 monochrome 58, 131 movie editing 187, 249 - 250 movie output 249, 251 movie playback 186 – 187 movie recording size 111 - 113, 169, 170, 186 movie recording format 111 – 112 movie shooting 33, 37, 42, 81, 87, 106, 111, 115, **167 - 187** Movie 1 menu **111 – 115,** 168 Movie 2 menu 115 - 116, 168 movie trimming 187 My menu 32, 40, 81, **109 – 111,** 243

N

neutral density (ND) filter (see filters) noise 15, 17, 53, 56, 93, 109, 119 - 121noise reduction 15, **119 – 121**, 138, 141, 152, 245, 246

0

one shot AF (see AF modes)

partial metering (see metering)

P

peripheral illumination correction 15, 85, 242 Picture Styles 33, 36 - 37, 51,**56 – 62,** 75, 92, 165, 170, 181, 246 Picture Style editor 243 - 244 playback 37, 39 - 41, 43, 48, 81, 97, 98, 121, 163, 164, 187, 249 playback button 43 Playback 1 menu 44, **94 – 96,** 247 Playback 2 menu 96 - 98polarizer filter (see filters) power switch 45 prime lens 213, 214, 215, 219 printing 23, 37 – 40, 43, 61, 77, 244 - 247program AE (P) mode (see shooting modes) program shift 134 protect images 94

Q

Quick Control button 33, 40, 57, 130, 200 Quick Control screen 15, 26, 35, 37, 40, 41, **50** – **51,** 67, 76, 89, 102, 154, 160, 161, **169 - 172**, 181, 200

RAW 14 – 16, 55 – 56, 63, 64,	
72 – 78, 82, 83, 89, 92, 97, 121,	
134, 165, 240 – 243	
RAW+JPEG 83, 121, 143, 247	
recording length 185	
red-eye reduction 51, 86, 197,	
200 – 202, 245	
rotate image 48, 51, 94, 99 – 100	

S

R

SD card (see memory card) SDHC card (see memory card) SDXC card (see memory card) self-timer (see drive modes) 14, 15, 27, 28, 29, 50, 51, **52 - 53,** 105, 192 sensor cleaning (see cleaning, sensor) Set-Up 1 menu 99 – 103 Set-Up 2 menu 104 - 106Set-Up 3 menu 107 - 109shooting modes aperture-priority AE (Av) 119, 129, **138 – 140,** 152, 153, 192, 196 bulb (B) 141, 145, 243 creative auto 32-33, 129, **130**, 194 full auto exposure (green mode) 32 - 33, 129, **130** manual (M) 196 – 197 program AE (P) 33, 129, 134 - 135shutter-priority AE (Tv) 129, 135 - 138, 152, 153 Shooting 1 menu 82 – 86 Shooting 2 menu 87 – 92 Shooting 3 menu 92 - 93shutter button 33, 114, 124 shutter-priority AE (Tv)

(see shooting modes)
single shooting (see drive modes)

slideshow 96
sound recording 116
spot metering (see metering)
standard definition video 111, 112,
182, 183

T

tilt-shift lens **220 – 221** tripod 133, 216, 228 – 229

٧

video compression 184, 250, 251
video frame rate 105, 112 – 113, 178, 183
video recording parameters 182 – 185
video resolution 15, 182, 187
video scanning type 183
viewfinder 46 – 47, 50, 88, 90, 102, 145, 171

W

white balance 16, 35, 51,
63 – 64, 65 – 69, 69 – 70, 70 – 72,
72 – 73, 90, 165, 181
white balance, custom (see custom white balance)
white balance bracketing 70 – 72,
90
white balance correction 69 – 70
white balance presets 65 – 69
wireless E-TTL flash 208 – 211
wireless remote (see remote release)

Z

zoom lens 215, 222

OUTCK CONTROL SCREEN

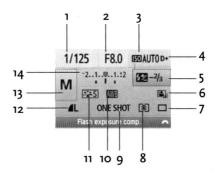

- 1. Shutter speed
- 2. Aperture
- 3. ISO sensitivity
- 4. Highlight tone priority
- 5. 52 flash exposure compensation
- 5. 42 Itasii exposure compensation
- 6. Auto Lighting Optimizer
- 7. Drive mode
- 8. Metering mode

- 9. AF mode
- 10. White balance
- 11. Picture Style
- 12. Image-quality
- 13. Shooting mode
- 14. Exposure level indicator / exposure compensation amount / AEB range

SHOOTING SETTINGS DISPLAY

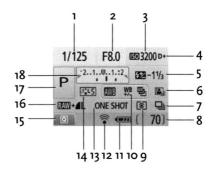

- 1. Shutter speed
- 2. Aperture
- 3. ISO sensitivity
- 4. Highlight tone priority
- 5. 💯 flash exposure compensation
- 6. Auto Lighting Optimizer
- 7. Drive mode
- 8. Shots remaining / self-timer
 - countdown / bulb exposure time
- 9. Metering mode
- White balance / white balance correction / white balance bracketing

- 11. Battery status indicator
- 12. Eye-Fi status
- 13. AF mode
- 14. Picture Style
- 15. Quick Control icon
- 16. Image quality
- 17. Shooting mode
- Exposure level indicator / exposure compensation amount / AEB range
- 19. Fi main dial pointer